What Photography Is

In *What Photography Is*, James Elkins examines the strange and alluring power of photography in the same provocative and evocative manner as he explored oil painting in his best-selling *What Painting Is*. In the course of an extended imaginary dialogue with Roland Barthes's *Camera Lucida*, Elkins argues that photography is also about meaninglessness—its apparently endless capacity to show us things that we do not want or need to see—and also about pain, because extremely powerful images can sear permanently into our consciousness. Extensively illustrated with a surprising range of images, the book demonstrates that what makes photography uniquely powerful is its ability to express the difficulty—physical, psychological, emotional, and aesthetic—of the act of seeing.

James Elkins is E.C. Chadbourne Chair in the Department of Art History, Theory, and Criticism at the School of the Art Institute of Chicago. He is the author of *Pictures and Tears, How to Use Your Eyes, Stories of Art, Visual Studies, Why Are Our Pictures Puzzles?, Our Beautiful, Dry, and Distant Texts, On the Strange Place of Religion in Contemporary Art,* and *Master Narratives and Their Discontents,* all published by Routledge. He is editor of *Art History Versus Aesthetics, Photography Theory, Landscape Theory, The State of Art Criticism,* and *Visual Literacy,* all published by Routledge.

WHAT PHOTOGRAPHY IS

James Elkins

Ｒ Routledge
Taylor & Francis Group

NEW YORK AND LONDON

First published 2011
by Routledge
711 Third Avenue, New York, NY 10017

Simultaneously published in the UK
by Routledge
2 Park Square, Milton Park, Abingdon, Oxon OX14 4RN

Routledge is an imprint of the Taylor & Francis Group, an informa business

© 2011 Taylor & Francis

The right of James Elkins to be identified as author of this work has
been asserted by him/her in accordance with sections 77 and 78
of the Copyright, Designs and Patents Act 1988.

Typeset in Bodoni and Minion Pro by
Florence Production Ltd, Stoodleigh, Devon

Library of Congress Cataloging in Publication Data
Elkins, James, 1955–.
 What photography is/James Elkins.
 p. cm.
 Includes bibliographical references and index.
 1. Photography, Artistic. 2. Photography—Philosophy.
 3. Barthes, Roland. Chambre claire. I. Title.
 TR642.E43 2011
 770.1—dc22 2010017231

ISBN13: 978–0–415–99568–9 (hbk)
ISBN13: 978–0–415–99569–6 (pbk)
ISBN13: 978–0–203–88648–9 (ebk)

Contents

Preface

It has been thirty years since Roland Barthes published his "little book," *Camera Lucida*. In the intervening years photography has become a major part of the international art market, and a common subject in university departments of art history and philosophy. An enormous literature has grown up around photography, its history, theory, practice, and criticism.

I think that three interests drive the great majority of current writing. First is contemporary fine art photography as practiced by the internationally prominent figural photographers such as Jeff Wall, Beat Streuli, Thomas Struth, Rineke Dijkstra, Thomas Ruff, and Andreas Gursky. That literature includes texts by Wall, Michael Fried, Diarmuid Costello, and numbers of newspaper critics and commissioned writers. What matters for it is modernism, postmodernism, the gallery system, the art market, and the status of photography as fine art.

Second is photography's social significance, a subject that has attracted a host of writers including contributors to *The Meaning of Photography* (2008) and *Photography Degree Zero* (2009), Margaret Olin, Georges Didi-Huberman, Paul Frosh, and even the novelist William Vollmann. What matters for those writers is photography's use as social glue, as witness to war, as mirror of the

middle class, as medium for constructions of race and gender, as a political tool, and as a principal determinant of our visual culture. It matters that photographs are made by the millions, sent by email, uploaded to photo-sharing services, sometimes even printed and framed. Much of the academic study of the history of photography also involves these issues.

The third subject is photography's way of capturing the world. Writers who care about this meditate on how photography provides us with memories, how it preserves the past, how it seems real, how it captures time, how it shows us other people's lives. For these writers, many of them philosophers, photography is centrally about representation, time, memory, duration, presence, love, loss, mourning, and nostalgia. This literature includes Roland Barthes's book, and also texts by Susan Sontag, Jacques Derrida (*Six Derrida Texts on Photography*), Serge Tisserand, Henri Van Lier, and many others.

I am not much interested in any of these subjects. I refer to the recent literature throughout this book, but the references are not systematic. Photography is a fine art "as never before," as Michael Fried says; and it has been a mirror and model of society since its inception, as Baudelaire knew. Often enough it is about time and representation. But for me photography is essentially not about art, society, or representation: I find seeing is essentially solitary, and photography is one of the emblems of that solitude.

While I was writing this book, I was editing a book called *Photography Theory*, which assembles thirty scholars' opinions about how photography can best be conceptualized. *Photography Theory* is skewed somewhat to a discussion of one theory in particular (the "index," which I will mention later on), but the book is reasonably representative of the directions of current thinking, and well stocked with references. The principal writers on photography are there—Liz Wells, Abigail Solomon-Godeau, Rosalind Krauss, Joel Snyder, Geoffrey Batchen, Margaret Olin, Victor Burgin, Nancy Shawcross, Anne McCauley, Margaret Iversen—and so are the major points of reference, from Vilém Flusser and Pierre Bourdieu to the strange and encyclopedic Henri Van Lier. By comparison this book is wayward and badly behaved. If this book seems unhelpfully disconnected from current concerns, you might turn to *Photography*

Theory or other recent scholarly books on photography such as *The Meaning of Photography, Photography: Theoretical Snapshots, Photography Degree Zero,* Fried's *Why Photography Matters As Art As Never Before,* Joan Fontcuberta's *Photography: Crisis of History,* or the new journal *Philosophy of Photography.* If you are a historian of photography, or a critic engaged with the currently famous photographers, please don't expect this book to be either helpful or relevant.

What I propose is to return, once again, to *Camera Lucida,* but in order to write against it, to find another sense of photography. Despite the rapidly growing literature, Barthes's "little book"—so he called it, reminding us how much is really in it—remains a central text. The punctum—little point of pressure or pain, hidden in every photograph, waiting to prick the viewer—is still one of photography's indispensable theoretical concepts, and *Camera Lucida* itself is widely assigned in classes and mentioned by critics, historians, and artists in a bewildering range of publications.

(If you haven't read *Camera Lucida,* you could stop reading this book about here, and take it up again after you've read Barthes's book. I rail about *Camera Lucida* intermittently throughout this book, but mainly in Chapter 1, so you could also begin with Chapter 2.)

Camera Lucida is both scapegoat and touchstone, marginal and model. It is cited in passing, trivially; but it's also pondered at length. For many people, it is too familiar to re-read, but it is still taught in college classes. At one moment it seems intensely scholarly, and in the next refreshingly free of academic pomp. It is understood as part of the history of postwar art theory, but it is also taken as a source of insight into photography.

It seems hardly a symposium goes by without an appearance of the punctum or the "Winter Garden photograph" (the photograph Barthes describes, showing his mother as a little girl). In autumn 2003 I attended a conference on visual culture in Nottingham; in his closing remarks the event's organizer, Sunil Manghani, asked why nearly every speaker had alluded to Barthes. We were surprised, I think, to realize we had each mentioned him, even though we hadn't all been talking about photography and even though we came from fields as different as geography and journalism. Manghani proposed

that *Camera Lucida* is still read because the writing is beautiful. There isn't an easy way to assent to that because the text's beauty, if that word could ever be the right one, is not clearly linked to what it has to say. Yet Manghani's remark wasn't wrong, either, and no one demurred. The conference ended there, with Barthes briefly on everyone's minds.

Like its author, who had recently lost his mother, *Camera Lucida* is unstable: on one page it lectures, and then suddenly it becomes a rhapsody or a soliloquy; at one point it is lucid, and then instantly nearly incomprehensible; in another place it is gentle and calm, then almost demented with sadness. The text pricks you, and then softens the hurt with prose: it mimics the punctum and its sterile salve, which Barthes calls *studium*. (For Barthes, studium is the punctum's often uninteresting counterbalance: it means the transmissible analysis of images, whatever is public and publishable and makes sense in classrooms. Studium has become the daily business of visual studies, a field Barthes would have disliked.) What kind of reading can follow that ebbing and flowing of voice, authority, and purpose? It seems Manghani's remark could never be wholly irrelevant, but neither could it ever be enough to describe what happens in *Camera Lucida*. As Geoffrey Batchen has pointed out, the photographs in *Camera Lucida* amount to a "carefully calibrated" "full survey" of photography, covering most decades from the 1820s to the 1970s, and ending, in suspense, on the question of what photography had become. (*Meaning of Photography*, 76–91.) So it's a document of its moment, the same moment that puzzled Susan Sontag, Rosalind Krauss, and others: true, but as Batchen says, that does not explain why it still speaks to so many people.

It is essential, I think, to sit down with Barthes's strange little book and take time to absorb it, consider its felicities and opacities, what it declines and admits, and above all what kind of writing it gives us. (Not only what kind of photography, but what kind of writing: the two are commingled.) One of my intentions is to read *Camera Lucida* as well as I can, and to give it back to current practice in a new and more problematic form: one that takes on board what Barthes did with writing, and what he did to writing. The format of this book mimics *Camera Lucida*'s format: I have written brief numbered sections, and, as in the English translation of *Camera*

Lucida, each section begins with a numbered black-field drop capital. The idea, which I will try to justify as I go along, is to write about photography by writing into or through Barthes's book—ventriloquizing if necessary, inhabiting the book, writing at first from inside it, in order finally to be outside it.

Like Barthes, I will be arguing about photography as well as working with writing, and my argument is that Barthes's book is too full of light to capture what photography does. *Camera Lucida* is generously lit with metaphors of memory and sentiment, but its thoughts are very carefully tended, as if its subject were tender and prone to wilt in the glare of harder inquiry. Of the many things elided in Barthes's book—not least of them his own lifetime practice of structuralist analysis, which he throws over to make room for his personal search for his mother's image—the most important is photography's inhumanity. For me, Barthes gets photography perfectly right when he sees how it hurts him (and how, although this cannot be a different subject, it hurts his habits of writing) and badly wrong when he imagines it mainly as a vehicle of love and memory. *Camera Lucida* is at the beginning of a flourishing interest in affect, feeling, and trauma in the art world, and that may be the best explanation of its staying power. Before the art world was caught up in affect and identity, Barthes's book was an anomaly, which needed to be rectified to be used. Now it seems much closer, and its warmth and weirdness feel just about right. In a sense, then, this book is against everything I think Barthes's book might be charged with starting—but none of that is aimed well, or done systematically or carefully.

Camera Lucida hides photography's non-humanist, emotionless side. Photography is not only about light and loss and the passing of time. It is about something harder. I agree with Barthes that at one of its limits, ordinary photography of people has something to do with the viewer's unfocused ideas about her own death. But I also think that photography has given us a more continuous, duller, less personal kind of pain. Again and again photographs have compelled people to see the world as they had not needed or wanted to see it. Photographs have forced something on us: not only a blurred glimpse of our own deaths, a sense of memory as photographic grain, a dim look at the passage of time, or a poignant prick of mortality,

but something about the world's own deadness, its inert resistance
to whatever it is we may hope or want. Photography fills our eyes
with all the dead and deadening stuff of the world, material we don't
want to see or to name. I am after a certain lack of feeling, a coldness
I miss in Barthes.

The beauty of Barthes's book, its watery spill of ideas, its gracious
turns of phrase, the cascades of evanescent thoughts and throw-away
terms that don't always quite follow from one another . . . all that
beauty works hard, drawing my attention away from the other face
of photography. I think Manghani is right that *Camera Lucida*'s
beauty is a principal reason the book is still on our bookshelves, and
I am going to take that beauty seriously in the pages that follow.
(Even if I won't be calling it "beauty" any more.) But for me the
famous punctum is just a pinprick. I think the wound is much larger.
Photography insistently gives us the pain and the boredom of seeing,
and the visual desperation that can follow. The strategy of this book
is to find that less pleasant, less emotional photography by writing
directly into the one book on photography that is both inescapable
and too often avoided.

* * *

Another book, *What Painting Is*, is intended to be uniform with *What
Photography Is*. The two are not companion volumes in the usual
sense, and if you are coming to this book after *What Painting Is*,
you would be right to see no connection, no common argument.
Neither book is a summary of the consensus views about either
medium, and neither is a reliable guide to the preponderant
directions of research. Both books abandon much of what has come
to matter to their two media. They are personal attempts to capture
what I care about when I am not preoccupied with academic
concerns. There is career and community, and then, for me, there
are also sources of visual pleasure and fascination that just do not
fit with current critical discourse. It's like Freud's division of desires
into "love" and "work." I see that for many of my colleagues, there
is a fairly good match between the things they love about visual art
and the writing they produce as scholars. For me, love and work have
finally been coming apart. It's not a divorce, exactly: I still spend

most of my time writing as an academic, contributing to books like *Photography Theory*. But increasingly I find that it matters a great deal to resist the tremendous tidal pull of academic discourse, to recover and nourish the things I have seen and felt on my own. So many scholars are overwhelmed by the oceans of words that well up from the past, by the intoxicating sharpness of academia, by the occasionally riveting language of scholarship, by the glow of hard-won approval. They come to forget that they are not writing about what it is in art that gives them pleasure, that transfixes them, that makes them speechless. Or they think they are, but what they are producing is books that only other scholars read, where moments of encounter are braced by hard argument or safely cosseted in soft footnotes. That kind of writing can produce rewarding careers, but not books that speak beyond the conference circuit. It is dangerously easy to live a full academic career, imagining that your writing expresses your best thoughts about art, when in the end it never really has. What matters in scholarship is research, argument, persuasion, and originality, and those ideals make it easy to spend your entire working life without thinking of your own voice. I know that almost nothing in this book can be justified as scholarship, or even as criticism, but it is what I want to write because it is what I have seen for myself.

Someone once wrote an essay with the lovely modest title "Part of What a Picture Is." That is more or less what I would say about this book and its deliberately very distant companion.

One
Writing

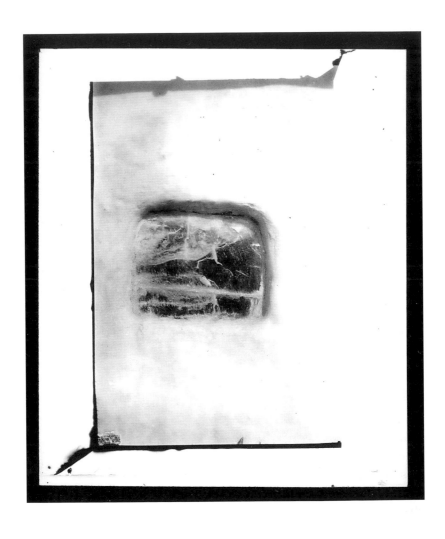

"This is the condition of photography"

Anonymous Photographer. A Selenite Window. c. 1927.

1 One day, quite some time ago, I happened on a photograph of a selenite window. It had once existed, and may still exist, in a pueblo house on top of Ácoma mesa in New Mexico. And I realized then, with an amazement I have not been able to lessen since: "This is the condition of photography." Sometimes I would mention this amazement, but since no one seemed to share it, nor even to understand (life consists of these stretches of solitude), I forgot about it.

My interests in photography took a more cultural turn. I decided I liked photography *in opposition* to painting, from which I nonetheless failed to separate it. This question grew insistent. I was overcome by an "ontological" desire: I wanted to learn at all costs what Photography was "in itself," by what essential feature it was to be distinguished from the community of images. Such a desire really meant that beyond the evidence provided by its tremendous market expansion, I wasn't sure that Photography exists, that it has a "genius" of its own.

2 So Roland Barthes wrote, with a different photograph in mind, on the opening page of *Camera Lucida*. I imagine him sitting at a large Empire desk, in the house where he had lived so many years with his mother. The shades are drawn, and he has spread out the family photographs, along with his favorite clippings from photo magazines and "the latest 'emergency' reportage." (p. 111) He is in a singular frame of mind. For some reason all that matters now is to think about photography: to think his way *into* it, pushing right to its "essence." He wants, perhaps obscurely at first, to use the imaginative journey to speak about his mother's death, to pin the meaning of her memory to a photograph, to "fix" it, in the inevitable photographic pun.

At least that is a picture we are permitted to conjure while we read *Camera Lucida*. This Barthes is not the same as the one that readers knew from his other writings: this is no longer the voice of the scintillating essayist, the famous interpreter of Panzani pasta or the Marquis de Sade. It is a sad and concerted voice, given

to melancholic parentheses, distractions, abrupt changes of mind, and pages, like this one, that quietly turn away from their opening ideas.

The Barthes of *Camera Lucida* is even loath to deploy his well-known semiotic analyses. He is given to writing numbered sections so short that they would not even fill a double-spaced typed page. (I have learned this by copying him, and discovering how short his book really is.) As he writes, some sections become dense, like prose poems, and at times the book is a whispering-chamber of French aphoristic prose from Baudelaire to Mallarmé and even Proust. For me Barthes is especially close to Proust when I start hearing the sections as excerpts from some tattered but richly patterned inner monologue. I hear the narrator's voice in *Camera Lucida* as an intimate steady undertone, a combination of softly muttered confession and public lecture.

Margaret Olin puts the voice that speaks in *Camera Lucida* in quotation marks—"Barthes"—to distinguish it from the voice in his more public books, which she assigns simply to Barthes. (*Representations*, fall 2002, 99–118.) Alternately, the letters and documents that preserve Barthes for us outside his own texts could be denominated Barthes, so that "Barthes" could stand for the voice that speaks in certain famous semiotic, sociological, linguistic, and structuralist texts: in that case it would be necessary to invent an elaborate notation, for example "'Barthes,'" for the singular character who speaks in *Camera Lucida*. This "'Barthes'" would have himself written "Barthes," but given him up for a reason that is not wholly clear; and "'Barthes'" would also have attempted to overwrite Barthes. But I will leave those branching distinctions to one side, because I am fascinated, as I am meant to be, by the melancholic author in his darkened and empty house. (Let's just call him Barthes, not forgetting his scare-quote avatars.)

What I want to know is: why does this figure make me so annoyed? His obsession with pictures of race, of mental debility, of lost places and people, and above all with what he thinks are unusual costumes and faces: all that might be annoying on a first reading, but it also makes sense as the very personal, mainly unthought, always inadequate solace of a person who has lost someone he loves. I can understand his "exotic" tastes even if I

don't sympathize with them, and even if I find his choices over-determined and over-familiar. I forgive him his orientalist attraction to what he thinks of as strange people, because I know he is searching, and I feel he knows he will be forgiven for just that reason. At the same time it's also clear that his central obsessions, especially concerning the photograph by James Van Der Zee, aren't visible to him as obsessions. In this regard I like the variable anger and empathy in essays by Shawn Michelle Smith, Carol Mavor, and Ruby Tapia. (*Photography Degree Zero*; *English Language Notes*, fall 2006.) But for me, all that just makes Barthes's book more complicated and intriguing.

Perhaps it is the voice itself that I find annoying. The closeted calm narrator's voice is certainly more obtrusive than I would expect in a book on the "nature" of photography. In some passages, the voice I imagine speaking the words of the text reminds me of the nauseating tutor in Sartre's *The Words*, the one who stood too close to Sartre, forcing him to inhale the tutor's sour breath. That could also be a source of annoyance, and yet here, the close voice is right for the subject.

No, what bothers me, at least at first, is that the uncomfortable intimacy of the voice, and its discomfiting affections, are supported by a certainty I cannot understand: a certainty, almost a conviction, that the author's frame of mind is not an impediment to his project of finding the "nature" of photography. Why doesn't he think his wounded imagination might be a problem? There can't be many things stranger than the notion that mourning is accomplished by writing memoirs about one's mother as a photograph.

3 *Camera Lucida* seems soft, at times even wet. It feels pliant and unhealthy, like an overwatered plant in a conservatory. And yet it is compelling: it makes me feel a pessimistic solace that I am led to think was sufficient, a clammy comfort that Barthes created by writing it into existence. It causes me to rethink what any writer's control might amount to, or what any theory can be when it is so entangled with desires that

it hardly appears as a theory. And all that humid emotion, that fierce carelessness about theory, that apparent willingness to let words drown their own sense, adds to my annoyance: is *this* photography?

4 "This book was born of impatience": so Hubert Damisch began his book on linear perspective (a book that, not incidentally, has also made me impatient over the years). My first reaction to Barthes's book, as far as I can remember, was enraptured attention, mingled with some difficulty understanding his method. That difficulty has not diminished. Nor has it become easier to understand how to read the burden of affect, how to attend—or not attend—to the saddened voice that speaks so carefully and yet so confidently about things that only it can know.

Readers have remarked on Barthes's melancholy tone, as if the affect of patient sadness can be read separately from the argument the sad voice undertakes. "Il y a un voile de tristesse répandu sur son oeuvre," according to Philippe Roger, "un timbre mélancolique." (Anne-Marie Bertrand, *Bulletin Bibliographique Française*, 2003.) But in *Camera Lucida*, as in many books that make me think of melancholy, melancholy does not impose itself on the text "from the outside," as T. J. Clark says, describing himself typing "nearly soundlessly into screen space at the fin-de-siècle." (*Farewell to an Idea*, 13.) Barthes's melancholy insinuates itself into the fabric of his argument, and even, insidiously, into my own responses, my own writing. I am aware of a cloying pull from the lulling authority of his prose. I am washed down along its currents. I adopt the French-style alternation of overly long and surprisingly short sentences. I employ apostrophes. I indulge in asides. I make sure my parenthetical remarks are slightly obscure, but never really opaque. I even, and only half in fun, dutifully format my pages with the drop capitals from the English edition. I try out the pretentious captions that Barthes, or his editor, chose for *Camera Lucida*: italicized quotations from Barthes's own text (how modest!), and the small-caps titles that were added in the English translation, as if the photographs were those pictorial headstones that can be found in

Italian cemeteries, or works of great art with engraved plaques beneath them. I am already looking forward to introducing my own rare words and neologisms. (But who can compete with Barthes: Ecmnesia! Animula!) I tell myself I am doing this to be as faithful as possible to the real openness of the book—the quality that Barthes named *écriture* and that used to be called "paraliterary"— in hopes of finding a reading and finally a use for the book, a use that begins by refusing to limit itself either to the book's half-ruined theory or its solipsistic story.

My first refusal, then, is the refusal to treat Barthes's melancholy as a symptom, and my second is to refuse to treat it *as a theory*—as Serge Tisseron does when he argues that photographs are not only backward-looking, infused with nostalgia and trauma, but also forward-looking and prospectively healthy. That argument is a nice symmetrical expansion of *Camera Lucida*, but it controls Barthes's melancholy by understanding it as a theory. (*Le mystère de la chambre claire: photographie et inconscient*, 1996, 159.)

5 *Camera Lucida* would be simpler if the unreliable adopted voice had been sequestered, say, to Part One, and the theory about photography had begun in Part Two. Then the speaker, Olin's "Barthes," could be divided from the matrix of claims about photography. Or it would have been simpler if Barthes somehow signaled each appearance of theory, temporarily suspending his experiments with writing in order to be clear. The book could then be parsed, disentangling Barthes's desire from "Barthes's" reasoning, dividing the Winter Garden photograph from the photographs Barthes reproduced. (It once would have been said: dividing the Winter Garden photograph from those out of which it was hallucinated, because a number of scholars were sure the photograph did not exist—until Barthes's diary was published, with its straightforward references to the photograph, which he clearly discovered and then decided not to reproduce.) (Barthes, *Journal de deuil*.) With theory neatly divided from writing, *Camera Lucida* would become usable for thinking about photography in the way it

has often been taken to be by readers who prefer to ignore the glass-house atmosphere that nourishes Barthes's strange thoughts.

The case of *Camera Lucida* ("case," as opposed to problem, because it has to do with pathology, as in Nietzsche's *Der Fall Wagner*; and also because *Camera Lucida* seems obdurately resistant to being taken as an example of how to write a book on photography) can be succinctly demonstrated by noting what happened to two art historians who approached the book from opposite sides: one who attended to the writing's effect on the argument, and another who took the writer's argument apart from his voice.

Rosalind Krauss praised the "paraliterary" back in 1981, one year after *Camera Lucida*. She cited other books of Barthes's, and proposed to re-conceive what might count as historical and critical writing in light of Barthes's sense of the inevitable mixture of fiction and non-fiction, literature and philosophy. (*The Originality of the Avant-Garde*, 295.) A decade later she was still thinking about the paraliterary, trying, in *The Optical Unconscious*, to combine analytic expositions of art history with pages written in a literary mode. The literary passages in that book include florid descriptions of Clement Greenberg's unpleasant face—his shaking jowls, his overbearing stare—and those passages are typographically marked off from the passages of art historical analysis. The two kinds of writing are jarringly different: for me, at least, they do not create a new para-literary writing or even call one another into question. My own reader's experience is that the pages of analytic art history—the majority of *The Optical Unconscious*—highlight the writerly ambitions of the descriptive passages, prompting me to judge the written portraits of Greenberg as I would judge first-person literary memoirs. Could the passages on Greenberg stand on their own as "creative writing"? Could they be read alongside, say, a short story in McSweeney's? For me they couldn't. They are awkward, even embarrassing interruptions in a far more accomplished art historical narrative.

A diametrically opposed reaction to the writerly challenge of *Camera Lucida* can be found, appropriately, in Michael Fried, who took just a few sentences out of one section of *Camera Lucida* in order to craft his argument about absorptive photography and the punctum. (*Critical Inquiry*, 2005, 546; *Why Photography Matters*

As Art As Never Before.) He deliberately ignores the prose in which those few sentences are entangled, and makes only two passing remarks on the quality of Barthes's writing, as if to say that no matter how troubled Barthes's text might be, it is still wholly legitimate and even responsible to seize on moments of analytic clarity and use them to construct defensible arguments. I can imagine Barthes disagreeing, but declining to say why.

I won't be arguing with either Krauss or Fried in this book. (My response to Fried is in *Critical Inquiry*, summer 2005, 938–56.) I am only interested because they show how difficult Barthes's book has been to use, or even to read. One tries to emulate Barthes's living hybrid of theory and writing, and ends up producing a clanging encounter of sharp-edged theory and foundering experimental writing. The other professes no particular interest in Barthes's hybrid project, and, like a surgeon probing for a bullet in a soldier's body, extracts one line of hard theory from the entire dubious book.

The difference between Krauss and Fried on this point could be expanded into an entire monograph on the vicissitudes of experimental first-person writing in the humanities, and the parallel universe of non-experimental, "merely" or "purely" analytic or expository prose. The former has given rise to many embarrassing jowl-shaking moments, and the latter is responsible for any number of academic texts that are not well written. Academics in the humanities don't yet know what to do with writing: real writing, dangerous, unpredictable, living writing, which can quickly turn on the arguments it is supposed to nourish and devour them. Fried's work on photography jails writing in favor of adamantine argument. (He keeps his real writing imprisoned in his poetry.) Krauss dips her toes in writing, but recoils. Barthes was weaker, and in him, things fall apart.

Comparisons of Krauss and Fried were a cliché of scholarship in the 1980s, the decade following *Camera Lucida*, but in this case the comparison is not exactly what it seems, because in the end Krauss did excavate Barthes for theories: she wanted his diaphanous text to support her understanding of the index and punctum. When Krauss's or Fried's arguments matter, the thing to do, I think, is to argue against their ways of extracting what they need from *Camera Lucida*, as opposed to arguing against what they (or anyone else)

does with those claims once they are extracted—but almost no one does that, because everyone wants something from *Camera Lucida*. Mainly people have been persuaded that Barthes's text does harbor theories, and I only know one attempt to argue just that the theories Krauss claims to find cannot be found—Joel Snyder's essay in *Photography Theory*. I am not aware of any other arguments that particular claims cannot be found in *Camera Lucida*: that would be an unrewarding exercise as long as the book seems to have something useful to say about photography.

 Annoyance is therefore partly the effect of never knowing whether Barthes's ideas can make sense outside their matrix of *écriture*, unless the book is strip-mined for ideas and then discarded. (As Fried does.) Annoyance is also knowing how treacherous it is to do anything but ignore the *écriture*. (As Krauss shows.)

And annoyance comes from realizing that there is a third option, but that it may not be achievable. I take it Barthes did not worry about *écriture* in his book in the way I am: for him the "essence" of photography was inevitably immersed in writing and discovered within it. That is a nearly unapproachable position for a writer interested in photography, because it cannot be sensible to say that the best way forward is to risk losing *any* theory about the subject at hand by writing so strongly that the writing might overwhelm what is said. As invested as I am in writing, I cannot bring myself to think that my way of writing will drown my argument, that this book will turn out to be more experimental fiction than rational inquiry. I can't believe that now and keep writing, even though I can imagine coming to the last pages of this book, looking back, and saying to myself: This is fiction after all, with "Photography" as its main character.

It even takes courage to *read* Barthes's book for the "pleasure of the text": not only because academic habits insist on interrogating a text to find what it says that might be true, but because *Camera Lucida* is more than just *scriptible*, as Barthes said of Balzac's *Sarrasine*: Barthes's book has a purpose, arguments, and a

conclusion. (*S/Z*, 4.) And who would pick up a book on photography, hoping to learn about photography, and be satisfied when the book becomes a strange muttered monologue on the author's mother?

Clearly, there are claims in *Camera Lucida*, and obscurely, we are to understand they gave the book its form and voice. But if I find myself reconciled with this, or tempted to go ahead without working on it, then I have declined to take up the challenge the text throws down. And I will have failed to actually read the book, which would leave the book free to go on being mined for its theory and admired, from a safe distance, for its writing.

Writing inflects sense, form and content cannot be unfused. Often that common truth is unimportant. I don't really care how scientists write, although I appreciate it that most scientists don't attempt to write anything other than informal spoken-style English. A writer like Barthes is a very different matter. Affect is as tightly bound to his book's message as nerve sheaths to nerves. With a book like Barthes's, reading for the writing or for the argument is like tearing the book apart one nerve fiber at a time. Any academic essay that locates Barthes's arguments and sees the writing as a symptom of mourning is not serious enough about the book's form, just as any reader who prefers the book as a meditation is not serious enough about its intention to argue.

7 There is a moment in nearly every academic text on *Camera Lucida*—at least every one that mentions Barthes's commitment to writing—that I call the turn. The author notes Barthes's beautiful, strange, compelling writing, and his willingness to follow that writing wherever it might go, and then the author says, in effect, But it is still possible to use *Camera Lucida*, to apply it to photographic practice, scholarship, history, theory, or criticism. At that moment the *danger* of the kind of writing Barthes was engaged in is closed off, the doors are shut and the room is cleaned.

Here is an example of the turn. Geoffrey Batchen introduces a collection of essays on *Camera Lucida* by recalling Barthes's

interest in "performative" texts that "refuse to fix meaning." Batchen notes that *Camera Lucida* was written a year after Barthes gave a course of lectures on *le neutre*, "the neutral," a kind of writing that resonates across the boundary between fiction and nonfiction. *Le neutre*, Batchen notes, was a continuation of a lifelong interest in forms of writing outside of genres. The title of Batchen's collection is *Photography Degree Zero*, an allusion to Barthes's idea that "how a text is written, its form, is as important . . . as what the text says." (*Photography Degree Zero*, 4.) As Barthes argued, and as Batchen affirms, there is no such thing as a "zero degree text," one without significant form. "*Camera Lucida*," Batchen concludes, "is marked by frequent double meanings, asides, learned allusions, self-assured aphorisms, and a sheer beauty of expression that all need to be appreciated at firsthand. Nevertheless"—he continues immediately, turning from the writing to the claims that may be embedded in it—"it is useful to have a general sense of how the book proceeds." (p. 12) He then summarizes *Camera Lucida*, as an editor is expected to do, hoping, I assume, to be helpful to those who haven't read the book or don't remember it clearly. The summary is silent on *Camera Lucida*'s "sheer beauty" and Barthes's investment in what that "beauty" could do to argument. Batchen's own contribution, in an essay at the end of the collection, "pursues the possibility that Barthes's book might productively be read as a history rather than a theory of photography." (p. 20) That is a second instance of the turn, because it makes *Camera Lucida* into a useful, or at least an interesting, *art historical text*. I don't deny that *Camera Lucida* can be read as a history: Batchen's reading is cogent and persuasive, for what it is. In general, the essays in *Photography Degree Zero* demonstrate that *Camera Lucida* has a politics, that it raises issues about sexism, racism, and the social place of photography. But to make *Camera Lucida* into a historical document, it is necessary to turn away from the possibility that the writing might undermine and overwhelm any such reading, even without contradicting it: that the writing might wash over any "general sense of how the book proceeds," that the writing might flood scholarly designs or utilitarian purposes. Turning *Camera Lucida* into material for scholarship is a matter of not minding the flood.

8 For Barthes, "writing degree zero"—the title of his first book—was the impossible dream of writing, where form did not matter and matter filtered transparently through form. Batchen's edited collection, *Photography Degree Zero*, is titled after Barthes's first book in order to evoke a "continuity of purpose" that links Barthes's first book to his last. But *Photography Degree Zero* doesn't participate in Barthes's theme, because its authors mainly attempt to write "colorlessly," as Barthes would have said. The essays in the book are written with minimal affect and maximal scholarly control, keeping near the impossible "colorless" temperature of absolute zero, nowhere near the incandescent pulse of the text they study. In that realm of orderly cold, the authors mostly treat *Camera Lucida* as if its form could be sequestered from its argument, as if no matter how heartbreakingly beautiful the writing may be, no matter how supersaturated and dripping with affect, *Camera Lucida* can still be read *as* history, *as* theory, *as* criticism. The essays in *Photography Degree Zero* (including one that I contributed—I am as guilty as anyone) are engaged but sober, energetic but dry, well mannered and nicely controlled. (The only essay that avoids the turn is Carol Mavor's "Black and Blue: The Shadows of *Camera Lucida*.") I'm imagining some of the authors, reading this, will protest that they care deeply about writing, that they take it seriously. Some do, but none take it as seriously as Barthes, because if they did, they would not be faithful to the studium of academic writing.

9 So now, as I write my answer to *Camera Lucida* thirty years too late, I think again of the fact that so many writers take it, and in particular the punctum, as a touchstone. Especially those who would not normally propose concepts that are so personal, so detached from history and close to solipsism. Even those who would not allow themselves to reason with such a breathtaking absence of scholarly support. It is as if that book, one of the least scholarly of the central texts of twentieth-century art, has protected itself by shrinking away from the glare of scholarly criticism, shriveling to a point-like punctum of its own.

Camera Lucida has no footnotes, and the English translation has no list of sources. The French original has a dozen marginal annotations, like this: "Lyotard, 11," and twenty-four references at the end. The omission of scholarly apparatus simultaneously declares "Barthes's" independence and leaves readers stranded on the text as on an island, with few other writers' voices in earshot and no escape from the peculiarities of the author's memory. It has even been possible to claim that the book owes everything to Lacan, or is a monumental evasion of Bourdieu. (This book, the one you are reading now, strikes a compromise in that regard. There is no index or footnotes, but the abbreviated references in parentheses should be enough to allow you to navigate from this book to the many others that address *Camera Lucida*. And by placing those references in the text, I keep an eye on moments when my own thought is at risk of losing itself in the forest of academic citation.)

It is clear to me that a full answer to *Camera Lucida* cannot be an academic essay: three decades of scholarship have not yet produced such an answer. And it is clear that an answer cannot be a work of fiction, a memoir, or anything proposed as creative or experimental writing. The only way to reply to a book as strange as Barthes's is to write another one even stranger.

Two

Selenite, Ice, Salt

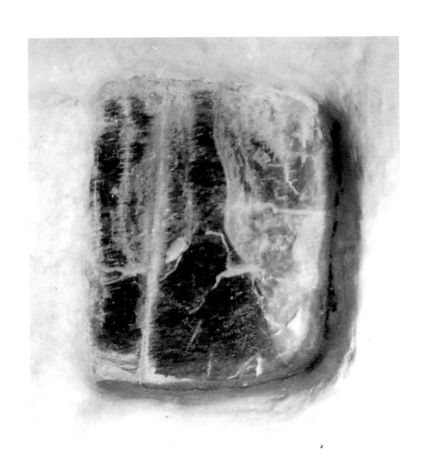

"I studied the photograph of the selenite window very carefully, and I discovered I could not tell which side was up."

Anonymous Photographer. A Selenite Window. c. 1927.

 So this is where I will begin, with a selenite window. A window made of selenite is first of all a flawed window. I cannot clearly imagine what the world would have looked like through it, even though I have been to the top of Ácoma mesa in New Mexico, where the adobe village still stands, because all the selenite windows have been replaced by clear glass. The mesa sits like a cylinder of rock in an enormous bowl of desert, with mountains curling up in the distance. The little garden plots in the desert below, where the villagers still grow native corn and beans, are so far away that the people tending them can just barely be discerned from the houses on top.

Through selenite windows, people in Ácoma would have seen nothing but the blue of the sky and the similar shades of adobe, mountain, and sand. Seen through the window, the world would look like ill-fitted pieces of mosaic crushed together, pressed and refracted by the translucent mineral into a nearly indecipherable pattern. The window's inclusions, its grit and spalling sheets of rock, would make the window more a reminder of the lit world beyond it than a representation of that world. The light would bend in such complicated and unhelpful ways that the view through the selenite window could only serve to demonstrate that something was not being seen. Rigorously unseen, according to inflexible rules of useless optics.

Photography can be compared, I thought when I first found the photograph, to that selenite window. It promises a view of the world, but it gives us a flattened object in which wrecked reminders of the world are lodged.

 The selenite window itself, not the photograph of it, was my first idea for a model for photography. Sometime later I thought photography could better be compared to a sheet of black lake ice. "Black ice" is what drivers call it when the road surface is frozen but the ice is not visible. This other use of the expression is less common: it is a kind of ice that forms overnight on a lake when it is bitter cold and there is no wind. I know from experience that it can be terrifying to walk on black lake

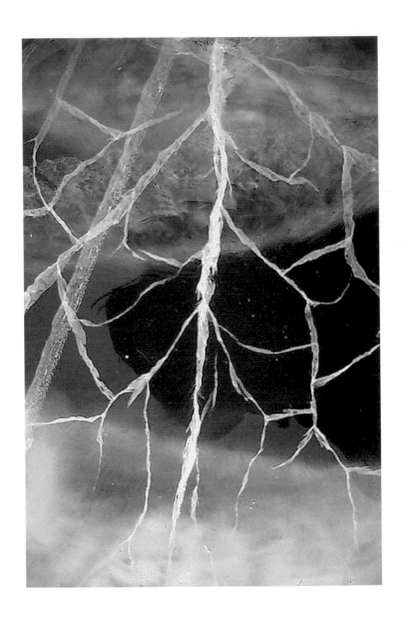

*"it can be terrifying to walk on black lake ice:
it fractures with each footstep and the breaks squeal and shriek as they
spread out on all sides"*

BLACK LAKE ICE, LAKE BONNEY, ANTARCTICA. C. 2005.

ice: it fractures with each footstep and the breaks squeal and shriek as they spread out on all sides. Underfoot, the fissures look like white crystalline ribbons moving through the darkness. Somewhere a foot or two beneath the branching fractures, the ice ends, and the black water begins. Black ice is a horizontal window that looks down onto nothing visible. You see into it as if into a thick deep darkness: you do not see a black surface like the wall of a room at night, but a place where light becomes weak, where it loses energy, slows, and dies in some viscous depth. The lake water underneath the ice seems unreal. The pooling cold water is like an abstract idea of sinking or drowning. That place beneath the black ice, where I know that water must be, admits light but does not give back any image. ("Ce lac dur oublié," as Mallarmé says in *Le vierge . . ., the poem about the frozen swan.*)

So I thought that looking into a photograph is like standing on black lake ice and looking down into the water beneath it. Like black ice, the material surface of a photograph is often transparent to vision: my eye moves right through the thin shiny surface of the photographic paper, except where I see scratches or dust, or where the coating reflects my face. If I look closely enough, a photographic print does have a certain minuscule thickness, and in that layer the mixed crystals and paper fibers create an exquisite, shallow, and uncertain illusion of depth. (Or: my eye moves right through the monitor, except if I see a greasy film on the screen, or if I notice my face reflected in the glass. If I look closely enough, a photograph on a computer monitor does have certain minuscule thickness, and in that layer a minuscule grid of soft phosphorescent lights creates an exquisite, shallow, and uncertain illusion of depth.)

How seldom Barthes mentions the surface of the photograph: he looks through, habitually, and does not reflect on how his gaze has penetrated the paper. Partly that is because he studied photographs reproduced in magazines, and partly it is the common reaction to photographs. Rosalind Krauss calls this the "it's" response: "it's a portrait," "it's a landscape," "it's a very beautiful woman," "it's a man on the right who is in drag," "it's an *x* or a *y*." ("A Note on Photography and the Simulacral," in *Overexposed*, 171–73.) For Barthes, the light of the object comes directly through the print, as if it were perfect commercial plate glass.

And Barthes is right, because normally looking at a photograph is only looking beyond its surface, seeing the people and landscapes back there somewhere beyond or behind the photograph itself. The lake ice metaphor made me reconsider. I thought, The light of my eye is lost in the darkness on its way to the object. I can try to look *through* the water, and see the bottom, but it is hopeless. Or I can try to look *at* the water, but nothing there catches the light. There is no foothold, no certainty, no object. Even the black ice hardly catches my eye at all. Only its cracks, its surface imperfections, and some faint reflections show that it is there at all, and so I look deeper, below it, searching for something to see: but there is nothing definitely there beyond the flaws and frighteningly thin thickness of the nearly invisible ice.

By contrast, Barthes looks confidently straight at the objects he desires. I am not sure of those objects. I am worried about the surface. And I wonder if the surface and the spaces beyond it are as different as they might seem. The black lake ice stills the water beneath it, and floats weightlessly on the surface of the water, so that the water has no surface, no beginning. Indeed there is no distinction between the coldest, most frigid water just below the ice, and the softest boundary of the ice itself: the pane, and the world beyond the pane, fused.

12 I chose these examples of stunted seeing because photography tends to be conceptualized with the help of brilliant metaphors: people write about perfect windows, lucency, transparency. Cameras are still imagined, despite their increasing complexity, as machines of logic and light. The pinhole camera, the camera obscura, the diagrammed eye with its inverted retinal image, and the Euclidean ray diagram, are all metaphors of the ease with which photographs are thought to capture accurate images of the world.

It has long been a problem that the medium provides its own concrete metaphor: once it was the simple Kodak box camera, and now it is the autofocus autoexposure professional-black megapixel

camera with wireless internet uploading, face recognition, blink detection, and diffraction-limited, multicoated computer-designed aspheric optics. Either way the actual machinery prompts the metaphoric machinery, facilitating the notion that photography is mechanical and therefore, in the logic that can only be persuasive to people who don't think too closely about their machines, potentially the equivalent of the simple pinhole camera.

The crushed-looking selenite window and the unstable sheet of lake ice were antidotes—so I hoped when I started thinking about this book—for those misleading and relentlessly optimistic metaphors.

13 The camera lucida, Barthes's choice for master trope and title, could be mistaken for one of those metaphors of light. The camera lucida is a device with a semi-silvered prism, which makes it possible to trace the outlines of an object, a person for example. It was popular in the early nineteenth century among silhouette artists and portrait painters, and again from the mid-nineteenth century through the 1960s, when it was adopted by naturalists to trace objects seen under the microscope, and by archaeologists and biologists to produce accurate outlines.

Barthes could have called his book *Camera Obscura*: that would have been historically appropriate given photography's origins, but he wanted an archetypal image of light and Enlightenment. He chose *Camera Lucida*, I suspect, in order to oppose the camera obscura's connotation of darkness. "It is a mistake to associate Photography, by reason of its technical origins, with the notion of a dark passage (*camera obscura*)." (p. 106) When he says this, he is prohibiting himself from "penetrating" or "reaching into" the photograph. ("Je ne puis approfondir, percer la Photographie," original edition, 164.) He quotes Blanchot saying photography is at once "altogether outside, without intimacy, and yet more accessible and mysterious than the thought of the innermost being." ("Plus inaccessible et mystérieuse que la pensée du for intérieur," 106, 165 in the

original.) Somehow that means photography's most appropriate metaphor is the camera lucida.

(The Blanchot quotation is one of the darkest moments of *Camera Lucida*. Even though the quotation is pivotal, and even though it is one of the densest and longest of the book, Barthes doesn't say where it comes from, and Derrida did not find the source when he cited it in "Les morts de Roland Barthes." I take the lack of citation as a mirror of the lack of argument—there is no clear link between the camera lucida and Blanchot's chains of paradoxes. Of course, scholarship being what it is, the text has been identified: it is from Blanchot's "En hommage à l'imaginaire de Sartre"; Camille Joffres, "De la photographie, faire son deuil, rêves et variations," *La review des ressources.org*, March 11, 2009.)

Even aside from its hermetic justification, the camera lucida is hardly a suitable metaphor of light: as Geoffrey Batchen says, it's a perverse choice for a title. (*Meaning of Photography*, 84; he also calls the choice "abstruse" and, finally, "apt," in *Writing Degree Zero*, 10–11.) The real camera lucida is a finicky instrument, which involves peering into a small aperture or squinting at a tiny prism, and when it is attached to a microscope, as it often was, it can be difficult to balance the little light it provides with the bright light of the microscopic object. Drawing a person with the help of a camera lucida clamped to the tabletop in front of you is like trying to read a book without glasses and with a tiny piece of sharp machinery hovering a few millimeters from your eye. Nor does Barthes notice, or care, that the point of a camera lucida was drawing, not photography. The camera lucida is just wrong for *Camera Lucida*: it's not about photography; it is a weird, difficult little instrument, not a metaphor of light; and it is not connected, by any logic I can follow, to Blanchot's observations about intimacy.

It is true, on the other hand, that a camera obscura can be very dark: it can take a good five minutes until your eyes adjust to the darkness of the image projected in a room-sized camera obscura. But even the camera obscura is too light for my purposes, too effective at pulling the world into a dark room and projecting it onto the walls: too spectacular, too easy, too successful. As long ago as 1568 Daniele Barbaro praised the motion and color of the image he saw projected in a camera obscura. In a well-constructed room-sized

camera obscura, ghostlike clouds move slowly across the floor, and birds fly by, upside-down, flattened against the walls. Buildings are vertiginously upended, hung from the ceiling, as Abelardo Morell's photographs tirelessly demonstrate. (abelardomorell.net) The image is dusky, but it can be enormous and thrilling even in the age of virtual reality and IMAX theaters. The camera obscura isn't really a "dark passage": it is the overgrown theatrical cousin of cameras, photography's ordinary little metaphor-machines.

All this is just to say: Barthes's chosen metaphor isn't about light, as he hoped, and the metaphor he rejected, the camera obscura, isn't enough about darkness.

 There was another reason, too, for the rock window and the ice sheet. I choose them to avoid the *indexical sign*, a concept that has served for a long time now as the crucial property of the photographic medium. (In brief: Indexical signs are those that physically issue from what they signify. Smoke rising from a chimney is an indexical sign of a fire in the hearth. In painting or drawing, so it is said, the artist is an intermediary between the world and the picture, so those media are not indexical. But photography is, because the silver compounds in the negative are causally affected by photons from the object. Light physically, directly produces the photographic image.)

The indexical theory of photography's nature was helpful for some art criticism in the moment of minimalism, when it was important to stress photography's material nature and its independence of ideation. That purpose aside, the allegedly indexical nature of photographs is not often convincing. Barthes's ruminations on time and death do not lean on Charles Sanders Peirce, the inventor of the indexical sign. To think of a photograph as indexical, you have to pay attention to the machinery and the physics of light. What is gained, Barthes might have asked, by proposing that the familiar elements of photography are best understood in terms of Aristotelian cause and effect or the most esoteric and abstract interactions of subatomic particles?

And there is hardly any help to be found in Peirce himself: he wrote prodigiously, monstrously, on the subject of signs. Once I took great pleasure in losing myself in Peirce's ten thousand kinds of signs and his mazes of mathematized logic. (*Culture, Theory, and Critique*, 2003, 5–22; *Overexposed*, 21.) I like, but I don't understand, his ideas about photography. An iconic sign of a rainy day, he says at one point, is "the mental composite photograph of all the rainy days the thinker has experienced." (*Collected Papers* 2.438.) But what is a "mental composite photograph"? I can't say I have ever experienced such a thing.

But because Barthes started his career as an expert in signs, some readers miss those themes in *Camera Lucida*. Perhaps the punctum is a special kind of sign, or maybe the book has a new sort of sign in it, one "that just is." (Ann Game and Andrew Metcalfe, in *Social Semiotics*, 2008.) Other readers have turned to signs of production and consumption, or to more exotic fauna of semiotics—post-semiotics, sub-semiotics, and supra-semiotics. (Paul Frosch, *Semiotica*, 2003; *Pictures and the Words That Fail Them*, 1998; Sunil Manghani, in *Culture, Theory and Critique*, 2003.)

The game of semiotics, signs, and photography is hard to stop playing, and I hoped that the frightening lake ice and the flawed rock window would help cure me.

15 The indexical sign might not be a good fit for photography, but in another sense photographs are all about touching. When I hand someone a photograph, I am touching its surface. If the print was made in a darkroom, my fingers slide or grip the water-resistant coating, and I can feel the paper base that holds the layers of dyes and silver halide molecules. If the photo is onscreen, I may touch the glass to point out something, smearing it a little with the grease in my fingertip. I can't agree with the notion that photography has become "information in the pure state" just because it is digital. (Joan Fonctuberta, *Photography: Crisis of History*, 11.) There is always the surface, and now there's light from the screen.

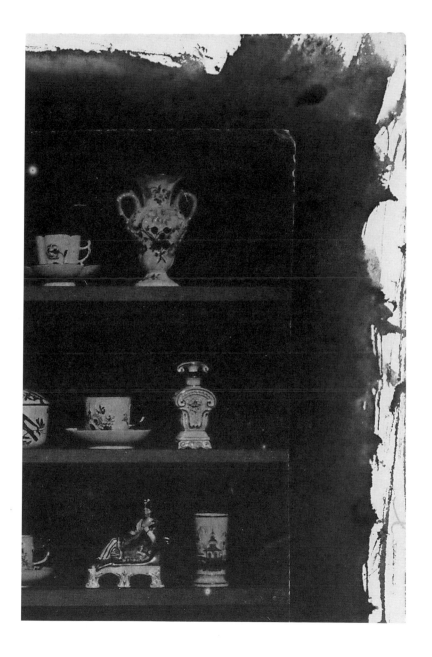

"a ghostly fingerprint just left of the china figurine on the bottom shelf."

WILLIAM HENRY FOX TALBOT, *ARTICLES OF CHINA*, DETAIL. 1844.

This surface, traditionally invoked and then forgotten, has been there from the beginning. William Henry Fox Talbot's photogenic drawings were made by brushing or sponging silver chloride over paper soaked in salt. They were, in effect, paintings before they were photographs. Normally the margins, with their thoughtless brush-marks, were cut away, but in a few instances they remain. This detail of *Articles of China* shows the slightly irregular corner of the paper (Talbot cut his paper to shape), sponged or painted with his special coating. Between the image and the sponged margin is a corner of the original paper negative, slightly dog-eared from multiple printings. (My thanks to Larry Schaaf for explaining the dog-ears.) The paper is speckled with embedded dust, stray hairs, and, I think, a ghostly fingerprint just left of the china figurine on the bottom shelf. How easy it is to mention these things, and how easy to stop attending to them.

My eyes can touch the surface of a photograph. If it is a print made in a darkroom, I can see its surface as a *griffonage* (an illegible handwriting) of marks and scratches. If it's onscreen, I can just barely make out the fuzzy mosaic of RGB sub-pixels or, if it's an older monitor, the woolly RGB phosphor dots. (I also can't agree with writers who speak of the weightlessness of ones and zeros, when digital photographs are always overlays of pixels, hardware routines that manage them for display, and screen sub-pixels of entirely different shapes and sizes—not to mention the environmentally appalling objects that give us those images.)

But neither of these two kinds of touching, crucial as they are, interested Krauss or Barthes. The handling of photographs is a social act, and the optical feel of a photograph's surface is something that almost everyone who writes on photography ignores. (With some exceptions: Olin, *Touching Photographs*; Peter Geimer's wonderful book *Bilder aus Versehen: Eine Geschichte fotografischer Erscheinungen.*)

16 The photo of the black lake ice resembles an amateur nature snapshot of the sort that is so common on the internet. Turn the image upside-down, and the surface cracks become a tree. It is an indifferent photograph, taken by a scientist in Antarctica as part of a documentary project. The original is a deep neon blue: "natural" in the sense that the scientist didn't tinker with it, but also distractingly close to the color I associate with bottles of mouthwash. I was glad, when I found it on the internet, that the photograph itself had no particular aesthetic or artistic interest, because I thought that would help it work as a metaphor.

The picture of the Ácoma window caught my eye because it was nearly lost in the files of the American Museum of Natural History: its only annotation was "260769, Selenite window," written in script with a steel-nib pen. The images around it in the same file were prosaic ethnologists' documentations of the Ácoma mesa; they belonged irresistibly to their place and time ("Aug. '27"). I found the file by chance; that location in culture has no particular appeal to me.

Not that there is such a thing as a pure absence of aesthetic or anti-aesthetic value, or of historical context: but I needed the noise of aesthetics, fine art, and history to be minimal.

 Things became more complicated when I began to attend to my two model metaphors *as photographs*, as two unique images, one on paper and the other on my computer.

I studied the photograph of the selenite window very carefully, and discovered I could not tell which side was up. If the window is recessed in the adobe wall, then one of the two shadowed edges should be on top. That choice of orientations is complicated by the frame: Is it wood? Paper, or perhaps canvas? On one side the frame appears to cast a shadow onto the wall, as if a box had been constructed and put in place in Ácoma to mask extraneous objects from appearing in the shot.

I noticed, too, that the framing edge and its shadow do not match. There is a notch in the frame, answered by a projection in the shadow. A chip in the adobe wall in one corner of the photograph makes it look as if the window was removed from the building along with a rectangular piece of the wall, and that the frame was a box. But that does not solve the problem of orientation. I reproduce the photograph here in two random orientations.

18 As an individual photograph, the selenite window is a good but imperfect model of imperfect visibility. Large sheets have split off the left and right like curtains— I am looking at the second reproduction, cropped and turned so the breaks look like curtains. A linear fracture (it looks like a pull cord for the curtains) runs down one side. In the middle there is a clear portion: perhaps an image could have been seen through the window after all. The file card at the museum has the line "Taken by_____." "Taken" is struck through and "cop." (copied) is written in its place. The copyist's name is given as J. Kirschner. My photograph—the one the museum produced in a darkroom and sold me so I could study it—is therefore a copy of a copy, at the least.

And my photograph, like the print in the museum, is tiny: the window itself is barely one and a quarter inches high. (The second reproduction is more or less life size.) To even begin to see its details I had to use a high-resolution scan, which resampled the photograph's fibers and grains and presented me with a uniformly blurred approximation. The only evidence of the surface of the original print are the black grains of dust that Kirschner carelessly preserved when he copied it. The museum imaging office reproduced them again when they copied their print for me, and I preserved them in my scan. The selenite window photograph is imperfect as a metaphor of the imperfection of photography, but its imperfection is exact.

19 The black ice photograph is also an intricate and specific model of imperfect representation. It records several layers within the ice: on top is the tree- or root-like network of cracks, and just underneath it is a diagonal fracture running from the top center to the bottom left. The diagonal fracture just touches the branching fractures, which shows that it is in a layer of ice just beneath the surface cracks. Lower still is a rough serrated ridge that crosses the field of view just above the dark opening. It touches the diagonal fracture without overlapping it. These three layers must represent stages in the freezing of the lake, from top to bottom. Beneath the three layers is another region where the ice has either partly melted or is still forming. That deepest and least perfect layer forms a curved opening onto the waters below.

Only when I had seen all of that did I finally notice that the darkest area of the image has an irregular outline, with two hair-like marks protruding from its upper left corner. And then, at last, I realized that the photographer had wiped the surface of the lake with his mitten before he took the photograph. The invisible top surface of the ice must have been covered with a thin film of snow, and some buckle or snap on the photographer's mitten left a sawtooth pattern where that film was brushed away. Five layers, therefore, between invisible water and invisible air.

20 The odd shadows of the selenite window, the imbricated layers of the black lake ice: I looked at them, wondering if they were too obstinately particular to have meaning for photography in general. They said the right things about photography, but perhaps they said them too narrowly, with too many qualifications. And the closer I looked, the more I was prone to playing the eccentric connoisseur. I wasn't after the aesthetic qualities that some photographers and collectors admire in the distressed surfaces of photographs. I only wanted to say: This, or something like it, is what actually happens in photography, when we stop thinking in optimistic metaphors of

light, representation, and realism. Maybe, I thought, photographs do not work well as metaphors, because they keep splitting into layers, distracting me with inappropriate detail, with clutter. . .

Later I found a third photograph that seemed more general and abstract. I was happy at that discovery, because by allowing myself multiple models, I was following a famous precedent: Leon Battista Alberti, the first to describe the "perspective window" that in turn modeled the camera. Alberti did not put all his trust in one model. He elaborated two procedures for linear perspective, leading to different historical practices. Albrecht Dürer imagined four different perspective machines and several kinds of perspective diagrams. Later those models multiplied. Maybe, I hoped, I could catch several species of inadequacy by thinking about several slightly different metaphors.

(Thinking this way makes it odd that the camera obscura remains the principal historical model for the photographic camera. Under what conditions of relentless generalization are camera obscuras taken to have been a single thing, a unified phenomenon, or even a set of commensurate experiences? Some were room-sized; others had poorly made pinholes, or lenses with serious aberrations that would have cast rainbows, comas, and caustics on the wall. There were camera obscura boxes with cloth hoods, and others like cramped phone booths—a whole encyclopedia of metaphors was compressed into one supposedly rational, light-filled model.)

 My third model was a photograph of a piece of rock salt about two inches wide. The rock originally condensed from salty water at the bottom of a desert lake about two hundred and fifty million years ago, and in the millennia since then it had been underground. The scientists who excavated it were looking for small cavities that formed inside the rock; the cavities are filled with salty water that never had a chance to evaporate. They drilled a tiny hole into the right-hand side of this stone; the hole is indicated with an arrow. Their drill penetrated the little chamber to the left of the arrow. Then they drilled a

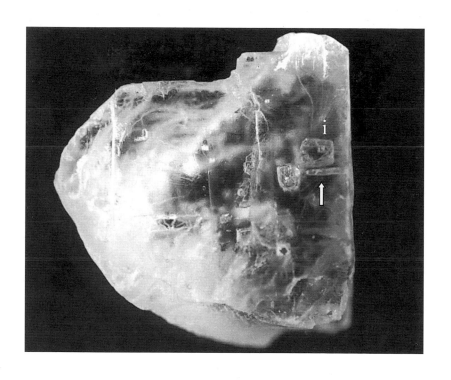

"In that small volume of salty water, just three millimeters on a side, the scientists found living bacteria."

RUSSELL VREELAND, HALITE CRYSTAL (ROCK SALT). 2000.

second drill hole just above it, which is not clearly visible in the photograph, and broke through into the little chamber below the letter i. In that small volume of salty water, just three millimeters on a side, the scientists found living bacteria.

Somehow, as the geologists put it in the dry manner customary in science, the bacteria had "survived within the crystal until the present." Once the bacteria were encased, they had no need to evolve ("evolutionary pressure" was relieved). They spent two hundred million years in their little dark droplet of water, while the other members of their species of bacteria became extinct. There must have been incremental melting and precipitation of salt to keep them alive, but the scientists have no idea how that happened ("at this point, we cannot address the mechanisms of survival"). As often happens in science, the discovery was cast into doubt soon afterward (at the 2002 annual meeting of the Geological Society of America), but the possibility remains.

The photograph is over-exposed on the left. It is focused not on the rock's front surface but on the first drill hole and the two tiny chambers, a few millimeters beneath the surface. The letter i and the arrow outlined in black were added in PowerPoint, marking the image as an informational object rather than an aesthetic one.

The rock has no visible support, no clamps or tweezers, and no intrusive wood grain tabletop or felt background. There is no unpleasant close-up of fingers, no outsized pencil tip or pen point poking at the object.

It is a truly lovely photograph. It asks me to see something I have never seen, which has not been seen at all, by any eyes, since the Permian age: and at the same time, I know that nothing here can be seen. The subject is unrepresentable using this kind of photography, and its invisibility is expressed, eloquently and inadequately, by the difficulty of peering into the fractured chunk of rock salt.

"the top few inches of dirt, silhouetted by gamma rays emanating from underground"

EVERETT LAWSON, *UNTITLED*. 2008.

 Through a selenite window, a sharp bright day will appear fractured and broken; in lake ice, everything beyond the surface sinks into night; in rock salt, the photograph is just a reminder that something cannot be seen.

Selenite, ice, salt: my trinity of failed photographic windows.

I could have gone on and chosen more photographs as emblems. If it hadn't been necessary to keep art to one side in order to think of photography as a whole, I could have chosen Marjaana Kella's *Attempt to Reproduce Light by Taking Pictures of the Sky*; Marco Breuer's wonderful *Obstructions*; P. Elaine Sharpe's series *Unanswered: Witness*; Thomas Demand's ice-cold photographs of paper constructions, which are so clearly not functional as ordinary images; Zoe Leonard's *You See I am Here After All*, in which several thousand picture postcards of Niagara Falls show us that we have no idea what the falls might actually look like. (*Six Stories from the End of Representation*; and for Kella, *Toisaalta tässää*/Here Then.) Some young artists, who have not yet exhibited widely, would also have joined the list: Aspen Mays's strange glowing green photographs, made by putting fireflies inside the camera (so much less burdened by nostalgia than Hiroshi Sugimoto's time-lapse photographs of movie theaters); or Everett Lawson's dim photograms made by painting gamma-ray sensitive emulsion inside a box, and then putting it down on a lawn at the University of Chicago, near where the first nuclear reaction took place: the resulting images show pop tops, dead birds, cigarette stubs, and coins in the top few inches of dirt, silhouetted by gamma rays emanating from underground.

But there was no need for more models, because I saw I was finding the same thing, over and over. These are all failed looks into or through something. In them, the world is fractured, folded, faint, undependable, invisible, more or less ruined. Photography doesn't work, the way it does for Barthes, diligently supplying memories, faces, love, and loss.

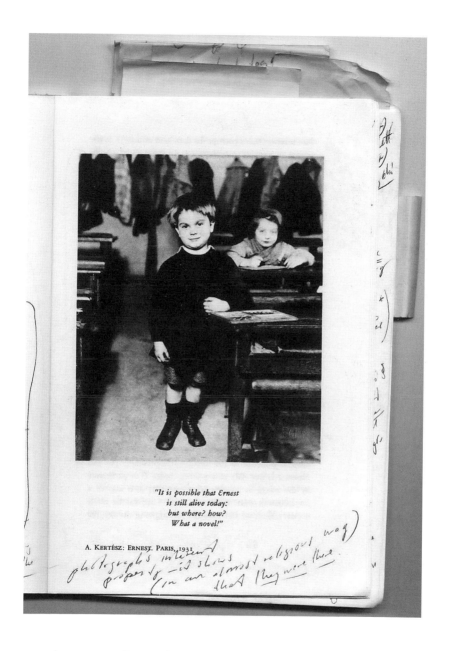

"It is possible that Ernest
is still alive today:
but where? how?
What a novel!"

A. KERTÉSZ: ERNEST. PARIS, 1931

*"He could be alive today, Barthes says:
'but where? how? What a novel!'"*

KERTÉSZ'S PHOTOGRAPH OF "LITTLE ERNEST," IN *CAMERA LUCIDA*.

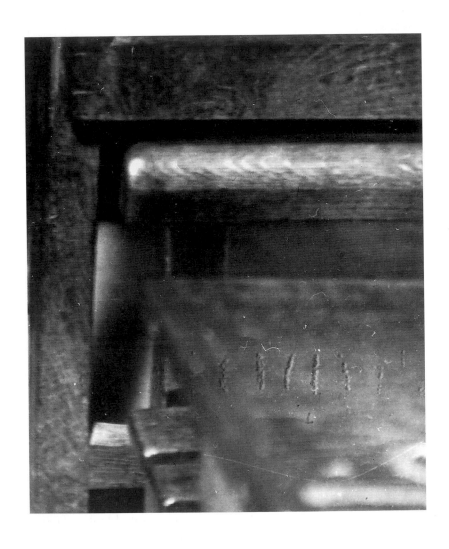

"In the lower right are several strange lines of impressed marks."

KERTÉSZ'S PHOTOGRAPH OF "LITTLE ERNEST," DETAIL OF ARCHIVAL PRINT.

23 If Roland Barthes were still alive, so that this book could be a long letter to him, I would propose this as an opening argument: Photography sees most of the world as it sees selenite, ice, salt, fireflies, and gamma rays, and not as it sees gypsies, prisoners, ex-slaves, or Ernest, the schoolboy Kertész photographed in 1931. (He could be alive today, Barthes says: "but where? how? What a novel!") (p. 84; original edition, p. 131)

Of course Barthes is right again: photography can be used to produce soft-focus romance (Kertész), hard-grained reportage (Sander, another of Barthes's favorites), shallow-focus realism (Nadar), floodlit fashion (Avedon), poignant social portraiture (Van Der Zee), or virtuoso provocation (Mapplethorpe). But where, exactly, is the photograph itself in all this romance and novelization? Where is the visual incident, the detail, the light, shade, shadow, depth, anything at all that would convince me these had to be photographs, and not film stills, paintings, memories, or hallucinations? And where, for that matter, is the matter of photography, the ground-level proof they are photographs?

At ground level, photographs like the ones Barthes had of his own family are compacted layers of paper and chemical grains, with protective layers on top. Photographs like the ones he saw in magazines are hairy mats of paper fibers, caked with dried flakes of printer's ink. In Barthes this material, this substance of photography does not exist. If he had cared to look, he would have seen the sharp-edged dust and scratches on his old studio prints, or the smeared Bendé dots and scruffy paper fibers of his newspaper and magazine photos. My own copy of the *Little Ernest,* provided by the Réunion des Musées Nationaux, and therefore an optimal, archival print, is a mess of dust and scratches. In the lower right are several strange sets of impressed marks, made with a round-pointed tool such as a blunt pencil. It looks as if the print was underneath some other page, and someone was bearing down hard, and accidentally made this pattern of hatchmarks. When I look closely at the print in the French and English editions of *Camera Lucida,* I see the same marks in both. The people who put that book together at Gallimard in Paris, and later at Farrar, Straus, and Giroux in New York City, must have used the same print. It's entirely possible that the reproduction

Barthes himself saw was made from the same print, but this isn't the kind of thing he noticed.

If I think just of photographs, their simple material, their surfaces, then I fail to find Barthes's Photography. Surfaces are not photographs—I am not reducing photographs to paper, glass, and chemicals—but once surfaces are forgotten, photographs are also forgotten. Barthes's view is normal, and that is why I keep saying he is right—we all use photographs to help us think of ourselves and our world—but there must be a cost, because selenite, ice, and salt are what we actually continuously see and scrupulously ignore.

24 Photography is domestic and domesticated in *Camera Lucida*, because it takes the form of a boy and his puppy, *Little Ernest, Little Italy, Idiot Children in an Institution*, or *Savorgnan de Brazza*. (pp. 46, 50, 52, 113) Ordinary photography is made strange—so Barthes implies—by the hunt for the punctum. He does not always look at faces: he also stares at shoes, necklaces, "incongruous" gestures, collars, bandages, "off-center detail." (pp. 51, 55) To him, those are the openings into the true nature of Photography, and it is clear he wants his readers to feel the frisson of discovery as they follow his wayward eye into the unnoticed and overlooked regions beyond photography's obvious faces and subjects.

I used to love the punctum, and why not? It is the very exemplar of romantic attachment, as Barthes himself knew so well: it is mine and only mine, it is unpredictable, outside the rule of reason, and always intensely personal. But it wears thin. In the end, it is not really adventurous: it's a kind of deliberate eccentricity, a self-consciously "aberrant" pensiveness. (p. 51) It's always in danger of being less affect than affectation. It's a tourism of the overlooked, spiced with little surprises and "shocks." Our eyes stray from the Queen to her "kilted groom," from "idiot children" to a "finger bandage," from "a family of American blacks" to "strapped pumps" and a "braided gold" necklace. (pp. 43, 50, 53, 57) And from there, where do our eyes go? Well, back into our own memories, and

*"He is looking at nothing;
he retains within himself
his love and his fear;
that is the Look . . ."*

A. KERTÉSZ: THE PUPPY, PARIS, 1928

*"He is looking at nothing;
he retains within himself
his love and his fear;
that is the Look . . ."*

KERTÉSZ'S *THE PUPPY* IN *CAMERA LUCIDA*.

then on to the next *Little Ernest*, the next *Little Italy*, the next *Idiot Children in an Institution*. Back to the faces and their novelized lives.

Barthes's adventures were never much of an adventure, after all. We pretended to be looking in a new way, askew, astray, awry, to one side of ordinary meaning. We thought we were doing something "potentially crazy." (p. 113) We found a few things that were overlooked . . . but those things were all *attached* to figures. The things we discovered were domestic middle-class ornaments: *staffage*, in the old landscape painter's terms—objects used to embellish, not to disrupt, or objects that could be experienced as embellishments even if they were unnoticed by the photographers themselves. (Technically: they could be experienced as disruptive exactly because they had not been noticed by the photographers themselves: that is Fried's point about Barthes's point.) It wasn't such a long trip, after all, from the woman to her pumps to her necklace, or from the child to her bandage and back.

It's true these little journeys are slightly haunting. Barthes would say that's because they pick out the "private reading," they speak silently to the "burning, the wounded." (pp. 97, 98) I don't really think so: the little trips from faces to *staffage* and back again to faces haunt us because they are toy journeys. I think they remind us, just a little, of something else. They are like amusement park rides that scare us a bit and then console us: by mimicking genuine terror, they half-remind us of real terror, and by half-reminding us they confuse us, blurring our image of terror with a toy version of terror. Or they are like detective stories—to which Barthes owes so much—in which the sleuth discovers an overlooked detail, apparently far from human meaning, and instantly solves the murder, wrapping up the harmless story in a delightful flourish. Suffering, pain, anguish, and mourning play no part in detective stories, and that is famously why they are so palatable as amusements: they put us in mind, just a little, of the fact that people we love will die—but then they make it seem that if we are clever enough, those deaths can somehow be solved.

The punctum is thrilling, to a point, because it mimics in its harmless way something more unsettling that waits beyond it. It half-hides the continuous slight unconscious effort it requires to ignore

the photographs themselves and look beyond them for romance and memory. Without our suspecting, Barthes's toy journeys shadow other far more upsetting journeys that we could have taken, and still can take.

25 At the conference in Nottingham, the one in which every speaker mentioned Barthes, I suggested that scholars might be using the punctum to smuggle their personal responses into their academic writing. *Camera Lucida* provides the imprimatur, the seal of propriety on ideas that would otherwise seem without foundation. Such a use is demonstrably a misreading, because the punctum is the property of each viewer's response and cannot be communicated with any authority or persuasiveness. A common maneuver is the analogic citation: such-and-such is like the punctum—but that can't make any better sense than a direct citation, because Barthes's punctum is itself inaccessible to public understanding. ("Stigmata and Sense Memory," *Art History*, 2001, 1–16.) Nor does it help to immerse the punctum in the Freudian unconscious, because that is not part of Barthes's presentation. (This is correctly diagnosed, against Victor Burgin, in an essay called "Re-Reading *Camera Lucida*," *Afterimage*, 2007.) And if the punctum is to enable a sense of solidarity with other people's lives, as Kaja Silverman argues, then it is only at the expense of the punctum's point-like solipsism. The punctum cannot be expanded and shared unless it is diluted by quantities of *studium*. (Silverman, *Threshold of the Visual World*, 185.) Bridges have been built from these adulterated *puncta*—plural now, because they are dispersed—to writers and artists from W. G. Sebald to Jeff Wall. But that is all part of the punctum's inaccurate afterlife. (Stefanie Harris, in *The German Quarterly*, 2001.) The popularity of *Camera Lucida* may partly stem from abuses of the punctum, and those abuses might also account for the punctum's conflicted and under-theorized reception, because scholars interested in the punctum would not be in a rush to acknowledge their motives for misreading.

(Of course, abuse is use. Postmodern writing on the arts mines many texts in many ways: Beckett is strip mined for art theory; holes are drilled in Gide's *The Counterfeiters*; *Finnegans Wake* is dissolved to extract its postmodern philosophy. The Portuguese scholar Mariana Pinto dos Santos read a draft of these pages and reminded me that Barthes is all the more useful because he is so open and literary. But all miners, from Fried and Krauss to Silverman, have to ignore what they destroy to get at what is underneath. It is Barthes himself who says the punctum cannot be shared.)

 And about Barthes's mother, the supposedly imaginary photograph, his intense roaming at the margins of despair: "Barthes" is near the edge of writing. His "little book" is dense with excrescences, rare orchids, "the burning, the wounded." ("le brûlant, le blessé," 155, 98 in the English.) But it is exactly there that I have to accuse him of remaining safe. It is just what the text presents to us as inviolate truth—the propulsive search, the disconsolate mourning that drives it—that is the last remaining cover, the safest defense, the best fiction.

Erin Mitchell has written an interesting comparison of lost mothers and grandmothers in writing: the grandmother in *Remembrance of Things Past*, the mother in *Camera Lucida*, and the mother in Marguerite Duras's *The Lover*. Mitchell calls written descriptions of lost relatives "virtual photography." "The actual image is rescued from the use and gaze of the public," she says, and so the image's meaning, and the love we can give the person it depicts, are controlled. (*Studies in 20th Century Literature*, 2000, 325.) Barthes's book is the riskiest of the three because it includes "actual photography." In the end "to write photography, to make photographic images virtual," is not a way of expanding representation, but a way "to contain and tame the excess of images." And therefore, I add, showing *other* photographs, and avoiding the Winter Garden photograph—which, as we now know, must have

been with him as he wrote—is a way of proposing that all strictures have been obeyed, all dangers met.

27 I prefer another photography, a broader and less controllable practice where we are not reliably given back what is familiar, and not reassured, by the giving, that it is familiar. That is mainly why I am not especially interested in the photography that Pierre Bourdieu so accurately conjures—the photography that provides us with evidence that we are reasonably successful middle-class subjects, confirming our place in the world and our apparent freedom, comforting us with what we take as proof that our lives, our families and marriages work and have meaning, freely giving what we take to be an incontrovertible validation of the truth of our beliefs about ourselves. I believe, but don't really care, that photography "is most frequently nothing but the reproduction of the image that a group produces of its own integration." (Bourdieu, *Un Art moyen*, 48.)

At the same time I recognize that by asserting my lack of interest in that understanding of photography, and by choosing things like rock, ice, and salt in place of family photos, I am wholly susceptible to Bourdieu's observation that asserting some "new" taste in photography is just a typical middle-class gesture of rebellion. For Bourdieu, photography is bourgeois to its bones, and it even includes its own futile anti-bourgeois gestures, like my own attraction to things that aren't family photographs.

Rosalind Krauss noted how Bourdieu's critique could engulf other understandings of photography, but she apparently did not want to notice how his critique could also swallow her own critical practice. Members of classes other than the one filled with "hicks and their Instamatics," she observes, can mark themselves as different either by abstaining from taking pictures altogether or by identifying "with a special kind of photographic practice, which is thought of as different." ("A Note on Photography and the Simulacral," in *Overexposed*, 175.) She does not say why Bourdieu's point does not pose a problem for her own project, which is also concerned with "a

special kind of photographic practice," namely minimalist and conceptual fine art photography and the philosophy of copies and simulacra. Bourdieu might have said all that was just as bourgeois as what she stringently refused. Barthes, too, knew Bourdieu's critique, and kept it out of his text without comment. Bourdieu's kind of critique is always available, and it always threatens to explain everyone's uses of photography, but it is not always in need of an answer because the practices themselves have meanings outside their significance for social relations.

I don't disagree that "we"—the billions who take family photos and vacation snapshots—need to find photographs touching, that we need to arrange them and share them, to preserve them and have them around to help us think about ourselves and our lives. (Olin, *Touching Photographs*.) But because we are distracted by faces and memories, because we do not notice, photography is released to do something wholly different. Or to invert the same thought: because photography does something wholly different, that has nothing at all to do with little Ernest, we need little Ernest in order not to see that other thing.

As I have read and re-read Barthes's book, I have accumulated a collection of photographs of my own. There are no well-known photographers in my collection, no portraits, and only a scattering of human figures. I still have my collections of family photographs, but when the subject is photography, I find it more rewarding to reflect on images that do not reflect a face in return.

Three
From the Green River to the Brunswick Peninsula

28 I admit from the beginning the *statistical* perversity of my search for this wider, less human, less geometric and lucid, less psychologically engaging photography. Most photographs, I suppose, are snapshots, and most of those are of people familiar to the people who took the pictures. There are also the millions of photographs that give us ideal versions of our own faces and families. That is what fashion and beauty photography propose to give us, from Penn to Avedon and Platon, and it is what Annie Leibovitz does with a dollop of unfelt eroticism and a sprinkle of ersatz surrealism. ("The *Vanity* Model," *Portrait32*, winter 2009.)

There are also the millions of photographs that give us "exotic" people and landscapes. "Exotic" deserves its scare quotes because there is little in *National Geographic*-style exoticism that is genuinely outside our experience. (*Exoticos*, "from the outside.") Little Ernest, the Queen's "kilted groom," "Savorgnan de Brazza," James Van Der Zee's Harlem portraits—these are just the slightly different images of Barthes himself, imagining his own alterity to himself, and for himself: even the more "exotic" photographs in *Camera Lucida* are just one safe, short step outside the image of himself that he had before he recognized it in the photographs. That is what *National Geographic* has been doing since the 1880s: its tired proposal is that even the most startlingly unfamiliar faces and breathtakingly strange locations are part of our shared world, provided they are shellacked with enough photographic beauty. I note, unhappily, the continuation into the twenty-first century of magazines like *Photography Today*, incessantly repeating instructions for making manageably poignant, predictably nostalgic, unthreateningly "exotic" pictures. Even serious magazines like *Aperture* aren't immune, running essays on photographers that make use of "exotic" locations. (My favorite is Pieter Hugo's portraits of Nigerian boys with their frightening, powerful pet hyenas and unsettlingly friendly baboons. The hyenas and their handlers are ferocious beyond what *National Geographic* permits itself, but Hugo's photographs are just as orientalizing.) The computer books sections of Borders and Barnes & Noble are stocked with Photoshop tutorials showing people how to create "exotic" scenes, and there are uncountable numbers of "exotic" art photographs on travelers'

blogs, on Flickr, and on eBay. The names of the books, magazines, software, and internet sites change, but it's the same swill. Photographs of the suddenly beautiful Other are the uncountable spawn of Exoticism and Nostalgia. (Mounira Khémir, in *Photography: Crisis of History*.)

The limitless worldwide production of family photos, the equally enormous production of idealized images of ourselves and our societies, and the perennially popular simulations of exotic subjects are the wholly normative functions of photography. So my starting point here has to be the admission that what I am trying to do is perverse.

29 I also admit there is *historical* and *critical* perversity in claiming that photography represents the world inadequately. Photography's link to the physical world and to a general sense of how the world looks—to naturalism, to realism—have not been seriously threatened even in academic criticism. The same theorists who say photography's realism is really a matter of what people want it to represent, still reserve the index as photography's physical link to the world. (Rosalind Krauss, "Notes on the Obtuse," in *Photography Theory*.) It is easy to agree that photography's apparent realism has been formed by the middle-class hope that photographs give us reality itself (as Bourdieu says), and it is hard to disagree that photographs are formed by a physical and mechanical interaction with the world (as a debased version of Peirce has it). By accepting both these ideas, photography has become an activity that is both the projection of our desires about the world and an accurate record of the world. Weirdly, but characteristically, the idea that photography's realism is wholly a matter of what we *want* to believe coexists with the observation that photography has a causal, physical link to reality.

The book *Photography Theory* showed me just how little these differences seem to matter for most people involved in the practice, history, or theory of photography. I am no longer sure there is

much argument about photography's nature, what it is "in itself." (In quotation marks, even in Barthes's opening section.) Some contributors to *Photography Theory* argue with each other, as they are expected to do in an academic book, and some misunderstand claims about photography's realism made by other contributors or have idiosyncratic positions that no one tries to address. But most contributors don't argue at all. They choose not to join the discussion except in passing, and a number do not say why they don't have a position on photography's realism or lack of it, nor do they say why they think it is *unimportant* that they do not have a position. (This curious opinionlessness about opinion is the subject of the "Envoi" in *Re-Enchantment*, 2008.) *Photography Theory* records an unaccountable insouciance about photography's realism.

All that is to say that either worrying about photography's inadequacy as a naturalistic tool, or exploring its conventionality, misses the strangeness of the carelessness of the people who decide to miss these points. Inquiring into conventionality or naturalism is more or less meaningless in relation to the common, unaccountable, intentional avoidance of any clear position about photography's nature. So it is off-key for me to worry the question of how photography represents the world.

30 And (my third perversion) I admit it is *phenomenologically* perverse to say that photographs of people are not central to what photography is. It is untrue to the normative understanding of photographs to prefer the photograph's flaws to what it depicts, to say, in the case of "Little Ernest," that a set of blunt depressions at the lower right of the image is more rewarding than Ernest's bold and confident expression. Possibly just as untrue as it is to see past him to the incidental shadows and unfocused depths that surround him, which meant so little to Barthes, but which I think are so important to what photography is.

If I choose to look at marks and shadows instead of a little schoolboy, it is not because I am hoping that the material of the

photograph, its matter, its grain, can somehow speak, that photographic substance is somehow more eloquent, more full of thought, than little Ernest himself. The idea that the material of an artwork is what really bears meaning runs through so much writing that it would be hard to count it all, from Tim Clark's intricate and cloistered *Farewell to an Idea* to Daniel Arasse's study of details in paintings. There is an old notion that the material of art is transfigured into meaning, and there are also inversions of that idea, such as Georges Didi-Huberman's conviction that materiality is a hypostasis of meaning into substance. (Didi-Huberman, *Fra Angelico*; Rosalind Krauss and Yve-Alain Bois, *Formless*; Jay Bernstein, *Against Voluptuous Bodies*.) The false companion to this book, *What Painting Is*, is spellbound by material and its alchemical transformations into embodied meaning. It would be possible to go down that road with photography, following essays like Kenneth Calhoon's "Personal Effects: Rilke, Barthes, and the Matter of Photography." (*MLN*, 1998; also Alexander Vasudevan in *Cultural Geographies*, 2007.) One of the most interesting contemporary fine art photographers, Marco Breuer, cuts, scratches, and burns his photographic paper, using hot frying pans, scouring pads, knives, and lit fuses. (*Six Stories from the End of Representation*, chapter 2.) An entire book could be written on this subject. At times I am as mesmerized by the eloquent meaninglessness, the meaningful muteness, of materiality as anyone who was brought up in modernism.

But I don't mean any of that here. For the duration of this book, I disallow the poetic hope that partial meaning can gleam out of paper, silver, grain, or pixels. When I mention the surface of a photograph, I mean surface and just surface, not eloquent surface: not hypostatic, fallen representation, crushed onto the sensitive layers of the photograph. The perversity of this position isn't that it is outside of modernist debates about meaning and materiality, but just that I want to keep coming back to what photographs actually are: what their surfaces and depths look like, what happens when I try to look into them, whether they have depth or weight, and how they feel—even if that feeling is a glassy computer screen or a weightless page from a newspaper.

When a photograph has no face in it, no immediate comfort for my eye, no instant pleasure in the seeing, then a strange kind of recognition begins to come into its own: not the troubled or happy discovery of another life ("What a novel!"), but a reminder of something outside personal and common memory. It might seem that any image without a person or a face would open up the different kind of seeing I am after. But in fact few do, because most images without faces or people are actually full of people: they are places where people can find themselves in imagination.

Someone gave me a glossy book produced by the image warehouse Corbis, hawking photographs that advertisers can use as generic backgrounds for their products. It seemed at first to be a commercial version of the depopulated photography I was after. There are relatively few people in the book, with the exception of a few happy young couples and the usual choice of a half-dozen obviously ethnic faces in *National Geographic* style close up. There is the wizened Asian, taken to be non-Han Mongolian or Tibetan; the northern European of impeccably unidentifiable nationality; the "exotic" flat-nosed Native American, presumably to be taken as a rare survivor in Amazonia. Mainly the photographs in the book are of temporarily empty airport lounges, dreamy depopulated suburban streets, undecorated apartments full of promise, breakfast niches bathed in sunlight, conference tables set with notepads and water glasses, and scrupulously clean maternity wards seen in shallow focus. Really none of the images in the Corbis book are empty of people, because they are portraits of people's potential lives. Advertisers are asked to buy Corbis's images as backdrops to their ads and catalogs, and then overlay people and products. The Corbis catalog, which seems so depopulated, is actually a family photo album.

The same may be said of the enormous swathes of contemporary photography that conjure people's lives with snapshots of kitchen pantries, clock radios on night stands, televisions turned off, leaning stacks of vinyl records, avalanches of books, or dust under the bed. ("Picturing the Art of Moyra Davey," *Border Crossings*, November 2008.) Daniel Boudinet's photograph of an unmade bed and Niépce's *Dinner Table*, the only two photographs in *Camera Lucida*

without people, are both intimate scenes that people have only just left.

Then there is the entire domain of photographs of deserted places that are wrecked, threadbare, or impoverished. From Atget to Lynne Cohen, Daniel and Geo Fuchs to Takashi Yasumura, there are photographs of crime scenes, sinister interiors, operating theaters, shooting ranges, rest homes, asylums, desolate back lots, dilapidated alleys, empty police stations, and creepy suburban living rooms. When the subject is communities, as in Robert Adams's *The New West*, depopulated photographs can be sober, antiromantic, depressing, and poetic. One of the roots of that practice is surrealism, as in Jindrich Styrsky's *Na jehlách těchto dní*, a book of deserted streets. A whole industry of photographic projects, beginning with Stephen Shore and books like Lewis Baltz's *The New Industrial Parks Near Irvine, California*, finds beauty and nostalgia in postindustrial landscapes. More recently, there are depopulated landscapes by Jeff Wall, Andreas Gursky, and Jean-Marc Bustamante.

All those images are about people, and it's fair to say that the majority of fine art photography, from Stieglitz to Boltanski, is also about people. (*The Book of 101 Books*; *Photoart: Photography in the Twentieth Century*.) I don't mean to say all these practices are interchangeable, just that there is a vantage point from which they are more similar than different. The principal exceptions are the icons of postmodernism, like Bernhard and Hilla Becher's *Anonyme Skupturen* (the book of water tower photographs, still revered by young artists) and Ed Ruscha's *Every Building on the Sunset Strip*. But my interest here is not art, so I won't need to try to draw lines between the Beckers or Ruscha and things that concern me.

From the distant point of view I'm taking up here, there is little escape from the photography of people—from little Ernest—in the photo industry, in fine art, or in commerce. I first found the kinds of images I was looking for in a peculiar kind of landscape photography called "rephotography."

32 Mark Klett's "rephotographic project" involves finding places that had been photographed in the nineteenth century by pioneer photographers of the American desert, and rephotographing them from the exact same spot and at the same time of day. They are the first exhibits in my gallery of depopulated photographs.

In some of Klett's pairings, a wilderness captured in the nineteenth-century photograph is replaced by a highway in the rephotograph, or a hill is reshaped to support a housing development. In a few of the pairs, the earth returns to its natural state: the nineteenth-century photograph shows a shanty town, but in the twentieth-century rephotograph the town has disappeared. In another pair, a nineteenth-century mine is abandoned in the late twentieth century, and scrub brush has begun to heal the land. But surprisingly, given the billions of new people that now crowd the world, most of Klett's rephotographs show that the landscape has not changed very much. Trees appear and disappear, and vegetation shifts, but the contours of the land generally remain the same.

In a few pictures, it seems that nothing has changed in the hundred-odd years since the first photograph. The earth seems static, and I imagine Klett standing with his camera, superimposed, at a hundred years' distance, over the figure of the nineteenth-century photographer, both studying the exact same landscape.

33 One pair of photographs, taken 107 years apart, looks at first like two copies of the same photograph. It seems nothing has moved. The bright cliff faces at the right match shadow for shadow, because the rephotograph was made at the same time of day, on the same day of the year. The serrated edges of the shadowed escarpment in the distance correspond angle by angle with apparently perfect precision. On the horizon of the bright slope, I note that the minuscule black shadows of rocks have not shifted: dark smudge, comma-like projection, dark smudge—each shape in the nineteenth-century photograph has its exact copy in the rephotograph.

The earlier photographer, Timothy O'Sullivan, used a different photographic process than Klett did. In the newer photograph the large rock in the foreground is more contrasty, and its lower edge is unclear. Yet the visible portions of the rock are in precisely the same positions in the two photographs. During the century between the two, "desert varnish," a mineral patina, darkened the top of the stone, and lightened one patch near the top.

And if I look even more closely? A rock cuts the lower-right corner of both photographs. Beyond it is a corrugated stone at a forty-five degree angle. It is brighter in O'Sullivan's picture, but it has not moved. The scree slope at the lower left has changed, and so has the stream bed, but I would expect that after 107 years of infrequent flash floods. Naturally the small tufts of grass that pepper the scree slope are different in the two photographs. Nearly everything else—every cleft, every bedding plane, every outcropping—has been utterly immobile for the full 107 years. (There is a website, thirdview.org, that juxtaposes the old and new photographs from Klett's project, but the registration is never perfect because of the optics of the cameras: the images themselves shift slightly as one fades into another. I find it more compelling to compare without mechanical aids.)

34 The Green River valley, where these photographs were taken, can be very quiet, especially when there are no insects and the creeks are dry. Often there is no wind. That stillness has a hollow sound, as if you could hear the volume of air shifting in the canyon walls.

These two photographs are even more quiet. They have a deadening silence, which deepens each time I compare a stone in one image to the same stone in the other image. The slight mist in the shadows of O'Sullivan's photograph is my only relief from the tense airless reverberation of identical shapes.

"the tense airless reverberation of identical shapes"

TIMOTHY O'SULLIVAN, VERMILLION CREEK CAÑON. 1872.

"the tense airless reverberation of identical shapes"

35 This, I think, is the photographic imprint: the nearly hallucinatory record of uncountable numbers of unnameable forms, impressed on my eyes with a senseless insistence. In the Photograph, Barthes says, time is immobilized, "engorged," frozen in "an excessive, monstrous mode," in "a strange stasis, the stasis of an arrest." And here he interpolates a story about the Spanish village of Montiel, where people were fixed in the past: it's a strange reference, blending psychiatry and E. T. A. Hoffmann. (p. 91) Time is locked, he says, incapable of the slightest movement. Barthes is right, but as usual he is thinking of people—the princess in *Sleeping Beauty*, and the people in the village of Montiel who imagine they are living in the past. But Sleeping Beauty breathed, and the people of Montiel still read newspapers and listen to the radio. These rocks have no comforting pathos, they are literally pitiless.

The insistent sameness of these immobile photographed rocks is the analogue of the insistence with which the world, especially this part of it, shocks my eyes with its hard-edged endless inhuman architecture. What I recognize is not Ernest, not the Look. In the enforced and unpleasant stillness, I recognize myself seeing—and that is exactly because I do not register what I am seeing.

36 "For the first time in history," Siegfried Kracauer says, "photography brings to light the entire natural cocoon; for the first time, the inert world presents itself in its independence from human beings." It does seem these rocks are "the last elements of nature, alienated from meaning," and they do claim my attention in an inhuman way. ("Photography," in *Mass Ornament*, 1927, 59.) Kracauer's position is more radical than most writers on photography, who prefer figures in their photographs. Serge Tisseron, reconsidering Barthes, adds only a few photos to his book that aren't ones Barthes would have liked. One is an image of leeks, with their roots out of focus in the foreground. It is immediately rescued for psychoanalytic purposes: "Est-ce l'image d'une fellation?" he wonders, and quickly returns

to ordinary pictures of people. (Tisseron, *Le mystère de la chambre claire*, 100.)

Meir Wigoder, contrasting Barthes and Kracauer, says the latter thought of photography as "a stockpile," "a heap of garbage," incapable of resurrecting the dead. Yet Kracauer did think photographs were useful as evidence of the dead, and in that there's a link to Barthes's more humanist claims. The rocks I have been considering are neither a euphemism nor a veneer, nor even—as Kracauer hoped—a sheath of reality polished and preserved for historical work. (Wigoder, in *History and Memory*, 2001.)

Kracauer's despondent materialism, like Barthes's despondent phenomenology, was a safe practice. Cameras do much more than provide aerial photographs of our lives, as Kracauer said, or fetch "crockets and figures down from Gothic cathedrals." (p. 62) These rocks, this photography, are stranger than that, less reliable: really, they are not reliable at all.

37 And so I keep looking, even more closely, obscurely impelled, perhaps, by a need to find some sign of life. Or perhaps I am after a remnant of the reassuring sense of the passage of time, an escape from the "arrest" that Barthes found so disturbing.

I enlarge a portion of both images to examine the silhouette of the far canyon wall, thinking that the hard edge will be the most sensitive to incremental change. I find a tiny stone, perched on a slope at the upper left of O'Sullivan's image, that rolled off sometime during those 107 years. I put an arrow to mark it. Looking back and forth between the two photographs, I watch the little rock blink in and out of existence.

The sunlit ridge also has a few rocks that have moved, and so does the scree slope. I mark them with arrows. They are like little gasps of air in the locked-down vacuum.

(Joel Snyder tells me that the skies in O'Sullivan's landscapes were painted white, but I can find no sign of that, no matter how closely I look. What I am seeing on the horizon line might be undependable, but if a brush went near these rocks, it left no trace.)

"I enlarge a portion of both images . . ."

Timothy O'Sullivan, Vermillion Creek Cañon, detail. 1872.

"I enlarge a portion of both images . . ."

MARK KLETT, VERMILLION CREEK CAÑON, DETAIL. 1979.

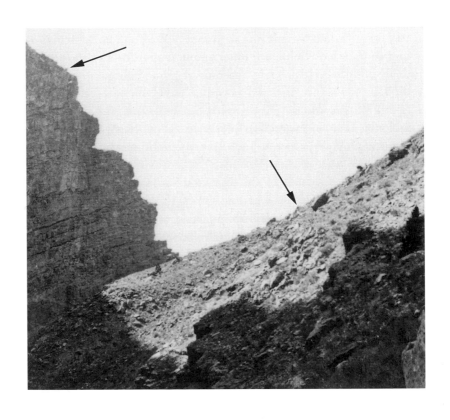

"I find a tiny stone, perched on a slope at the upper left"

TIMOTHY O'SULLIVAN, VERMILLION CREEK CAÑON, DETAIL. 1872.

38 Still looking, more closely, more desperately. It is hard to focus on the little stones: they waver and blur even without moving. It is hard to see the shape of the larger stones: some seem to be changed, but it depends on cloudy nuances of gray and black. In Klett's rephotograph the largest stones look deformed, blurred, or stained. I thought I had identified every stone that moved between the time of the two photographs. But now I am surprised to find that is impossible, because many stones have moved. I start finding dozens of minuscule changes. Many of the pebble shapes are hard to correlate. My arrows multiply. And now I cannot find even a single rock-solid point that is unequivocally unchanged. Things are "fundamentally unclassifiable"; the world has become "an array of casual fragments." (Sontag, *On Photography*, 80; and Michael Finnissy, *Musical Times*, summer 2002, 32.)

I see that the shadow has moved, and because the cliff that cast the shadow is more or less intact, that means the rock slope has slumped—it has a different shape, and everything in it, and on it, is differently arranged. And then at last it dawns on me that *nothing* is the same, *everything* has moved. There is no duration, nothing remains. (Derrida, "The Photographs of Jean-François Bonhomme.")

So I begin an inverted search, looking for anything at all that has *not* changed. The entire landscape begins to seethe, engorged in a stasis so intense that it cannot hold still.

39 I turn away, not because I am bored, but because I know there is no end to this searching. I don't want to say there is no point in going on, because I don't know if there needs to be a point to seeing. Why should I always mine images for meaning? Why should there be a solution, a significance? Yet it's a strange feeling: I know that looking in this way is indulgent and maybe just idle, but it is the photographs themselves that seem to have been leading me. And what do these photographs have other than rocks? If I were to start talking in the

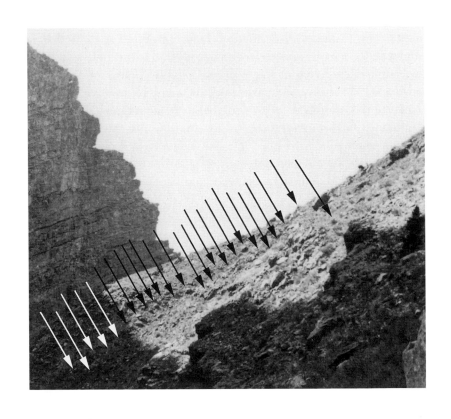

"at last it dawns on me that nothing is the same"

TIMOTHY O'SULLIVAN, VERMILLION CREEK CAÑON, DETAIL. 1872.

usual way about the virtues of O'Sullivan's art or Klett's project, I would be leaving the exactitude of these images behind, in favor of their histories—and there are many to choose from. (Joel Snyder, *American Frontiers*; Mark Klett, *Third Views*; Rebecca Solnit, *Yosemite in Time*.)

Counting pebbles, I have become *catascopic*: I see from above, but I see only tiny things, and now, thinking only of grainy images of pebbles, I have become anascopic, seeing from below, from the tiny details, and struggling to come back up to the light and air of normal seeing. (Barthes did not use these words, but he wouldn't have needed them anyway because he remained in the open, floating above the photographs. The tidal pull he felt took him safely through the photographs and into memory. There was no stopping for pebbles.)

Embarrassing, self-indulgent, pointless. But also hypnotic, riveting, compulsive. Evidently this is part of what photography is.

40 I turn to another rephotographic project, less celebrated than Klett's. It began with nineteenth-century photographs of iron and masonry obelisks that mark the border between the United States and Mexico. The obelisks were built and photographed between 1892 and 1893, and then found again in 1983 and 1984 by a plant ecologist named Robert Humphrey. Because he did not need to duplicate the exact viewpoint in order to study plant distribution, Humphrey's rephotographs lack the fetishistic precision of Klett's. In Humphrey's project it is as if the nineteenth-century photographer had just shifted a few feet and taken another snapshot.

Marker 104, for example, is west of the Huachuca Mountains in southeastern Arizona. Humphrey notes that Emory oak and Mexican Blue oak had become more widespread when he visited. The grass and mesquite cover was thicker at the time of the earlier photograph, he says, even though that might be due to a drought in the years just before 1893. Looking back and forth from one of these photographs to the other produces a blink-microscope effect: the man turns into

"In place of the incremental ratcheting displacements of the Klett and O'Sullivan, a soft and unmeasurable movement and growth."

ANONYMOUS PHOTOGRAPHER, MILE MARKER 104, SOUTHEASTERN ARIZONA. 1892.

"In place of the incremental ratcheting displacements of the Klett and O'Sullivan, a soft and unmeasurable movement and growth."

ROBERT HUMPHREY, MILE MARKER 104, SOUTHEASTERN ARIZONA. 1983.

an oak tree, and then back into himself again. (Blink microscope: an optical device used by Clyde Tombaugh in the discovery of Pluto. It switches rapidly between two different images of a star field, so that anything that has moved between the two exposures will seem to blink. Tombaugh spent thousands of hours over a period of years looking into his blink microscope, flashing between pictures of identical star fields until he spotted Pluto, the star that moved slightly between two frames. I have visited the observatory, and tried the blink microscope: it is immediately exhausting.)

Man, tree: a placid and harmless illusion, not like the hysterical hallucination conjured by Klett's and O'Sullivan's photographs. In place of the incremental ratcheting displacements of their photographs, Humphrey's pairs produce a soft and unmeasurable movement and growth. In the newer photograph plants proliferate, the land seems to have undulated a little; the stones may have rolled and settled. Perhaps stones were moved when the border fence was built, or they were kicked out of place, one by one, by generations of cattle. I can see a row of three or four stones just in front of the left side of the obelisk that have more or less remained in their places. But my eye has no reason to linger. I look again at the man who blinks into a tree, and the agave flower that appears on the left, like a second obelisk. And then I am done, ready to move on to another image.

41 The continuous millennial movement of rocks and shrubs is somehow a relief. Klett's and O'Sullivan's photographs felt like some kind of trap, they had the sour taste of something mindless. Leafing through Humphrey's book, it's as if I have been released. But released from what? From a strange interminable analysis of rocks? From any close looking, from the obligation to look closely? From the awareness that close looking is itself pathological? Perhaps I have been released, but released into what? Into a dependable pleasure in harmless flux, a vague complacency about things that refuse to remain in place? A license to stop looking after a cursory glance or two? If I'm happy with that, what does it mean for photography?

"The earlier picture has a subject, but it is invisible.
The later picture has a subject, and it is the earlier picture."

ANONYMOUS PHOTOGRAPHER, MILE MARKER 189, SOUTHWESTERN ARIZONA. 1892.

ROBERT HUMPHREY, MILE MARKER 189, SOUTHWESTERN ARIZONA. 1983.

Photography has this capacity, often noted and sometimes criticized, to put its viewers into a trance. Klett's project sinks me into an especially deep and troubling kind of trance. Humphrey's project feels more normal, less like a trance than a daydream. In clinical hypnosis, low-level trances are used to relax patients, but deep trances, at levels 8, 9, and 10 on the hypnotist's scale, can make people believe they are infants, crumpling them into abject terror, atrophying their adult coordination. In that state, hypnosis reaches very deep into what a person is: patients in oral surgery can voluntarily stop the bleeding in their own mouths. Rephotographic projects make me wonder about what counts as normal seeing, and how photographs can lead us from faint musings to deeper compulsive trances.

 Occasionally Humphrey failed to locate one of the old obelisks. The law governing the construction and documentation of the obelisks had stipulated that they be built at the border, which sometimes meant hauling iron for the obelisks up the mountains. Each obelisk also had to be photographed, but the contract did not explicitly require the workers to carry their heavy camera up to the tops of the mountains. So they sometimes just photographed the obelisks from the valleys, even though the pictures they produced were worthless. Mile Marker 189, on top of the Lechuguilla Mountains in the Sonoran desert, is not visible in the original photograph. When Humphrey tried to find the obelisk, he couldn't, nor could he locate the peaks that are documented in the original photograph. He says he knew he was within a few miles of the correct position, and so he made his rephotograph, documenting a place near the original location. The original and the rephotograph give us two stretches of desert mountains, one with a marker somewhere in it. It is possible that the same peaks are visible in each photograph, and it may even be that the obelisk is present in both visual fields. Humphrey remarks that the viewpoint of the original photograph was so distant that he could not even be sure of the species of vegetation. It "appears to have been foothill paloverde and ironwood," he writes, and other

species that appear in the newer photograph "may be assumed to have been present but unidentifiable in the 1893 picture." (*90 Years and 535 Miles*, 392.)

These two photographs produce a third form of hypnosis. It is not the mechanical, driving hypnosis of the Green River pair, or the loose, directionless wandering hypnosis of the Mile Marker 104 pair. This time I find myself feeling lost twice over, in two different places, or in two places that may be different, or may be slightly or partly different. In the earlier picture my eyes are lost up on the mountaintops, in the fruitless search for the obelisk that must be there but is not visible. In the newer picture my eyes are lost in the mountains, searching for common points, wondering if one picture is contained within the other as a detail, or whether the two views share a part of the same landscape seen from different angles. The earlier picture has a subject, but it is invisible. The later picture also has a subject, and it is the earlier picture. So the later picture may, or may not, contain a photograph within itself, which in turn may, or may not, contain the image of an obelisk. It is a hypnosis about hypnosis, a search within a search. And as in the pair of images by Klett and O'Sullivan, I know nothing can be solved, but I am caught.

Looking back and forth at the Green River images reminds me of the shaking metal grids that are used to separate sizes of gravel: they are motorized, and they move very quickly. Watching them is dizzying and rebarbative. Looking at the Mile Marker 104 pair reminds me of something quite different, perhaps time-lapse photography of growing plants: I contemplate those images calmly, and they are almost pleasant to compare. Looking at the Mile Marker 189 pair reminds me of waking, as I have sometimes done, from one dream into another dream: it is entrancing but unsettling.

43 There are a number of other such projects. David Taylor has been rephotographing the obelisks, creating a third layer of images. (*David Taylor: Working the Line*). There are rephotographs of Madison, Wisconsin; of the Grand Canyon; Lake Tahoe; San Francisco; Alabama; and desert

geology. Each one magnetizes me into pointless searches. (Zane Williams, *Double Take*; Peter Goin, *Stopping Time*; Robert Webb, *Grand Canyon*; William Christenberry, [Alabama]; Klett, *After the Ruins*; and most beautifully, Don Baars, *Geology of Canyonlands and Cataract Canyon*.)

Non-photographic comparisons, for example a popular book that pairs Piranesi's prints of Rome with modern photographs, don't have the force of these rephotographic projects. (Herschel Levit, *Views of Rome Then and Now*.) New photographs that repeat old photographs set up a strange machinery of attention, as if I need to prove to myself that photography actually possesses the accuracy that I have always thought it has.

Rephotography like Humphrey's or Klett's is also different from postmodern experiments such as Sherrie Levine's rephotographs of Walker Evans's photographs or John Grech's restaging of the Graeme Thorne kidnapping. (Grech, *Rephotographing History*.) Of those it can be said that their "now fully familiar strategies of appropriation," their "systematic assault on modernist orthodoxies of immanence, autonomy, presence, originality, and authorship," their "engagement with the simulacral," and their "interrogation of the problematics of photographic mass media representation" are characteristic of "the concerns of a critical postmodernism." (Abigail Solomon-Godeau, "Living with Contradictions," in *Overexposed*, 247–68.) In the 1970s and 1980s it was often noted that photographs can be mechanically reproduced, and it was then claimed that reproducibility is photography's intrinsic property, one that serious photography therefore has to pursue. I've become familiar with that claim and the way it looks in Levine and others. Photographic projects that involve replication or appropriation do not necessarily set me looking: I can believe their claims without needing to see them. Something different happens when I see a new pairing by Klett: I am returned to some infantile stage of gazing, or plunged into some insatiable St. Thomas-style skepticism.

When I see a face in a photograph, my attention is at once narrowed and blurred. I tend to focus on the face, and my sense of the rest of the photograph goes out of focus. I'm apt to be distracted into musings on history, society, art, portraiture, empathy, and presence, or time, death, memory, and mortality. I'm likely to

"a man suddenly appears, half-hidden by the brush."

Mary Tarbox, Unidentified Subject. c. 1958.

ponder what it means to look at portraits in general. After the first half-minute, the more I look the less I see. It's the same with appropriated photographs: I get the idea and I turn away, at least in my mind, to consider it. When there is no face to mollify my gaze and straighten my meandering meditations, my seeing is hurt, and put to work on useless tasks, until I come to recognize my helplessness in the face of the endless irrelevant details of the world that photography impertinently and obstinately keeps giving me.

44 By some strange luck a magical machine from my childhood has survived, and I still own it. It is a metal and Bakelite Stereo Realist camera from the 1950s, which takes three-dimensional slides—two slides mounted side by side in an elongated cardboard frame. The slides have to be dropped one by one into a Red Dot viewer, named after the oversized red button that has to be held down to keep the light on.

It is not possible to express how astonishing Realist pictures can be. Some people who haven't seen them expect ViewMaster slides, miniature color slides that were sold pre-mounted on cardboard wheels. Others think of the amusement-park effects of old 3-D movies, or the IMAX-style immersion of films like *Avatar*. The Stereo Realist system produces pictures so amazingly like the actual objects that I have often imagined I was walking along a Caribbean beach in blazing sunlight, or standing in the chill twilight on a damp boardwalk in San Francisco, or crouching at the edge of a sulfurous mud spring in Yellowstone. With the lights in the room turned down, the glow from the Red Dot viewer is as forceful as daylight, and the illusion so strong I can smell the sulfur of the thermal spring, or the sour humid odor of the kelp on the boardwalk, or the slightly burnt Caribbean air.

I have owned the viewer and the camera since my grandmother, Mary Tarbox, gave them to me along with several thousand of her own slides. She died thirty-five years ago, and she only labeled some of her slides, so in many cases I don't know where they were taken. One stereo pair shows mountains on a sunny afternoon. Because books are helpless to communicate the astonishing magic of this kind

of image, I reproduce the left-hand photo from the pair as an echo of the original. The soil is reddish, and the mountains are covered in dry brush and pine. Lenticular clouds hover like halos over unseen mountains. A bank of cumulus drifts above a distant valley. There is a paved road. A house can be glimpsed off to the right. The scene looks a little cold, and I imagine the empty mountain air, dry, pine-scented, leached of oxygen. By the side of the road is an illegible sign, washed out by the sunlight. The date would be around 1958, and the place could be Australia, New Zealand, or California, all places my grandmother visited in the 1950s.

When the stereo pair is placed into the Red Dot viewer, a man suddenly appears, half-hidden by the brush. He is walking on the road, just to the left of the picture's midline. The stereo brings him out: when either photograph is seen on its own, his legs—he is in full stride, walking toward the sign—are confused with the pine branches. It reminds me of a photograph by Alec Soth, showing a hermit half-hidden in a thicket: once the walking man appears, it seems the picture must be about him. But I know it probably wasn't, because my grandmother took mainly landscapes. (Soth: "Trolling for Strangers to Befriend," *The New York Times*, August 2, 2009.)

The Stereo Realist slides are poor little windows onto my grandmother's life. But there is something more here than the residual attraction I feel toward her and the places she may have visited. (To be truthful about it, I would hardly think of her if it were not for these photographs: I wonder if Barthes thought about the way photographs subtly redirect our emotion, making us care about people more than we might have. Photography's power to reorient our interest is something Sontag knew better than Barthes. The Winter Garden photograph, Barthes says, revealed a memory of his mother, but that memory, and his mourning, are also produced and sustained by photography.) It matters to me that many of my grandmother's slides cannot be identified. Those empty landscapes, photographed for no apparent reason, are among the most compelling images I know. Having people in them would ruin them, because people would become their labels: "Uncle Joseph hiking up the road to Palomar" (if it were California) or "Frank walking to Rotorua" (if it were New Zealand). And the labels would make me think, again, of my grandmother. If I were to identify the slides, my

life and hers would be artificially bound. If I were in mourning, perhaps I would want to press these photographs to just that use, but I am not, and I feel only photography's invasive coercion.

I do not want to figure out where the pictures were taken, or why. Partly that is because I do not want to be drawn into reveries about my grandmother's life, and what it might have been. Partly it is because I do not want to explain the slides, to somehow solve them, as if they were crime dramas. But at the same time I am not after mystery, and I don't love these pictures because they are enigmatic. A visual object is mysterious enough without also being a puzzle. (*Why Are Our Pictures Puzzles?*)

I desire neither explanation nor enigma. I only want to be able to see these slides as photographs.

45 It is not photography but the uses we find for it that give us the universe so nicely labeled: "The Grand Canyon at Sunset," "A Field of Tulips in Holland," "A Villager from Sükhbaatar." Landscape photography "itself," photography without families, without romance, without labels, gives me places that have no immediate use for my life, no voice that I can hear. Some uninhabited landscapes are like smooth surface to which memory cannot adhere. I love the feeling of memory trying to attach itself, starting to stick to an image, and then losing grip and falling away. I love the blank emotionless surface.

I have in my collection other stereo photographs that possess that same quality, entrancing my memory, tempting me to feel something, and then stepping back. The Keystone Stereoscopic Service produced a series of test cards, intended to test the eyesight of schoolchildren. These were cliché sorts of tourist views, overlaid with geometric shapes elaborately and skillfully hand-painted in ink or thick Chinese white. In those pictures random landscapes are overlaid with strange test objects. In one, a tourist photograph of a woman and child in Tyrolean costumes is overpainted, on the stereo card itself, with three india ink circles. When the slide is put in the viewer, those circles hover menacingly close to my eye,

*"like some seventeenth-century alchemical emblem,
in which bizarre symbols congregate in ordinary German forests"*

Test Slide, Keystone View Company. Undated.

as if the ink circles themselves were round knives that could slice into my cornea. The floating Tyrolean ink circles are an annoying and apparently pointless apparition. The surrealists would have loved them.

On another Keystone card, an indifferent picture of a pine forest is overlaid with an openwork sphere delicately drawn in Chinese white ink. The sphere is slightly different in the two images, and when the card is put in the viewer it produces an apparition of a shining metal globe suspended in the branches of a tree. The left-hand image also has a horizontal white line segment painted at eye level as if it were a zinc bar nailed into a tree trunk. The right-hand image has a vertical segment, which looks like a second bar planted in the earth. In the viewer they come together, with some effort (the effort makes me a little dizzy) into a white cross floating unsteadily in midair. These ordinary pine woods are haunted by an armillary sphere and a gleaming cross, like some seventeenth-century alchemical emblem in which bizarre symbols congregate in the landscape, producing arcane meanings.

In images like this I again recognize myself seeing. I can feel the muscles of my eye accommodate with difficulty to the new information, trying to put the two white bars together. As I force them into a cross shape—and I have no power, it seems, to do otherwise: that is clearly what they are for, and they ask to be united—I can sense a slight strangulation of meaning. Why would this spherical sculpture hang just here, in these branches? It doesn't help to know that the sphere and the dismembered cross were once useful for someone, that there was once a person in the Keystone Stereoscopic Service who could have explained them. Nor does it really matter that the purpose of these photographs was to calibrate stereoscopes so that consumers could see dull views of Tyrolean tourists or picturesque log cabins nestled in pine forests.

It does matter that the world given to me in these photographs is demanding, and its demands are inexplicable: in that dilemma I glimpse photography at work, insisting how hard is it to see the world, and insisting that I find that difficulty, which has always been there for me to discover, in photographs.

46 In contemporary fine art photography, when the camera is not pointed at a person, the word that does the most work in describing what happens is "sublime." The work of the superstar photographers of the turn of the millennium is replete with attempts at sublimity: Thomas Ruff's startling dark fields of stars, printed six feet high and frighteningly sharp, with pinpricks of stars and pink cotton dustings of galaxies; Andreas Gursky's airport-lounge size photographs looking down onto Asian archipelagos, where the viewer looks up at the enormous scene, but also plummets in imagination into the ocean like the falling Icarus; Thomas Struth's colossal interiors of churches and synagogues, filled with portentous emptiness and glowing from ethereal stained glass windows; Hiroshi Sugimoto's foggy becalmed oceanscapes, where you can almost hear the little waves lapping at the dismal gray shore; Tacita Dean's heartbreaking photos of the *Teignmouth Electron*, the boat once piloted by Donald Crowhurst, the sailor who became psychotic and drowned himself during an around-the-world race, the boat decaying and forgotten on a beach in the Cayman Islands. The sublime is one of the principal things that ambitious fine art photography attempts when it does not depict people. (*Six Stories from the End of Representation*, 2008.)

I have three exhibits here, and I want to use them to argue against the sublime. It's not that Ruff, Gursky, Sugimoto, Dean, and so many others aren't sometimes sublime: it's that the sublime is sublimely distracting, preventing me from noticing so many other things. I want to be able to concentrate on the imperfect selenite window, and I need to remove distractions. (I won't be using fine art photography to argue against the sublime, because it's easier to see the issues when the art volume is turned down.)

The sublime is a pitch-perfect concept for academic art criticism: it has intellectual glamour, it is notoriously difficult, it comes packaged in a treacherous and complex history, it is both frighteningly austere and impossibly dreamy. The postmodern sublime is not the trumpeting sublime of the eighteenth or nineteenth centuries, with its belching volcanoes, its thunderclouds and rainbows, its snowy peaks and dizzying abysses. Sugimoto and others explore a nearly static and silent postmodern sublime, one that has been

smoothed and quieted until it is nearly inaudible. I am becalmed by Sugimoto's faceless oceans. I am pithed by Gursky's colossal prints. I can hardly think of anything except infinity, silence, and time, and that, at least in this context, is the problem.

The measured chill and reverberating emptiness of the postmodern sublime is an insidious sweet addiction. It is an opiate, and yet I can feel misgivings prickling through my anesthesia. These empty churches and oceans are soothing me, helping me to forget something, something that might cause me real pain. ("Gegen das Erhabene," in *Das Erhabene in Wissenschaft und Kunst*, 2010.)

47 First example: noctilucent clouds. These are not ordinary cirrus clouds, or even the opalescent nacreous clouds that sometime shine at twilight, but a nocturnal phenomenon. They appear around the time of the summer solstice, in the night sky, a half-hour after sunset. They are deep pearly blue, with faint streaks of burnt brown, pink, and yellow. Some look like thin strands of raw silk. (www.kersland.plus.com) In this photograph, taken by a German photographer, noctilucent clouds encircle the earth in a diaphanous web. It's as if the earth were an egg cradled in an enormous bird's nest.

When I was young noctilucent clouds were considered to be very rare, because they were mostly seen in the Arctic. Now people see them in places like Colorado, New England, Scotland, and northern Europe. It is possible that they are migrating south because the ozone in the air is getting thinner. In that case they would be a genuine portent, a sign that the Earth is falling apart. Another theory has it that some noctilucent clouds are frozen water vapor expelled from the US Space Shuttle. Either way their origins are obscure. They are far higher than other clouds, so they glow long after sunset; they are a last remnant of the day in the night: impeccably sublime whatever they mean and wherever they come from.

"as if the earth were an egg cradled in an enormous bird's nest"

Wolfgang Hamburg, Noctilucent Clouds, Bernitt, Germany. 2001.

"I can't keep my mind on what the photograph is giving me"

WOLFGANG HAMBURG, NOCTILUCENT CLOUDS, BERNITT, GERMANY, DETAIL. 2001.

 Noctilucent clouds have a frail, threaded appearance, like a thin fabric waving in the breeze, and in videos they flutter and ripple. This photograph has hundreds of these threads or skeins, flowing and weaving together. It is a high resolution panoramic image, and there is an endlessness about it.

I would like to call this the world's on-and-on, following Thomas Weiskel, the best theorist of the sublime. (*The Romantic Sublime: Studies in the Structure and Psychology of Transcendence.*) For him, the image of this endlessness is the wasteland, a place that continues forever, at least in imagination, and has no features, boundary, or orientation. T. S. Eliot has a wonderful phrase for this: in *The Waste Land*, he uses the German phrase *Öd und Leer das Meer*, meaning, more or less, "the sea is bleak, desolate and empty," although the English lacks the hollow reverberation of the German words. This photograph of clouds is another wasteland, a look far up into frozen space. Clouds have always been sublime, and noctilucent clouds raise that romanticism to a very high power. (www.cloudappreciationsociety.org)

Yet this talk of sublimity and the wasteland is moving me away from the photograph. What is actually in this photograph? Just the on-and-on, not the poetry or theory that it conjures. Just these faintly bluish or rosy threads—hundreds, maybe thousands of them, too many to see. I take in the silhouettes of trees in their full summer foliage, and I notice how the threads gather and rise into waves, especially on the right of the picture. But I can't keep my mind on what the photograph is giving me, because it's giving me too much—too many frail woven waves, too much senseless detail. I find myself sailing listlessly on this frozen ocean of dark peach-colored threads. It is easy, a relief really, to gather the threads into a story about the ozone layer, or bundle them into the usual basket of the sublime. It is easier to think in metaphors, analogies, and stories. There are many of these images on the internet, as for the people who collect them it is easy and fun to study the technical requirements of high-resolution panoramic night photography. Anything, I'd say, rather than pay attention to those faint braided threads. All they do is go on, and on.

"the water in the Worm Hole is being sucked slowly down into the cave and out to the ocean"

 Second example: on the seacoast of Inishmore, an island off the Irish coast, there is a place where the rocky seacoast has eroded, naturally but inexplicably, into a perfectly rectangular pool. It is called in the Irish language the "Pol na bPeist," meaning Worm Hole. Tourism overwhelms the island in the summer months, and the Worm Hole is a bit out of the way: it is a place where visitors can escape from the usual itinerary of Neolithic ruins, pubs, and Aran Island sweater shops. It is a bit of a mystery how the Worm Hole happened. It is a hundred feet from the sea, and a submerged cave at the bottom of the Worm Hole connects it with the ocean, letting water in and out with the tides. The rock-cut rectangle with its hidden drain are uncanny, and people have said the Worm Hole must have been fabricated.

My sister took this photo; on the afternoon she visited, sea foam was forming a textbook image of a galaxy on the water's surface. The tide was going out, and the water in the Worm Hole was being sucked slowly down into the cave and out to the ocean. I once swam in the Worm Hole, and saw a glow underwater, where light filtered in from the ocean through the submerged cave. The Worm Hole is more like a tomb than a swimming pool. My only companions on that swim were two globe-shaped purple jellyfish.

The Worm Hole can be a sublime place to visit. I could say the photograph is sublime on account of the beautiful spiral of foam, silently spinning in the perfect rectangular pool. But I have visited the Worm Hole three times, and I have seen many photographs and videos of it, so I am a bit tired of obvious and melodramatic things like vortices and crashing waves.

The Worm Hole itself is mysterious and deep, and its surface is never wholly still. Perhaps a bottomless depth and an inexplicable geometry are enough for a photograph to express the sublime. In thinking that way I am following in the path of contemporary photographers from Roni Horn to Alan Cohen and Hiroshi Sugimoto: I am refusing the dramatic and theatrical (the booming old-fashioned sublime), and opting for the ordinary and unremarkable, in search of meanings that can still speak to me. Horn's photographs called *Some Thames* show nothing but swirling currents of water. Cohen's photographs of the rippling ocean surface at the

Equator may capture currents colliding, or they may show nothing but meaningless waves. Sugimoto's ocean views are excerpts from vast oceanscapes. His pictures avoid anything dramatic, including even contrasts of sky and ocean. (That rigorous quiet escapes some of his admirers, as you can see by looking at the more theatrical photos in the Flickr group called "Seascapes After Sugimoto.")

50 Tired of the dramatic sublime, I look at the photograph again, in search of quieter things. I notice a rectilinear fracture at the lower right, which looks decidedly man-made. I see the small pools of water nearby. These fractures and pools might be the simple beginnings of the next Pol na bPeist. The original print is in color, but it is mainly sandy gray, with one spot of brighter color: a small pool of mixed salt and rainwater at the lip of the Worm Hole, at the lower left, where the greenish black water is ringed by bright green algae.

I am tempted to say this little pool with its liminal stain, together with the right-angle fracture, are the most affecting parts of the image. They are overlooked details, miniatures of the thundering profundity of the Pol na bPeist. The evaporating pool and the drawn-looking crack could be signs of the "re-enchantment of the world," a phrase that has been used since Max Weber to name the way transcendence seems to exist quietly and tentatively, far from the trumpets of religion or the heavy machinery of symbolism. The art world has long been attuned to this subtle re-enchantment. (*The Strange Place of Religion in Contemporary Art.*) If I crop my sister's photograph, and print only the little pool and the depths of the Worm Hole beyond it, then my image resembles any number of fine art photographs. It has echoes of Sugimoto's blurred photos, R. H. Quaytman's silkscreened out-of-focus images, Roni Horne's blurred faces, P. Elaine Sharpe's blurred records of famous places, and many other intentionally unfocused images. Focus itself, along with defocus, blur, unsharpness, smearing, and Gaussian filtering, have become themes in the history and criticism of photography, and the blur of this detail brings it into that pool of ideas. (*Six Stories*

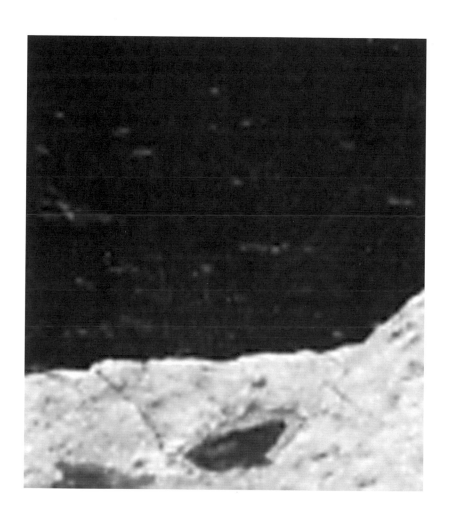

"an overlooked pool, transitory, never to be seen again"

LINDY ELKINS-TANTON, THE WORM HOLE, INISHMORE, IRELAND, DETAIL. 1994.

from the End of Representation, chapter 2; Mirjam Brusius, "Impreciseness in Julia Margaret Cameron's Portrait Photographs," *History of Photography*.) The little pool becomes, suddenly, much more interesting: at first I had overlooked it, and now it rescues an image that had become too familiar.

Barthes's punctum is not far away here, because the punctum is also about the intense and personal wonder of overlooked details. *Camera Lucida* itself is suffused with half-hidden religious meaning. The original French edition had a passage on the back cover taken from the Tibetan Buddhist Chögyam Trungpa. "Marpa was very upset when his son was killed," we read, "and one of his disciples said, 'You used to tell us that everything is an illusion. How about the death of your son? Isn't it an illusion?' And Marpa replied, 'True, but my son's death is a super-illusion.'" Jay Prosser calls this "Buddha Barthes." (*Literature and Theology*, 2004; *Photography Degree Zero*.) Barthes keeps silent about his reasons for choosing this passage, and in the book he speaks of the punctum in exclusively secular terms. But I suspect the punctum itself comes from the medieval Christian doctrine of "compunctive tears," which are tears that pierce you: they come from Jesus's suffering, and you owe them to him in return. They puncture you when you receive them, and again when you let them return to their source. I wonder if Barthes didn't have compunctive tears in mind as he wrote about his apparently secular punctum. Both the punctum and the Buddhist story move through the transcendental air that the book wants to breathe.

Camera Lucida is soaked in theological meanings, to paraphrase a comment Walter Benjamin made about his own work, but tacit religion is not the key to the book precisely because it is tacit. I am no longer attracted, as I once was, by photographs that show me overlooked details: they do not seem to re-enchant the world, and they don't prick me with their poignance. They are just the dregs of the sublime, the last feeble hopes that something in the stuff we see has meaning.

In black and white, my sister's photograph is a collection of eroded rock shapes, and it is mainly about staining, spills and "varnish," as in O'Sullivan's and Klett's photographs. I am almost unable to look at the dark rocks on the top half of the cliff face. They are too intricate, too ordinary. They fail to reward me with a story

or a subject that can help my eye escape. And that is why I want to look at them more than at the fabulous Worm Hole with its resident galaxy, or even at the enchanting but unconvincing little tide pool and its companion cracks in the rock.

 Third example: on the day I discovered the selenite window, I also looked through the Natural History Museum's files of an expedition to South America, led by the ornithologist Frank Chapman. He wrote a book and several articles about his findings, and deposited the remaining photographs in the archives of the museum, where he was Curator of Ornithology. There are several hundred pictures in the file that are not labeled, presumably because Chapman didn't think they were important. Most are pictures of unidentified ports and market towns in Chile. There are also photographs of local weaving and pottery. Leafing through those, not sure what I might find, I came across a picture of a bare hillside.

It seemed deserted except for a small tree near the top. I was attracted by the emptiness, which I thought must be a good reflection of the ordinary landscape in that part of southern Chile, just west of Tierra del Fuego. When I turned the photograph over, I was surprised to read the following, written in a neat florid script: "Darwin's Rhea, near Punta Arenas." I flipped the photograph over and looked again, and saw what I had taken to be a minuscule tree was actually a rhea, a large flightless bird. I suppose that was as close as Chapman ever got to one, and it was rare enough to warrant a photograph even though the photo had almost no value. Darwin had seen small rheas on his famous voyage; they are different from the better-known larger rhea that lives throughout Argentina. From Darwin's time to Chapman's, few Europeans had observed the smaller species of rhea. People must have wondered if they were going to become extinct, like the bluish-gray dodo in Mauritius, or the eleven species of moa in New Zealand. Today Darwin's rhea is not quite on the endangered list; it is currently classified as NT, "near threatened."

*"the unnamed frozen foothills of the Brunswick Peninsula,
just across the windy Magellan Strait from Tierra del Fuego"*

ANONYMOUS PHOTOGRAPHER, DARWIN'S RHEA, NEAR PUNTA ARENAS, CHILE. C. 1924.

What a lovely picture, I thought: Darwin's rhea, *Pterocnemia pennata pennata*, on its bare hill, giving the far-off photographer a last look before it makes one of its typical "sail-turns," raising one wing to catch the wind, whirling suddenly and running out of sight down the far slope and into the unnamed frozen foothills of the Brunswick Peninsula, just across the windy Magellan Strait from Tierra del Fuego. So sublime, especially because the rare bird is vanishing into an Antarctic desert (another trope of the sublime, as Weiskel notes).

 But then again, the picture only exists because the rhea is in it, and the rhea isn't in it enough to make the picture important, either for Chapman or for the curators of the Museum of Natural History. When I look more closely, the bird's body is like an eye, floating above the horizon, and there is only the faintest blur of neck, head, and legs.

When the subject vanishes, what is left? Grains of striated rock, a featureless sky, five or six careless ink marks, some mottled white UFOs caused by chemical bleaching, fading around the edges from inadequate fixing of the print, a hail of dark grains superimposed on the rocks, the photogram of a stray hair. Some photographers are entranced by such things. They certainly enrich the surface, making the photograph more aesthetic, precious, old, and even sublime. But scratches and dirt don't hold my attention for long. After a while I just don't want to see any more fading, bleaching, fingerprints, or grains. (I no longer enjoy the intentional antiquing in photographs by Joel-Peter Witkin, Sally Mann, Doug and Mike Starn. They signal preciousness too stridently.)

This is photography at its most empty, its subject nearly vanished, its inventory reduced to blurred rubble and the transient interest of unintentional flaws.

"When the subject vanishes, what is left?"

ANONYMOUS PHOTOGRAPHER, DARWIN'S RHEA, NEAR PUNTA ARENAS, CHILE. C. 1924.

 Around the edges of every photograph, on each side of the thing that is named in the photograph's title, that thing at which the camera was putatively pointed, is a seeping cessation of meaning.

If I picture Barthes's Winter Garden photograph—as good an exemplar of vernacular photography as any, especially since it now may exist only in the collective imagination of Barthes's readers— I can see his mother's face. At first, her face has "distinctness," and an expression of innocence, but later in the book he says it is "vague, faded." (pp. 69, 99) If I take my eyes off that face, and look instead at the things crowded around it, then I see almost nothing, because Barthes doesn't give me anything to imagine. A bit of railing on a wooden bridge; his mother "holding one finger in the other hand, as children often do"; a plant or two. (Barthes says just "the palms.") There is little else in *Camera Lucida* to help me see that photograph. That is not strange, because for Barthes the Winter Garden photograph cannot be shared: but at a deeper level, it's not strange because for Barthes photographs conjure people's lives and little more. He did not need to tell us anything about the shapes of the leaves of the plants in the conservatory, or the dust and droplets on the glass-house windows, or the dirt on the raised plank floor.

If I perform this same exercise with a family snapshot, one I actually hold in my hands, then I become aware of the stains that photography wants me to see. At once I notice that half-occluded piece of furniture, that mess of foliage outside the window, that overexposed glare on a high-gloss wall, that dirty switch plate, that bit of baseboard. Things like those are the scrap heap that signify "home." Outdoor versions of them signify "vacation." They are parts of the environment, the setting, the place—they are the particulate matter of the world that sustained the people whom the photographer cared enough to photograph.

The photograph was intended to pluck its subject out of the distracting matrix in which we are all, in fact, embedded. There is no name for those nearly unseeable pieces and forms, shapes and parts. They are things to which my thought will not adhere. They are the on-and-on of the world, its apparently unending supply of often dull and sometimes uninterpretable stuff. All photographs are packed with this stuff, and it is obdurate and indifferent to the

interests of popular and commercial photography. Professional photographers have only weak tools to cut the clutter and clean away the unending uninteresting fragments of the world: they can place their subjects in photography studios, against texture-free backdrops; or they can use alpha filters to delete everything around the subject, returning their people to the imaginative vacuum in which they prefer to be remembered. Irving Penn was good at blank backdrops, and so was Richard Avedon. The photographer Platon Antoniou, heir apparent to Avedon in US media such as *Time* and *The New Yorker*, uses gradient filters to put a bright halo around his subjects' heads. The effect is sanitizing and sanctifying, as if to say: Even a flat matte background is not enough to show how important this person is. Alternately, photographers can ramp up the clutter, building the marginal objects into an entire inventory of a place or a way of life. That route leads to journalism and to the packaged armchair tourism of *National Geographic*.

54 The half-visible stuff that surrounds the objects of photography is often cut by the frame, or by the person being photographed. Truncated objects, forever incomplete, can thrive in our peripheral vision like an infestation. They can be distracting, ill-behaved, even unsettling. At the extreme they can even be labile, obscene, and hallucinatory, as if they have lives of their own. They then become what the surrealist Georges Bataille called part-objects. A large literature, infused with psychoanalysis, has grow up around surrealism and photography. It can be interesting, but I won't be pursuing it here. Surrealism is, for me, as exhausted as the ordinary bourgeois life that seemed to call it into existence in the first place. (I can't agree with Susan Sontag that surrealism lies "at the heart of the photographic.") It's important not to forget that most of the things that fill my peripheral vision as I look at the person who centers the photograph are not that interesting. They resist interpretation not only because they are hard to make out, or because they aren't the point of the photograph, or because they have no stories to go with them, or because they are

oddly hallucinatory or provocative, but mainly and simply because they are boring: they are only available to be seen because photography has placed them there. That is why this isn't a surrealist reading. (Perhaps some surrealists needed the world to be something jarring "like a spider, or spit," as Bataille said, because it so often is less than that.)

Every once in a while a cluttered corner will start to seethe with meaning, a shadow will seem to move slyly across the floor, or some strange illegible thing will catch my eye and make me jump: but much more often it is a strain just to keep looking at the utterly unpromising and unrewarding things that dumbly inhabit photographs. Boredom interests me, and interest bores me, because boredom is what the camera continuously threatens.

I recall Maxim Gorky's reaction to a screening of one of the first motion pictures, a film by the Lumière brothers:

> This mute, grey life finally begins to disturb and depress you. It seems as though it carries a warning, fraught with a vague but sinister meaning that makes your heart grow faint. You are forgetting where you are. Strange imaginings invade your mind and your consciousness begins to wane and grow dim.

Walter Benjamin also pondered the numbing effect of film, and identified another kind of threat: film, he said, creates a percussive shock to the consciousness by continuously changing scenes: "I can no longer think what I want to think," he writes.

> My thoughts have been replaced by moving images. The spectator's process of association in view of these images is indeed interrupted by their constant, sudden change. This constitutes the shock effect of film, which, like all shocks, should be cushioned by heightened presence of mind.
>
> ("The Work of Art," in *Illuminations*, 238)

The theorist Melinda Szakoly, who reminded me of this passage, also tells me that Gilles Deleuze, Georges Duhamel, and Antonin Artaud had similar thoughts. In the overwhelming popular victory of film

over other media, this strain of anxious resistance has been lost. I want to recall it, and note that the same applies to photography, but in a more sinister form. Because the "frame" never changes, and the photograph remains compliantly in front of my eyes, I feel I am still in control of my gaze and my thought. I don't sense the "powerlessness at the heart of thought," as Deleuze puts it. (*Cinema, 2,* 166.) And yet I am also hypnotized: my consciousness has waned without my noticing. I am unaware of the masses of things, the on-and-on of things, that I am permitting myself not to see. They are loud in my eye but inaudible to my ear, insistent but meaningless, rebarbatively present and yet numbly absent. I do not remember how to see (*amnesia*). I refuse to remember to see (*amnesis*) until afterward, when I am no longer looking—perhaps when I am writing about looking—because it is only then that I remember I have once again failed to see (*ecmnesia*). (That last word is one of Barthes's, meaning a lapse in the memory of recent events, and a recovery of more distant ones. It seems I must always have been able to see photographs, but when? Sometime in the past.) My sense of my power to see, my conviction that I am seeing the photograph, depends on my obliviousness to what the photograph continuously insists on presenting to me.

55 The concepts I am developing here—the on-and-on, boredom, amnesis—work outside the closed system of punctum and studium. For any given viewer, they can be either. But it doesn't matter. What matters is the usual state of photography, which means those many photographs that don't particularly work, that fail to sting our inner thoughts, that don't help us preserve our treasured memories, don't offer any useful information, and aren't especially edifying, noteworthy, curious, disturbing, cute, awe-inspiring, kitschy, skillful, delightful, or entertaining.

The famous photographs that we use to mark our passage through the social and political world we live in (such as the two photographs known as *James Watson and Francis Crick with their DNA Model at*

the Cavendish Laboratories in 1953, Joe Rosenthal's *Raising the Flag on Iwo Jima*, or Kevin Carter's untitled photo of the starving child in the Sudan) are the tiniest minority of all photographs. (*The Photography Book*, Phaidon.) Photography also fills the family albums, magazines, and art galleries of the world, but even those pictures are the rare exceptions in relation to the total number of photographs. It is important not to forget the billions of photographs that aren't saved or printed. They are the population of photography, just as a count of living things shows bacteria are incomprehensibly more numerous than the kind of life we end up noticing. (William Whitman, "Prokaryotes: The Unseen Majority," *PNAS*, 1998.)

Four

A Drop of Water, World Trade Center Dust

56 I propose to pay attention to some things that photography shows us. We show photography what to show us, we feel we see what photography shows us in the faces and things that it shows us. But photography also always shows us things we would have preferred not to see, or don't want to see, don't know how to see, or don't know how to acknowledge seeing.

In this book the quality of my attention and the languages in which I can articulate my responses vary, but they will not cross into regions ruled by the sublime, affect, "the pangs of love" or pity, "madness," or—this was Barthes's final thought in *Camera Lucida*, faintly echoing Bataille—"photographic *ecstasy*." (pp. 116, 119) Photographs that concern me do not usually harbor any particular punctum: no local, "intense mutation of my interest"; no "fulguration"; no "tiny shock"; no "*satori*"; no "explosion" that "makes a little star" on the image. (p. 49) That is all just so romantic, or more accurately late romantic, leftover romantic. It's stale stuff. Romanticism was once an ocean of metaphors of excess; in *Camera Lucida* the ocean has dwindled to rivulets. Barthes's little ecstasy, the punctum, is like the last remaining pinhole of access to the light within photography. He knows it is small: it is a tiny satori, sparkling like a "little star." Yet nothing matters except that pinprick, that last little death.

The images I want to look at are not as absorptive, dramatic, or theatrical. Mainly, they are just hard to see. Some are violent or unpleasant, and they repel my attempts to look at them. Others are hard in the sense of obdurate: they resist my intention to look, and even my interest in trying. They are "merely" informational, "simply" not beautiful, "wholly" uninteresting. With such images it can be hard just to pay attention, to keep my eyes on the photograph, to focus my faltering interest on the unpromising image.

These hardnesses I am after are neither precious nor rare. Most any photograph has some hardness, something that turns the eye away, and if we choose not to notice, it is because we are looking so intently for the last plangent signs of "love" or "madness." ("Plangent": a word Nabokov knew was both rare and excessive; it is the name of a "fundamentally hysterical" chord played on a piano at the end of *Lolita*, to point up the player's exquisitely desperate,

pitiful and kitschy dying speech.) Little punctures and shocks of all sorts help distract us from photography's routine hardnesses. If you take the punctum away, or if you take away the desire for it, you can see most photographs for what they also are: things that are flat and hard, and don't promise much pleasure at all.

57 So here I am, at the boundary of what photographs are too often taken to be, looking outward, in the direction away from all these things—ecstasy, the sublime, the punctum, memory, history, race, gender, identity, death, nostalgia. This is a good time to say goodbye to photographs of people.

What would it be like, I wonder, to go through the photographs I own—the ones I have framed, the ones in my photo books and cabinets and the ones on my computer, the ones in the books and magazines in my home and my office—discarding all the images that have people in them? Which would be easiest to relinquish? Which ones would be so close to me that I couldn't bear to give them up? I imagine this as a series of farewells, and I am curious to see what will be left of photography when all the people are finally gone.

58 First farewell: unlabeled family photographs. Maybe it is prudent to start with images of unidentified people, the kind that are so easy to find in any antique store or box of old photographs. They can be quite striking and poignant. ("Poignant": meaning something that prickles, from *poindre*, "to prick or sting," from *pungere*, "to prick." So like the punctum.)

It's strange that so many photographs of people I have never known can be poignant. In an antique store I come across an old photograph of a man wearing a box-back shirt and a stetson hat. He looks at the camera (at me) with a smirk, overconfident and

standoffish. Did he suspect that generations later his unlabeled photograph would become the object of a sudden and intense but transient fascination? That his real life, which he owned, would become poignant when all its details were long forgotten? *He is already dead*, she is already dead, he is going to die, we say over and over to ourselves as we shuffle through old photographs in the back of an antique store, vaguely searching for one that has more than the usual background radiation of poignance. Yet the curious man was not unknown to himself, any more or less than any of us are unknown to ourselves, and his image was presumably not much of a mystery to his relatives, so the affecting *he-is-going-to-die* reaction is not only indulgent solipsism but adventitious voyeurism. That did not bother Barthes, but as I join him in peering at little Ernest I feel a little pang of guilt: I am peeping through a keyhole little Ernest could never have seen.

It is not a hardship to say goodbye to unlabeled family photographs, with their low-level pathos. When I encounter them in antique stores or flea markets, I find them only marginally more interesting than the endless tightly packed cardboard boxes of old postcards, or the glass-top table displays of heirloom watches, war medals, election campaign pins, lost buttons, and multipurpose folding knives. When I catch myself shuffling through a tray of tintypes, it is usually because I am in the mood for a very weak, homeopathic dose of poignant nostalgia, or because I have nothing better to do than look around for some hidden gem that I never quite seem to find.

59 Second farewell: "found photography."

(There are so many kinds of photographs of people. "Found photography" is subtly different from "vernacular photography," or "everyday photography," meaning the whole worldwide practice of family picture-taking, mainly of people, but also of the places they have been. "Travel and vacation photos, family snapshots, photos of friends, class portraits, identification photographs, and photo-booth images," is

how Wikipedia succinctly defines vernacular photography. [At least as of August, 2010.] By that definition, the man in the stetson would be a vernacular photograph, although it could also be counted as an example of professional portrait photography. "Found photography" usually means vernacular photos that have been discovered and reconsidered as art. Vernacular photography practiced in the past hundred years or so, mainly in cities, is also called "street photography." All of these overlapping categories are distinct from the monumentally scaled "fine art photography" that stormed the art market in the 1990s, although the artists themselves refer to vernacular, street, everyday, family, portrait, and found photography. I am only listing things this way to help me with my farewells.)

To help me give up found photography, I bought a packet of unidentified snapshots from eBay. Because I selected them, and brought them into this book, they are "found photography": they aren't quite art, but they are also no longer what they once were. They chronicle a family, whose name has been lost, through two or three generations of lower-middle-class life in what appears to be a cold part of North America. Before I bought them, when they were languishing alongside the 60,000 other photographs then on eBay, they were the very stuff of vernacular photography. They draw me, with an infirm but nearly irresistible force, into a imagined world.

Here is a diffident-looking woman, standing in a small patch of sunlight at the back of her bungalow.

Here is a middle-aged couple, photographed June 4, 1944, at the side of their house. (The date is written rather carelessly on the back.) He has told a joke, or said something endearing, and she is smiling, and pulling back slightly. The summer awnings are out.

Here is a young man leaning against a tree. He may be smoking. He is jaunty and a little aggressive: the photographer has stood well back. An iron rod has been driven into the ground in front of him.

Here is a young woman, in a lovely gesture of happiness or embarrassment. She stands stiffly at the corner of a manicured lawn, across from a school or factory. It is the 1940s, as I can tell from the cars in the far background. It's hard to see much, because the print is so small. (I am reproducing these about the size of the originals. They were mementos, and size matters.)

Here is what was probably their town, several storefronts around a cold lake scattered with ducks. A low winter sun casts the long shadow of a power line across a patch of bare ground.

Here is a tiny photograph (the original is one inch in height) of two men walking away from us, down a sidewalk. One has his hands clasped behind his back. Again the long shadows of the winter afternoon. The image was made with the cheapest of box cameras, and it is blurred around the edges. It must have been very precious: I imagine it as the only image of one of the men, the only picture of their life back then.

And here is a rock. It is in a well-traveled place, as I can tell from the tamped-down earth. But now there is no way to know why it was worth a photograph. I only know that it must have been meaningful to someone in the other photographs, or someone who owned them.

These, and a dozen more, came from one person's collection, as I know because people and places recur in several images. The photos have lost the contexts that gave them value. And yet they have a pull on my imagination: the weak, persistent tug that comes from any picture of any person, made ever so slightly stronger by the knowledge that these people have been forgotten. Pictures like these don't always sell on eBay, but many do, because there is a sizable market for other images of other people's lives.

There is no easy way to stop this kind of reverie, no patch to staunch the floods of false nostalgia for people and places I don't even know. Sympathy and curiosity well up in me. I want to reproduce all thirty-odd pictures in the packet, and begin to piece these people's lives together. If I were a novelist I might work the pictures into a story. The same thing happens with fabricated collections, like Zoe Leonard's *Fae Richards Photo Archive*. It hardly seems to matter what's real and what isn't. My interest is nothing more than an illness, a voyeurism, an apparently idle but adhesive concern with other people's lives: a specific sickness brought on by photography.

I see these people's lives as if they are covered with an old veil: they feel dank. Nostalgia itself is stale, and this is second-hand nostalgia. A breath of someone else's life, breathed out into my mouth.

 Third farewell: street photography. Farewell to all the photographs of street life, from Daguerre to Alfred Eisenstadt, Brassaï to Beat Streuli. From the more-or-less spontaneous, like Robert Frank's *The Americans*, to the somewhat staged, like Ruth Orkin's *American Girl in Italy*, to the completely contrived, like Robert Doisneau's *Kiss by the Hôtel de Ville*.

This is two farewells, really. One is to the cliché that a street photographer can find the perfect instant. (Always the example is Henri Cartier-Bresson.) The other is to the cliché that a street photographer can find a type—a person, place or institution—and capture it once and for all.

Is there such a thing as a perfect instant, a moment when the randomness of ordinary life becomes a transitory *tableau*? To be successful, the composition of a street photograph has to possess a kind of insouciant imperfection, the token of reality and photography. Street photography like Cartier-Bresson's depends on an interest in spontaneous gestures and "the precise organization of forms" in passing configurations, but I know those apparently spontaneous instants can never be anything more than examples of ideas I already have concerning spontaneity. Otherwise how would I recognize them as spontaneous? (Cartier-Bresson, *The Decisive Moment*.) I admit that Cartier-Bresson sometimes surprises me with new sorts of parallax, disorder, asymmetry, poise, imperfection, coincidence, and juxtaposition: but what are all these little *trouvailles* except confirmation that the world's hidden beauty takes the form of clever compositions? If that is all photography is, then I don't need to see it more than once or twice a year.

The second cliché of street photography is that it takes special skill to find a type or a kind of person, place, or situation. Partly that's true, but it is not always the case that what is found is interesting: a type is, after all, close to a stereotype or cliché. In August Sander and Emil Mayer I can understand I'm seeing types that no longer exist. In Weegee I see types that I recognize from the movies. In Streuli I see types I know from television and magazines. Street photography like Sander's depends on a desire for types and social roles, but I know those apparently typical people can never be anything more than instances of ideas I already have concerning what was once typical, or what may now be typical. Sometimes Sander or Streuli show me types that I hadn't realized existed in quite those ways, and so they help me along in my sense of how my society, and other societies, were structured. But if that is what photography is, it is not very powerful or interesting.

In those two ways I can give up street photography, more easily than I thought I might.

61 Fourth farewell: international fine art figure photography, by people like Struth, Wall, Ruff, Dijkstra, Catherine Opie, Gregory Crewdson, and Evelyn Hofer. It is hard, in a different way, to give up photographs of people when those photographs are intended as art, and—let's say—do a fairly good job of being convincing artworks. Then the machinery of art theory and art history roll into place, confusing and silencing my own reactions. That machinery is loud and coercive, not unlike the "shock" effects Barthes so disliked: art historical claims on the photo's significance remove much of my freedom to see what I might want to see. Michael Fried's formidable propulsive arguments echo in my mind as I look at Ruff's blank-faced sitters (supposedly connected to themes of "facingness" from the Manet of the 1860s) and Dijkstra's self-conscious models (supposedly they work in the gap between awareness of the camera and awareness of themselves, re-energizing the "antitheatrical tradition"). (Fried, *Why Photography Matters As Art As Never Before*; "Michael Fried's Modernist Theory of Photography," *History of Photography*, 2010.)

But for me, art historical references can't save the day. They do not always persuade me of the work's significance, and they are often old fashioned. Jeff Wall's elaborate staged street scenes, beginning with *Mimic* in 1982, are homages to street photography and to the history of painting. They reveal an erudite and scholarly devotion to the past, beyond anything any previous photographer has managed. (Some of Wall's essays could have gotten him tenure as a professor of art history, even without his photographic practice.) Wall works very hard to achieve a simulacrum of the photographic instant and fuse it with the impacted thought and micro-management of nineteenth-century French painting. *Mimic*, and his other posed and composed scenes, are minutely staged facsimiles of spontaneity, achieved as if he were a painter. (It was a virtue, I think, that Cartier-Bresson was an indifferent draftsman, and did not really have a sense of drawn composition, because that lack led him to choose compositions that are weak from a painterly point of view. And does it matter that Barthes's own paintings are all-over patterns, with no eccentric details to discover?—*Roland Barthes: Intermezzo*, edited by Achile Bonito Oliva.) I love Wall's perverse artificiality as much as anyone, but why is it interesting to

emulate the values of nineteenth-century painting in the twenty-first century? Why make art that draws on art historical scholarship written in the 1970s and 1980s on the subject of French painting of the 1860s and 1870s? In some thoughtful essays, Wall argues that photography has needed to remember it is a naturalistic art, and therefore not a good fit for conceptualism or minimalism, but that does not justify the exact practices he adopts. The photographs seem to be on an elaborate life-support system, intravenously fed by pure streams of academic art history.

(I find Thomas Demand's practice much stronger because it does not need that life-support system—and, not coincidentally, it does not need people. I would have a hard time giving up Demand's photographs, and luckily I don't need to because they depict only paper. If this book were only about contemporary fine art photography, Demand would loom large in it.)

62 I'm imagining that these last few pages may seem especially irritating or perverse. What I have just written may not be convincing to people who care about contemporary figural fine art photography. I know that given the interest of curators and critics around the world, rejecting Wall, Struth, Streuli, Ruff, Crewdson, and the others is the sheerest nonsense. These photographers' works can be mesmerizing, especially when they are printed or projected the size of an airplane hangar wall. But as photographs, printed at photo-album scale, they can also be unconvincing. Andreas Gursky's photographs nearly disappear in Fried's book: they become simple patterns, less interesting than the fiercely focused prose that surrounds them. Printed at colossal, imperial scale, the same photographs produce a kind of contented stupefaction that is dangerously close to the hypnotic unthinking absorption Fried complains about in film.

The large-scale photography that was popular in the 1990s and 2000s emulates the exact traits of cinema that concerned Gorky, and that modernists reviled: when you see the white screen, you are seen

by a vampire, and your blood drains out without your noticing it. You become white like the screen, helpless, and you do not think, as Fried hopes: you tend to just hang there, almost motionless and nearly thoughtless. (*Photography Degree Zero*, 179–81.)

Fried asks his readers to please come up with "superior" arguments to his own. My own response in these pages won't cut it, because all I want to say is that for me, the fine art superstars produce work that mainly fails to compel conviction. The new work depends too much on art historical values (that is why it is so attractive to art historians and curators: it comes practically pre-interpreted); it mines the late nineteenth century, as if modernism had never happened (Dijkstra's work continues John Singer Sargent's kind of virtuosity, and Wall continues Manet, just as Mapplethorpe continued fin-de-siècle erotica); and it depends on scale to pith its viewers. It is ephemeral art, except where it is obsessively artificial.

 For another few moments, I linger over these kinds of photography that depend on figures, floating in the languorous thoughts about people I don't know, thinking of W. S. Merwin's poem about a photograph of his mother: "I open an old picture of you," he writes,

> one photograph found after you died
> of you at twenty
> beautiful in a way
> I would never see
> for that was nine years
> before I was born
> but the picture has
> faded suddenly
> spots have marred it
> maybe it is past repair
> I have only what I remember

With these photographs, I don't even have what I remember. I have only the thought that if I were to feel something for the people in these photographs, it would be photography that had helped me to think I had remembered. ("A Likeness" from *The Shadow of Sirius*.)

Echoes of Barthes: Merwin is also writing about a photograph of his mother that he does not reproduce, and his photograph also conjures a time when his mother was young, a time he never knew; but Merwin's photograph is "past repair." He relinquishes it, and his memory (not, as I read it, his memory of the photograph, but of his mother in later years) is all that remains. And what is that memory? We are not told.

64 Final farewell: photographs of my own family. I had thought this would be the most difficult thing to give up, and in truth I have not discarded my collection of family photographs. But I no longer look at them. I have been writing this book, on and off, for five years, and in the course of that time—but not while I was actively writing—both my parents have died. In the months after my father's death I went through the family's collection of several thousand photographs. I scanned negatives and color slides, digitally removing dust, restoring the color balance, adjusting the white point, saving the results as Photoshop files with layers: doing all the things that archivists do to preserve aging photographs. (Katrin Eismann, *Adobe Photoshop Restoration and Retouching*.) That process took several months, and in the course of it I reviewed the long arc of my parents' lives from the 1920s to the 1950s, and the lives of the people in my family from mid-century to the recent past. It was a work of mourning, and I was nourished by the sheer size of the task and the technical exactitude it required. Although there were many moments when I was struck by certain images—I would sometimes show them to my mother, who was already ill, and ask her if she remembered scenes or people—most of the work was not about seeing or memory. It was about not seeing: I registered the technical requirements of each image, and I focused on filters, resolution,

grayscale curves, and color balance more than on faces and places from the past. By optimizing each image, and training my eye to scan for technical issues rather than emotional ones, I produced a massive archive of images that had somehow been systematically and carefully seen, and therefore did not need to be seen again. They had at least been looked at in passing, with an eye to preserving the sum total of my own life and the lives of my parents and grandparents and all the places they had lived, but preserving them in such a way that the photographs could, in some unforeseeable future, be seen carefully and fully but also calmly, more as a reliable and exhaustive encyclopedia of remaining evidence than as a mine field of piercing emotions. I made the archive in order to plunge myself into the past without reserve, but at the same time I needed the technical apparatus of photography to help preserve me from the rawness of some images. Once I had scanned the last few prints, dating from just months before my father had died, I was finished. The past was classified and controlled, meticulously and permanently preserved—salted away for some future in which I imagined myself to have forgotten the images, or to be in sudden need of them: and in that future, I dimly pictured myself using the archive to open myself to experiences that might be intense and painful, but which, in some corner of my mind, I knew probably would not be, because each potentially destructive image would be protected by a shield of technical manipulations that would distract me from anything that could be genuinely hurtful.

The archive was complete about a year and a half ago, at the dining room table of the house in which I had grown up, adjacent to the room in which my mother, increasingly ill and with only a few months left to live, sat at her computer or watched television. I knew, as I packed up the last boxes of negatives and prints, and turned off and unplugged the scanner, that I would not need to return to those photographs.

65 In my unseen archive, which I am not opening again to write these pages, there are a few photographs that I feel I would not want to erase, even if I don't feel the need to see them again. And, in a curious parallel with both Barthes and Merwin, the photographs that stand out in that regard are the ones of family members taken before I was born.

There is a picture of my father from 1927, when he was three. The original print, which is now gone, was about the size of the photographs of the unidentified family I bought on eBay. (People tend to forget how small prints were in the 1920s and 1930s.) In the high-resolution scan, filling my thirty-inch computer screen, it is full of detail. The little boy who would grow up to be my father wears a baby t-shirt that says LIFE GUARD, and he stands like a little pugilist on Coney Island beach. Flappers walk by in the background, wearing dark pumps and white caps in the summer sun. I don't recognize my father, but it is enough to know it is him. The picture's value to me lies in the hope that if I were to look longingly enough, I might begin to remember my father's real face in that little boy. But I didn't recognize him when I scanned the image, and I will not reproduce it here: not because it is too personal—it's not my Summer Garden Photograph—but because I have come to doubt that I will ever return to it and suddenly see something of my father in that face. The photograph is actually barely connected to me. I have, in effect, given it up, even though I still feel in some tenuous sense, which I know is only the failing remnant of a hope, that it is more precious than the many photographs of my father as I later knew him.

After I realized that I was only hoping to reconnect to that face, and that I valued it because it could possibly, conceivably contain and reveal something about my father, I also saw that I valued it because I had an obscure sense that all the other hundreds of pictures of my father could not reveal anything other than what they openly depicted, and that searching for memories in photographs was therefore a false solace, in which I had fooled myself into thinking that my own memories, which are naturally growing fainter and more inaccurate with each passing day, are not ruined and ultimately erased by the force of the particular faces captured in photographs, but that somehow, paradoxically, those memories could actually be strengthened by reviewing those same images. But photographs of

people I know and love are actually a poison to memory, because they remain strong while my memories weaken. The more often I look at a photograph of someone I loved who is no longer alive, the more my own faltering memory tries to accommodate itself to the unchanging image (which remains insistently itself, obstinately particular and stubbornly slightly different than what I had recalled), as if my memory were trying to convince me the photograph is accurate by distorting itself, harming itself, conforming to what the photograph continues to present, until my memory is nothing but a tattered shadow clinging to the photograph, pretending to be the very face in the photograph, which it never was, clinging and growing weaker, until it disappears entirely.

By constructing the archive, and by writing these pages, I have been learning to give up images of my family. It is possible that in future I may be able to give up most or even all of my family photographs, and keep only my own naturally failing memories.

66 So: farewell to photographs of strangers and photographs of people I love, farewell to vernacular photography, street photography, found photography, and fine art portraiture. My attachment to all those images is sickly, in the end. When Baudelaire said photography made the whole "squalid society . . . rush to gaze at its trivial image" he was being sour and splenetic, and he was out on a personal mission to save Art and Imagination: but he wasn't wrong. (*Salon of 1859*, in *Charles Baudelaire: The Mirror of Art*, 1955.) When I feel my head turning to see a photograph of a person, when I sense my eye swiveling and fixating on the person's face, I feel at once entirely normal and just the tiniest bit ill. I am tired of the unending, persistent need to see images of people. I want to go on to whatever photography might be when it is not compelled to bear witness to our ordinary lives.

So farewell to photographs of people, and also to the photography of the sublime (and the picturesque, and the simply beautiful). Farewell to surrealist photography, which continues to underwrite

so much current practice. Farewell to pictures that burst with emotion, affect, sentiment, nostalgia, sweetness, warmth. Farewell to pictures with labels and subjects, places and dates, where everything is explained and classified and useful.

These are all distractions.

 When photography is released from its obligation to forever show us ourselves, then what is it? When photography is no longer our engine of memory, our portal to the sublime, our record-keeper of choice?

If the figures and intended subjects of photographs were cut away, the mass of photography—the acreage of prints and slides and screens and posters and digital frames—would be comprised of overlooked, un-needed, and unwanted details. In the photo of the rock from the eBay collection, the rock gets more space, proportionally speaking, than the people do in the other photos. Even so, most of the picture is incidental. Cut out the lovely laughing woman who stands at the edge of the lawn, and you'll have a picture that will seem, improbably, to be a portrait of a blocky brick building. Cut that out, and you'll be left with dull shadows, overexposed sky, and patches of grass. Those parts are actually the majority of the photograph. The lake with the ducks is a bit harder to parse, because its subject is dispersed. It is by far the most interesting image of the set, because the eye swims around in it, not knowing where to stop.

Judged by the square inch, photographs of people—that is, most photographs—are not mainly photographs of people. In terms of square inches, they are mainly pictures of other things. Even a snapshot of something as vast as the Grand Canyon, taken from a tourist overlook, is likely to have uninteresting scrub and rubbish in the foreground, or part of the stone safety wall, concrete curbs, or portions of parking lot pavement with its painted yellow lines. The pebbles and rocks in O'Sullivan's and Klett's photographs are just expansions of all that unwanted stuff.

The *surround*, as I like to call it, is not the same as the *background* that painters know, because backgrounds are put in mark by mark

and are therefore always noticed, always intended. Fine art photographs are also said to have backgrounds, which means the photographer is supposed to have noticed what goes on around the figure, and taken it into account as part of the image as a whole. Modernist painters replaced *background* with *ground*, and the difference has been taken as a sign that in modernism figure and ground are co-equals, because each complements, balances, undermines, and defines the other. Again very different from the surround, which is often enough unwanted, and is only noticed when it helps identify the place the photograph was taken, or when it adds a general atmosphere. Ground and background are two of the terms artists use: there are also *backdrops, frames, negative spaces,* and *settings.* The surround is something different—it is, I think, one of the best names for the gap between painting and photography. The surround only becomes an object of attention when the photograph is going to be used as an advertisement, in a publication, as a formal portrait, or as a scientific or technical illustration. Or when it is looked at oddly, for odd purposes, as I am doing.

Most of the images in *Camera Lucida* are art photographs, so they have backgrounds, and some are studio photographs, so they have backdrops (including Avedon's and Mapplethorpe's white studio backdrops). To Barthes, those devices are surrounds, because for him they are perfectly invisible. Alexander Gardner's *Portrait of Lewis Payne*, the one of whom Barthes says "the *punctum* is: *he is going to die*," is a good example. (p. 96) All Barthes says of it is that Gardner photographed Lewis "in his cell." The wall is apparently two iron sheets, welded together with enormous rivets. The photograph was taken not in Lewis's cell, but in the Navy Yard in Washington, so it is possible Payne was posed on front of a ship: but knowing that does not remove the mass of apparently unimportant detail that *is* the photograph, apart from the small portion that depicts the "handsome" boy. (p. 96) This is—just to be literal about it—an image of scratches and scrapes on iron sheets, with a figure interposed.

These ordinarily unnoticed forms can prick me, as the punctum is supposed to do. But more often they thrive in my peripheral vision like an infestation. They resist interpretation, not because they are usually irrelevant to the production and dissemination of photographs, not because they are personal like the punctum, and certainly not because they are likely to be fragmentary and hard to identify, but mainly because they tend to be boring. It's as if they are only available to be seen because the photograph has placed them there. I take it Gardner wanted an instantly recognizable backdrop to signify "military area" or "prison," and that is all.

Yet in Gardner's photograph I find the scratches—including those on the print itself—more absorbing than the "handsome" boy, more "wounding" and "bruising" (two more of Barthes's words) than Payne's shiny manacles or his prison-issue woolen shirt and pants, and certainly more "poignant" than his fixed, off-center stare. (p. 27) In saying this, I am not coldly ignoring the young man who was about to die, who died so long ago, whose death, so long ago, struck Barthes, now long dead himself, so strongly: I am trying not to see what other people have seen, on the assumption, perhaps frail but for me insistent, that insistently seeing only that face is itself a form of not seeing.

69 The surround does have a ghostly role in photojournalism and other twilight genres that are poised between the massive photographs in museums and the billions of snapshots on Flickr, Shutterbug, Photobucket, Snapfish, Picasa, and other ephemeral photo-sharing sites. Ambitious photojournalism requires that the surround be just a little bit unusual, because that lends the photograph the aura of fine art, which in turn helps the photograph stand out in the field of photojournalism. I have been watching this happen in *The New York Times* beginning around 2000. Intermittently but consistently, they publish photographs with the main subject out of focus or half-obscured. The Queen seen from behind, just half the back of her head and her hat. Barack Obama, blurred in the background.

Bernard L. Madoff, leaving court in New York on Tuesday, is accused of running a scheme that stole billions from investors.

"an indicted banker sinking in a sea of heads and arms"

BERNARD L. MADOFF, PHOTO BY MICHAEL APPLETON. MARCH 11, 2009.

Someone's foot huge in the foreground. The façade of Google's headquarters in China, out of focus, the camera adjusted to capture a bird flying high overhead. An indicted banker sinking in a sea of heads and arms.

Surrounds like these push themselves forward because the subject recedes, but they are still invisible in the sense that viewers aren't meant to interpret or study them. Their visual incidents remain incidental. It is meaningless that Air Force One has dark varnished cabinet doors in its conference room, but the doors are prominent in a photograph that *The New York Times* put on its front page, and I suspect the photo might not have made the front page without those dark varnished doors. A philosopher fond of paradox could say that the condition of invisibility of a surround is its claim that it is the true subject, a claim it makes with all the volume and eloquence it can—which is no volume, and no eloquence.

The indicted banker is shown "leaving court," in disgrace. He looks swamped, and also hemmed in, and it seems he is falling. Those are appropriate connotations because he was charged with fraud, and was about to plead guilty. But why was this exact photograph chosen? The lower right quadrant of the picture is entirely occupied by someone's out-of-focus sleeve. A man's face looms in from the upper right, separated from the banker's face by a streetlight and some other object, perhaps a microphone, at a strange angle. At first it appears the banker is being ushered into a car, but the object at the left is unreadable. It may be a waterproof hood covering a video camera. Between the banker and the illegible object is the right half of a person's face and one eye of another person. It is these exact unexpected collisions, these specific illegible objects, these asymmetries, that made this a good newspaper picture. And those traits have nothing do to with the article that the picture was meant to illustrate, or even the general message, BANKER IS DOOMED, except that they denote the tumult of the banker's exit from court.

I have been on the juries of art exhibitions, but never in the editorial room of a newspaper when they choose photographs. I can only imagine the scenes are similar. A photograph will strike the editors, or the jury, because it is incrementally different from what they have seen before. The difference may be a spray of sea water

caught by a flash and also by the sun, or a new kind of smeary blur in running figures, or a streak of overexposed light trailing a new kind of tail-light glow, or a new kind of scattering of dust and water on a dog's fur: whatever it is, it will be incidental to the actual subject of the photograph, which is "really" a dolphin jumping out of the water at the new amusement park, or an athlete sprinting across the finish line, or a photo of Mardi Gras, or a rescue worker bringing a dog out of a ruined house.

70 On the next page is a magnificent photograph. But why, exactly, do I think it's good? Because it is nicely balanced, because it captures an instant: that would be the easiest sort of response. If I follow the criteria used in photojournalism and popular photography contests, I may note that the depth of field is breathtakingly shallow. If I were asked to give my reasons, I might add that the picture is precariously balanced in time, just as the dog is perfectly poised: one front leg straight out, the other straight down, and the hind quarters in impeccable one-point perspectival foreshortening. The dog's shadow is orderly and touches the dog at just one point, proof of the dog's perfect pose. The dog is off-center, and so is the figure in white, and that adds to the sense of rocketing speed. It looks like the photographer worked hard to get this, and I can imagine it must have taken dozens of exposures and many trial runs. (The photographer may have been proud of this shot, because he or she wrote a copyright © sign at the lower center, but never signed the photograph—so it remains anonymous.)

This kind of analysis is a stock in trade in popular photography contests. Let me try to sharpen it up. The greyhound, for example, is not quite centered in the plane of focus. The sandy road is in focus from a foot or two in front of the dog to five feet behind it. The depth of focus can be gauged by six tufts of grass in the road, three close to us (the first one, as I count them, has the © sign over it) and three further away. The sixth one is the darkest and sharpest. It looks prickly, like iron shavings bristling on a magnet. The dog and the

"Here is a magnificent picture. But why, exactly?"

figure are off-center, and that adds to the sense of speed, but so does the way the trees on either side are out of focus. They are far enough out of focus so that the light is eating into them, corroding away their leaves, punching holes in their outlines. On the left those out-of-focus leaves flow down, like an avalanche, onto the roadside, getting crisper as they go, ending sharply just at the dog's shadow, where they are crisp and sharp. On the right the out-of-focus trees are pitch black, mirrored by the spiny edge of the road. On the left: a tumbling froth of vegetation. On the right: a twilight scene, swallowed in blackness. It is another asymmetry that throws the picture off balance.

It turns out that what matters in the focus is hard to pin down, and the evidence for it is bits of grass and dirt. What matters in the dog's pose is its ever-so-slight imperfection: the back of the dog, including its tail, have a really fearful symmetry, but that left front leg is not horizontal. The foreleg tilts down, the paw angles back up. What matters in the instant of the exposure is the paw that makes contact with the ground—but does it? There is a triangle of shadow just under the paw, which may be a rock, or the road meeting the pad of the foot. What matters for the picture's sense of speed is the different kinds of imbalance evoked by the positions of the dog, the figure at the vanishing point, and the different sides of the photograph, left and right. Nothing in this photograph is quite in line or exactly perfect. The depth is uncertain, the pose is off by millimeters, the instant is incrementally indecisive. These ever-so-slightly off kilter details are splattered with a spray of imperfections: black ink dots scattered in the foreground, a strict row of pebbles marching down the tire-track on the right, sooty ghosts in the air.

These are all things that need to be in the picture before I will say it is magnificent, but they are not things I normally name, or even really notice. We talk about photographs in more general terms: we say the photo is "balanced," "posed," "poised," that it "captures the instant," that it took hard work. Those kinds of descriptions, the ones I put in the opening paragraph, signal that we *could look more, if we wanted to.* But usually we don't look as closely as I did in the previous two paragraphs. When photographs are praised in photo contests or in classrooms, these details are taken as seen, as if we really had seen them, or as if we knew something of the sort was in

the picture but we did not need to spell it out, or as if we had agreed to postpone a more thorough discussion for some future occasion. Our ordinary observations of photographs are stories about acts of looking that we have not really performed. But this is strange. Why would we want to arrange our way of appreciating photographs so that it relieves us of the very kinds of looking that we privilege?

71 The surround does not advance our knowledge of the subject. Even if it is not entirely meaningless, it doesn't seem pertinent to spend time looking at it. When we attend to a picture's surround, we are interrupting our ordinary ways of talking about how we see. And yet in popular photography, photojournalism, and photography classes, what happens in the surround is a crucial guarantee of quality.

Here is a protest in Peshawar, again from *The New York Times*, with half the image unaccountably smeared—until you see that the protestors are carrying translucent black flags, and one has flapped in front of the camera. Even in relation to the experiments the *Times* has been running, trying to push photojournalism toward more ambitious photography that approaches the conditions of fine art, this photograph is unusual. The blur informs us the protestors used veil-like fabric: but that doesn't matter, and it is not mentioned in the story. It is as if only irrelevance can be promoted as art.

If I try, I can *make* the out-of-focus veil-flag relevant. I could propose that the blur is meant to remind the newspaper's readers of the difficult position of the faction that allied itself against the Pakistani government in winter 2009. Or I could suggest that the blur is an emblem of how unsure the West's understanding of Pakistan really is. Or I might say the blur is a token of the fact that photojournalism can never show the whole truth. Those are, of course, sophisms. For a very small percentage of readers, the blur will be reminiscent of Gerhard Richter's smeared paintings and the contemporary fine art interest in out-of-focus photography. (*Six Stories from the End of Representation*, chapter 2.) More likely the unfocused flag was received in the editorial room as a new device,

Lawyers and opposition parties rallied Saturday in Peshawar against the Pakistani government.

"It is as if only irrelevance can be promoted as art"

MOHAMMAD SAJJAD, PROTEST IN PESHAWAR. *THE NEW YORK TIMES*, MARCH 15, 2009.

an innovation, something out of the ordinary, and therefore as a signal of the paper's ambition in the domain of photojournalism. I imagine only the tiniest fraction of the *Times*'s one million readers stopped to wonder what it was.

The photograph was published because it was unusual, and the unusual element is, in itself, insignificant, irrelevant, and illegible, and therefore, potentially, art.

72 If the photograph is presented as art, the surround is what needs to be glimpsed, and perhaps briefly invoked, but not fully seen, not articulated or elaborated in criticism or theory—ostensibly because analyzing the surround would reveal the machinery that makes the image art—it would reveal that the photographers, editors, or jurors are straining to make the photograph art. Beyond that, talking about the surround as I did for the photograph of the greyhound also reveals that the surround is boring, and therefore that this kind of photography is partly boring, and possibly also that photography as a whole is, in the end, also a bit boring.

73 Michael Light's *Full Moon* is a little further away from photojournalism, and closer to an art project. It is a coffee-table picture book, a compendium of previously unseen photographs from the NASA archives. It is meant to recapture the awesome thrill and stupendous achievement of the Apollo Moon missions. To my eye, it fails because Light has the eye of an art photographer: every image he chose for the book uses a trick of lighting, framing, symmetry, texture, shadow, focus, occlusion, or parallax that is a stock in trade of art photography. There are backlit photos with halos, landscapes showered with lens flare, perspectival shadows, evocative blur in the far distance, washed-out reflective metal surfaces, tilted horizon lines, apparently

"tiny shadows . . . appear everywhere in the dust, like scattered pepper"

DAVID SCOTT, UNTITLED [LONG-HANDLED TONG BEING USED ON THE MOON],
PHOTO CHOSEN BY MICHAEL LIGHT, ORIGINAL TAKEN IN 1971.

empty scenes with figures out of focus at the margins, bursts of color in monochrome scenes, sudden darknesses at the center of the image, delicately managed grayscale prints à la Ansel Adams. (*Full Moon*, 99, 92, 97, 74, 98, 85, 81, 82, 73, 87, respectively.) Light did not usually manipulate the images, but he was drawn to photographs that already exemplified fine art strategies.

The ground in this photograph of the tongs that were used to pick up stones from the lunar surface has a peculiar look, like a surrealist drawing of a hand. Pools of shadow seem almost to overflow their depressions, and on close inspection the ground seems pock-marked by many little black stains. These are effects familiar from art photography: the pooling-shadow effect can be accomplished by nearly solarizing the print, and the pinprick spot effect can be done by "printing for grain" (enlarging and using high contrast). In this case Light did not manipulate the photograph; these effects come from the lack of atmosphere on the Moon. Because there is no air, tiny shadows are not blurred together. Instead they appear every-where in the dust, like scattered pepper. Shadows of larger stones seem to pool because their darkness is uniform out to the edge of the shadow. (Long shadows tend to look drawn-in, like the shadows the tong tool casts on the large stone.) It is the picture's affinity with art and darkroom techniques that makes it expressive, not its raw reporting of a distant world.

The many small adjustments in the photojournalists' images are meant, I take it, to make them appear more serious and ambitious as well as more striking and memorable, and nearly the same could be said of Light's choices. In both, it matters that the working of the surround is not noticed in any detail. The images in *Full Moon* are less awe-inspiring when it becomes clear that the astronauts' ordinary pictures weren't expressive enough to print. And beneath that injunction not to look too closely, there is a sense of the truth: the means these photographs use to ensure their publication or their status as art, and the ways they arrest our attention, compelling us to look at bankers, protestors, running dogs, or tongs used on the Moon, are deeply uninteresting except as technical flourishes.

74 In exceptional cases, backgrounds can take on the focal attention that is usually reserved for figures. That happens, for example, in the police investigation of pornographic photographs of children. In Ireland, and I assume in other countries, there is a task force whose job it is to identify the places where such pictures were made by studying details that appear around the children. The investigators look at bits of carpet, wallpaper, trees glimpsed out of windows. In such an image, with the children cut out to preserve their anonymity, things as trite as hotel ashtrays or electric plugs are objects of intense attention.

The absent figure is like a black hole, invisibly drawing everything in toward itself. Seeing is caught in a tidal pull, an undertow. The surround is electrified, because now it answers to the absent subject.

75 I do not mean to imply that figure and surround are necessarily distinct from one another. Inevitably and immediately, beginning with the first glance at the image, the surround invades the figure, until eventually there may be no difference between them. A figure in a photograph is like a person drifting in a flood, clinging onto a piece of floating debris. The surround is the muddy water and the drifting bits of detritus that swirl and accumulate around the figure. The figure bobs up and down, sometimes lost for a moment in the current—I am thinking of those news videos of people in floods, taken from rescue helicopters—but in news footage, the person is always lifted out of the morass. In photography, the figure is stuck. In photojournalism, the figure at least remains visible, even when it seems to be on the point of drowning, like the disgraced banker in the sea of reporters. In art photography, sometimes the surround is managed so that it nearly swallows the figure, as in the photograph of the lunar tongs. However the figure is managed, in photography—unlike in life—it is stuck, and the swirling chaos continuously threatens to overwhelm it.

Microscopic images are one of the best illustrations of this themaphagic (subject-eating) property of the surround, because despite the microscope's concentration on invisible specks of matter —a concentration that might be thought to exclude everything except the object of the scientist's attention—photomicrographs reveal a universe made wholly of drifting inclusions, particulate matter, flares, grit, and aberrations. Like the paralyzed bacteria trapped in blocks of salt, microscopic creatures are locked in their matrix, and at the limit, they are the matrix itself.

76 At high magnification water is elastic and sticky, and the creatures that live in it have to fight to move. Water is seldom pure: in ponds, rivers, and streams, the water tends to be full of soft rotting remnants of plants and suspended stone fragments of all sizes. In some parts of the ocean, the water is also silted with bits and flecks of plastic and glass, little poles and broken-off pieces of things, granules, bubbles, fibers, and hairs. And in that viscid swarming liquid the living creatures themselves are pocked and bubbled, mashed and deformed, diluted and swollen. An amoeba swimming in its slurry is not like a girl on a beach (I'm thinking of Rineke Dijkstra's portraits of self-conscious teenagers): not because one is a monster and the other isn't—that's a subject for yet another book—but because the girl is different from the wet sand crushed under her foot.

Life in a drop of water, which has become the province of high school biology classes, was once an object of serious attention. The eighteenth century was fascinated by the things that live in water. Naturalists watched in astonishment as microscopic creatures burst a bubble from their sides instead of evacuating through their intestines, or split themselves down the middle in order to reproduce instead of mating in the usual way. (This also fascinated Freud; see *Beyond the Pleasure Principle*.) Some small creatures, the naturalists observed, have eyes even though they are green and plant-like and do not move on their own; and others look like plants with stalks and fruits, but then they suddenly come apart into

swarming animal creatures. The microscopic world—"theater" as it was called, because its antics were so entertaining—disoriented its discoverers. Some of the scientists were expecting little watery creatures made on the model of themselves, and instead they found a sexual and conceptual chaos. (*Pictures of the Body*, chapter 5.)

The domain of microscopic creatures remains as difficult to come to terms with as it ever was, although the relentless neologisms of modern science have softened the strangeness. Now biologists speak of pseudopodia, microspora, oocytes, schizonts, ciliates, flagellates, and merozoites, instead of trying, as the eighteenth-century observers did, to describe the creatures in human and animal terms. "Animalcules" was the eighteenth-century word, and it is more honest but less accurate than the many words that have replaced it. Microscopic creatures do not seem to be made on the model of familiar animals, and yet there is nothing else they can be but animals. They are as ill-organized and ill-conceptualized as the swarming waters in which they swim: they are the condensed and animated surround, pressed into service as objects of attention.

Here is part of an ABC of animalcules.

W is for Water Bear

These microscopic animals stumble and clamber through thickets of algae. They are unmistakably bearlike. They seem clumsy, endearing, and powerful. Some have a bear's snout and beady eyes, and they nuzzle, lumber, clamber like bears. Each of their fat legs ends in four claws. I don't know how many claws bears have, but that seems about right. Their speed is about right, too. They have the deliberate hunting movement of a large animal.

But there are problems with the bear analogy. Water Bears have eight legs. (In the photograph, the rear legs are pressed together.) They do have vaguely bear-shaped heads, with soft-looking noses and little black "eyes." But instead of mouths they have sharp "stylets" that slide through tubes in their heads and pierce plant cells, like a mosquito's proboscis. Water Bears have no fur, and their

"Instead of mouths they have sharp 'stylets' that slide through tubes in their heads and pierce plant cells, like a mosquito's proboscis."

WATER BEARS.

bodies are squishy and translucent. Because you can see through them, it is clear Water Bears have no bones. I can see their gurgling organs inside, sliding one over the other. The masses of tissue inside their legs are not muscle but swollen "claw glands." Often there is a dark lump inside their heads: not brain, bone, or muscle, but salivary glands. And what is worst, when they are pregnant their bodies fill with enormous green eggs. (Martin Mach, www.baertierchen.de)

The Water Bear is a monster because it continuously reminds me that it is not what I wish it to be. A monster: a thing that I want to recognize, but I cannot. I look for a sign from the monster, letting me know that it is really a bear, as I hope it is, but the thing, the monster, refuses. In photographs, the Water Bear is a bag of intestines, eggs, and bubbles. A bubbly thing, that swims in bubbles.

T is for Tear of a Swan

Here is *Lacrymaria olor*, which means the genus of Tears, species of Swans, as if swans were a kind of teardrop—it's a classification that a Romantic like Keats would have loved. Sometimes in English this creature is also called "Tear of a Swan."

Its body is a teardrop shape, more or less, and it also looks somewhat like a swan with an especially long graceful neck and a head of some kind. When the Tear of a Swan appears in the microscope's field of view, it can seem momentarily that a swan has miraculously shrunk and joined the underwater community of paramecia and other animalcules. The effect is startling, and the swarming liquid in which the Tear of a Swan swims can suddenly transform into the surface of a woodland lake, floating with full-size driftwood and leaves. The early microscopists must have spent hours, as I have done, watching the unaccountable spectacle of the diminutive swan, transported into the bright thin film of water on the microscope slide.

Observing the Tear of a Swan, you know you are not seeing a normal swan, and that is part of the fascination. The creature's neck

"The Swan seems to be dreaming that it was once a swan"

"If this is a swan, it is a swan ruined by a nightmare"

TEAR OF A SWAN. © GERALD HELBIG.

does not curl demurely like a swan's but whips back and forth, spurts in and out, in a movement that seems purely insane. The neck is like a rubber flail, whipping madly from side to side. But those are momentary failures, like interference in a video, and at other moments the Swan seems to remember that it is a swan, or it seems to be dreaming that it was once a swan.

If I look more closely, I notice its neck is planted with a spiral pattern of spiky hairs, and its body is a mess of burbling protoplasm. Its head has no eyes, but some kind of hairy grasping mouth. It feeds and swims frantically, continuously forcing me to shift the slide on the microscope stage in order to keep up with it.

One observer, who found a Tear of a Swan in the Madog River in Guam, says it is an "incredibly malevolent looking" creature. (Brenna Lorenz's blog, 2008.) The first one she saw had its body stuck in some debris, but that didn't stop its head and neck from flailing in search of animals to bite. If this is a swan, it is a swan ruined by a nightmare, carnivorous and shaking with amphetamines.

Saying "swan," "tear," "neck," and "head," is just wishful thinking. The hopeful analogies break down, become senseless: head becomes "head," neck turns into "neck." After an hour looking at photographs of the Tear of a Swan I re-read these pages, and wanted to put everything in scare quotes: "graceful," "swanlike," even "whips," "spurts," "insane." I have nothing in common with this creature: and when I say this, I realize the Swan shares more with the clots and fibers of rotting plant matter that it swims in and eats than it shares with a swan. The Tear of a Swan is made of the same unpleasant stuff as the murk around it. And I think again of one of Dijkstra's uncomfortable girls standing on the beach: it's as if the girl were more like the sand than she is like me.

S is for Sun Animal

Some animalcules are more mineral than organic, and they promise some relief from the assault on common sense. From a biological supply house I bought a jar full of an animal called *Actinosphaerium*, a Heliozian (Sun Animal). They look like

"As I watched one of these Sun Animals, another animalcule, a ciliate, swam in a little too close and was snagged by one of the spines"

SUN ANIMAL INGESTING A PROTOZOAN. PHOTOS BY THE AUTHOR, 2006.

little stars or brambles, tossed in among the usual scrap heaps of algae and refuse suspended in the water. Close up, the Sun Animal's spines are thin and dark, and its insides gassy. It is large by the standards of protozoa, and by focusing up and down I can see its spines are not rigid; they are bent a little by the microscope slide beneath the creature and the cover slip above it, as if the Sun Animal were a furry animal pressed gently between two glass plates.

As I watched one of these Sun Animals, another animalcule, a ciliate, swam in a little too close and was snagged by one of the Sun Animal's spines. It seemed as if the spines were sticky. The ciliate squirmed, trying to get away. I became aware of skeins of jelly coming out of the Sun Animal, drifting toward the wriggling ciliate. The curtains of mucus (or veils of jelly, or whatever they were) looked fixed in place—I could not quite see them move, but each time I looked away and then back again, they had inched a little further out toward the ciliate. The loose net of soft translucent mucus was a trap, being built before my eyes. In three or four minutes, moving at the pace of an afternoon shadow, the trap reached the helpless animalcule and gently enclosed it. The prey was sealed in a watery bag. The bag was then pulled back, in toward the center of the Sun Animal.

I understood why the interior of the Sun Animal is so bubbly: the bubbles are stomachs, digesting its meals. *Actinosphaerium* is one of the Sarcodia: it is an amoeba, but with spines. It has a horrible way of leaking out of itself, silently constructing soft bags that smother its victims. Before my eyes, it shifted from cartoon sun to crystal to furry animal to carnivorous mechanical device. When I look back at my first photo of it, the Sun Animal seems only slightly different than the gleaming curds around it, as if each little stain and congealed spill in the world could become a Sun Animal. This is what some early microscopists thought: according to the doctrine of Panspermism, the world is full of seeds, is nothing but seeds.

 is for Proteus

The heart of darkness of the eighteenth-century panic about microscopic creatures was the Little Proteus, a more common kind of amoeba than the Sun Animal. Little Proteus flouts all the most basic requirements of a body: it has no head, no limbs, no hair, no internal organs, no brain, no eyes, no mouth or anus, no particular shape at all. Photography demonstrated that to the world; the early drawings are mainly hopeful sketches made when the Little Proteus temporarily sprouted "antlers" or "arms," or momentarily seemed to have a head. (*Pictures of the Body*, 225; *Archiv für Protistenkunde*, 1931, 14–29.)

Photography destroyed the observers' illusions by insisting on the ongoing formlessness of the creature and its disanalogy with other living things. Still, it was always possible to do what the eighteenth-century draftsmen had done, and capture the Little Proteus in a photograph just at the moment when it looked like a rabbit, a snake, a reindeer, or a rodent.

A few years ago I took a photograph of an amoeba that resembles a bunny, with a big eye and a little paw. If I turn the photograph on its side it becomes a duckling, like Wittgenstein's famous "duck/rabbit picture." Mine is a duck/rabbit amoeba. It is less comforting than Wittgenstein's image, because no matter how it is seen, it is always also a monster.

At high magnification amoebas show what they are really made of: protoplasm studded with "granules," as they are called—little acorn-shaped nuggets the shape of what the Irish call "pinhead oatmeal." The Little Proteus is a slop running with these granules. Sometimes it is watery oatmeal, and sometimes a thicker gruel, always wrapped in a thin membrane that has a tendency to burst and release the amoeba's gritty porridge out into the surrounding water.

When an amoeba moves, it spills out a pseudopod in the direction it intends to travel. ("Pseudopod," meaning "fake foot," is as good a euphemism as any.) If it changes its mind, the pseudopods shrink back into the body. (Or should I say, If it changes its "mind," the "pseudopods" shrink back into the "body"?) When amoebas float in lake water, they stretch out their pseudopods in search of firm ground, and then they begin to resemble stars. Other times they are

"a duck/rabbit amoeba"

AMOEBA. PHOTOS BY THE AUTHOR, 2006.

*"One side sprouts fresh healthy pseudopods,
but on the other side the pseudopods slowly shrink into a mass of
boils and warts"*

Amoeba. Photo by the author, 2006.

more monstrous. When they no longer need one of their pseudopods, they can "forget" to heal the pseudopod, to reabsorb it into their main mass. One side sprouts fresh healthy pseudopods, but on the other side the pseudopods slowly shrink into a mass of blisters and warts.

In this photograph the amoeba had been going down toward the algae at the bottom of the frame. It reversed direction and poured out a half-dozen pseudopods at its top. The dozens of bumps and sacks at the bottom are shriveled pseudopods that will be dragged along. They are more like pustules than limbs, and the new pseudopods are less like limbs than wounds flowing with gore (that would be their human equivalent).

 is for Mastigamoeba

Sun Animals and the Little Proteus are only the beginning of the world of amoebas. Mastigamoeba has a front and a rear: the rear is a bump with a set of little pseudopods, like a bald head with a few hairs. The front has a flagellum—a long, rigid wire-like extension that is many times the length of the rest of the Mastigamoeba. At the end the flagellum curves a little, and it can be rotated like a propeller to draw the amoeba along. At its sides it has a few weak pseudopods, like a seal's flippers. As Freud knew, things are most uncanny when they are temptingly close to things we know, and yet irreparably distant, as if the world was mocking us or as if the world was a mother who lies to her child, saying, Relax, everything is fine, everything will be fine.

 is for Gromiidae

To my mind the Gromiidae are the most disturbing amoebas. They are mainly egg-shaped, and their pseudopods are very thin and fine, like threads. They grow out like the branches of a tree, often in straight lines. But unlike tree

*"Mastigamoeba has a front and a rear:
the rear is a bump with a set of little pseudopods,
like a bald head with a few hairs"*

MASTIGAMOEBA. 2002.

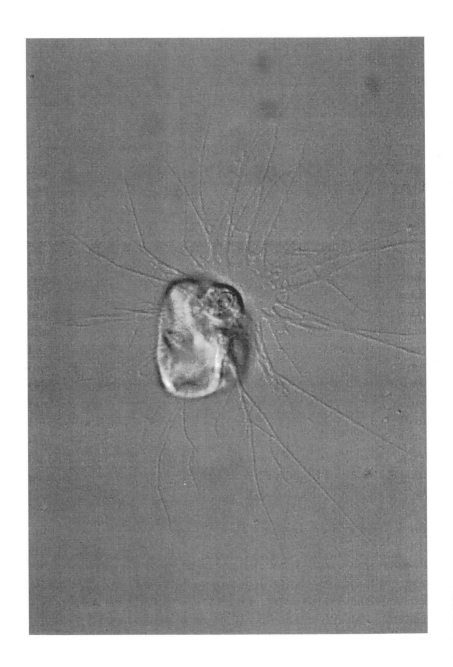

"it requires three neologisms to describe something as inhuman as this"

GROMIID. 2002.

branches, these fuse when they meet, forming a viscous network. Biologists call them "anastomosing filose pseudopods" (I suppose that would have to be translated as "threadlike fake feet that merge into one another"). It requires three neologisms to describe something as inhuman as this. (*Protist*, September 2002; *Archiv für Protistenkunde*, 1980, 166–91; 1994, 55–61; *Protistologica*, 1985, 215–33.)

In high-resolution photographs, the Gromiidae look like fat spiders in webs, except that here, the spider *is* the web. Or the pseudopods are the spider's long thin legs that fuse to one another whenever they touch: something I can say, but I cannot quite imagine. When I look at the photographs either I see a weblike network, or else I see limbs: I don't seem to be able to comprehend both at once. Instead of a duck/rabbit amoeba, this is a web/limb amoeba, further down the road that leads from everyday life to the destruction of anything that makes sense. The illusion Wittgenstein made famous is either a rabbit or a duck, and supposedly never both at once. It's the same with the rabbit and duckling amoeba, and the prickly and bizarre Gromiid. I either see its web, or its limbs—or to be more accurate, I either see it *as a web*, or *as having a web*, or *as limbs*, or *as having limbs*. But there is also something new here, that is not in Wittgenstein's example: the limbs, the web, the rabbit, the duckling, are always also amoebas. They are slime, grit, and oatmeal particles in thickened broth. Photography will not let me forget that things are made of nameless stuff. Wittgenstein's rabbit and Wittgenstein's duck are made of nothing (of drawn lines). And they live in nothing (a white page).

One afternoon I watched as the amoeba's very thin and fine reticular network spread and retracted. The threads are very tiny, at the limits of the microscope, so they flickered in and out of visibility. It was not possible to watch them grow, because I could not keep any one thread in sight. They appeared and disappeared, somehow dragging the fat berrylike body of the amoeba along the surface of the glass slide.

The photographs arrest the nauseating ghostlike motion of the web of limbs. In the sequence the creature slowly passes some black grit on the microscope slide. Each photograph has a different arrangement of the sticky net, the "filose anastomosing pseudopods." All

"The photographs arrest the nauseating ghostlike motion of the web of limbs. In the sequence the creature slowly passes some grit on the microscope slide."

around the creature there are threads and smears, scratches, blots and stains and bubbles. The creature itself is threads and smears, blots and bulbs of jelly. My thoughts swim and tangle in my mind. I have no idea how to think about this creature. It is at the end of my language and the end of the visible world: and yet I cannot help thinking this is a general condition of things in the world, as photography forces us to see them.

77 Photography has given us these microscopic creatures in ways that drawing, etching and engraving never did. It gives us their unattractive textures and the mess of their surroundings, which the early microscopists always omitted, and it gives us their conceptual inaccessibility. Before photography, there was a time when the Tear of a Swan really was a miraculous denizen of a wondrous microscopic garden. After photography, the garden was ruined, ravaged by monsters.

My ABC of microscopic creatures does not need to be extended, because the full version already exists in heavy scientific monographs. The book *Five Kingdoms* is an example: it reflects photography's capacity to present things that could otherwise barely be described. It is an illustrated guide to life, phylum by phylum. Thumbing through it I pass page after page of creatures with no common names, known only by polysyllabic Greco-Latin neologisms, and if I turn too fast I miss the four pages devoted to all human life, together with the other mammals, fish, birds, and lizards—all of them classed as Craniata, creatures with brains inside cranial cases. The authors of *Five Kingdoms* choose a salamander and a swan to represent the Craniata, our tiny corner of creation. Before Craniata the authors discuss lancelets—a kind of brainless eel—and after Craniata it's on to the first of several phyla of fungi.

Photography inhabits all the phyla equally: no special interest in human skin, no particular skill at human bodies, no brief with portraiture.

78 Before I return to the theme of the disappearing figure and the rising floodwaters of the surround, there is something else to say about these photographs: something as excessive and unexpected as these creatures, as specialized and intricate as their anatomies. I mean the equipment that was used to make these photographs. It may seem surprising but it is here, in a cul-de-sac at the end of my detours, that it is possible finally to attend to something that exists in all photography as an often unheard accompaniment. Photography's apparatus is consistently fetishized: most everyone who is serious about photography has a special attachment to some of their cameras and lenses. Equipment is a principal subject of conversation among some professionals and amateurs, but it is rigorously excluded from academic writing about photography. The group of scholars who gathered to produce the book *Photography Theory* in Ireland in 2005 talked about semiotics, realism, history, metaphors, and many other things when we were in front of microphones: but when we were alone, over drinks or at dinner, the conversation often turned to equipment. "I have a Maximar from 1935," one of us would say, and the response might be, "Is it the kind with the double extension macro bellows?" "Of course," would be the knowing reply. I remember telling the group about my Stereo Realist, and remarking that it required Kodachrome ISO 25, because otherwise the grain would show. That led to a conversation about the best kinds of extremely slow-speed color slide film. At one point, I chided the group, and said that if they did not start talking about equipment when the microphones were on, I would have to prompt them. (I never did.) To say that photographic equipment is fetishized is not to say that academic discourse isn't also fetishized, and perhaps that is the problem: a fetish requires absolute, intimate devotion, and it is exclusive. The pleasure of equipment and the pleasure of discourse can be observed with equal but separate devotion, and therefore be at odds with one another. The fetish for theory, philosophy, and history may exclude the fetish for apparatus.

The celebration of the pleasure of photographic equipment takes place at home, among friends, at the mall and the merchandise convention, at the popular photography contest—but not in books like *Photography Theory*, *The Meaning of Photography*, or *Camera*

Lucida. Microscopy is one of the places where photography's fetishized equipment reaches a kind of mesmerizing apotheosis, and that is what forces me to broach the issue. The microscopes that make these pictures—I know because I own them—have a labyrinthine complexity that makes consumer cameras look like home-made pinhole cameras. I use Anoptral phase contrast, darkfield with mirror condensers, Nomarski differential interference contrast, epiplan objectives, water immersion objectives with irises and compensation rings, microflashes, polarization equipment with Bertrand lenses, gamma plates, and quarter-wave plates, eyepiece micrometers, Watson objective interferometers, and eyepiece spectrometers. To capture images I use 8 x 10 plates, 3 x 5 plates, 35 mm cameras with beam splitters, a Leica digital microscope camera, a Polaroid back, and three different camera lucidas. In my study the scene of photography is a densely compacted mass of bottles, pipettes, optical sliders, slide cabinets, small bottles of immersion oil, variable amperage power supplies with meter needles and flashing lights, bellows, microscope parts in black enameled metal and burnished steel, wooden cabinets full of objectives, and a small forest of cables. It is an apparatus fetishist's paradise, and professional fine art photographic equipment is simple by comparison.

Vilém Flusser says equipment always exceeds our imagination. (*Towards a Philosophy of Photography*, 27.) He means that the photographic camera, enlarger, and other apparatus mimic and extend our bodies, like prostheses, and they also mimic and extend our ways of thinking. Equipment is addictive, Flusser argues, because it is always in some sense more intelligent than I am: it shows me how to see, how to understand what photographs can be. When I make pictures like the ones in this chapter I am in the furthest reaches of equipment, where the mechanical prostheses swarm in my imagination. If the protozoan I am trying to photograph swims to one side of the frame, I don't just move the camera to follow it. I make several different adjustments—stage x-axis, stage y-axis, stage rotation, z-axis fine focus, z-axis coarse focus, condenser fine and coarse focus, field iris, condenser iris, change of objective, ocular adjustment, camera focal plane adjustment. There is a race between my idea of seeing and the complexity of microscopical

equipment. Like amateur astronomy—which can also cost tens of thousands of dollars, and necessitate the building of back yard observatories—the equipment in microscopy can become an object of consuming attention. At this end of the spectrum of complexity, photographic equipment grows like a maze, branching and dividing and never revealing an exit. Flusser would say it works harder to expand my idea of what photography is than an ordinary camera could.

When I return to the light of ordinary photography, with my consumer digital camera, the polyphonic voices of the intricate equipment calm to whispers. I feel I can leave my camera aside when it comes to theorizing or writing the history of photography. But the whispers are loud and they are insistent, and if I listen to them I am taken away again . . .

I have no idea how to stitch the pleasure of equipment into this book. Even here, I have had to smuggle it in, under cover of microscopic animals. It is hard to imagine what a book that mingled theory with equipment might be like, but it is clear, I think, that our theorists' and historians' ongoing silence about their desire for equipment is a failure in the conceptualization of photography, for which I have no answer. (Patrick Maynard, *The Engine of Visualization*.)

79 My microscopic abecedary is meant to exemplify the seething surround, or rather the seething of the surround in the figure, and also as a hiatus from looking at ordinary photographs. Sometimes the best strategy for changing a way of thinking is to just spend time looking differently. *Catascopia*, looking down into the world of small things, is inevitably *anascopia*, looking up from among those things and toward the world above—a world that is then somehow changed. Spend time pondering photographs of things other than people (it doesn't matter if they are amoebas: they can be stars, industrial samples, walls, clouds, whatever doesn't immediately remind you of yourself) and your habits of seeing will slowly become visible.

The strangeness of looking at unfamiliar material dissipates—biologists get used to amoebas, and surgeons become accustomed to gore—and what emerges in its place is something like the lasting strangeness of attending to photographs.

Here is an allegory. At first, looking at a photograph is like standing on a rocky coast at high tide, watching the waves crashing, sucking in and out, the spray breaking over the rocks. It is a beautiful sight, and you may be tempted to swim, but you keep your distance because it is not clear how deep the water might run, whether the rocks beneath the surface are large or small. Then, as the tide recedes, the shape of the rocks is revealed, and they are stranger than you could have guessed. Some are house-sized, others are riddled with pits or covered with kelp. They have fantastical shapes, and they are divided from one another by deep sharp-edged clefts. Even at low tide there is no bottom in sight, and you can hear salt water boiling in the dark depths. The coastline is revealed as an unpleasant place, where no one can walk or swim. In this allegory, high tide is the normal condition of looking at photography. Low tide is photography drained of the distractions of people.

(Why, I wonder, is this book so soaked in images of water? Why do I think of water when I think of Barthes's writing, of again water when I want an example of the figure in the photograph? I seem to have chosen photographs that are either powder dry—the Moon, desert rocks—or swimming in fluids. Dry thought, wet thought: it seems Barthes is pulling me to think this way. Ice and salt, two of my opening metaphors, are liquids fixed in place.)

80 I am wandering here, I know: but what else is there to do but wander, when people and places have been cut out of the picture?

For a while I was content with amoebas and Water Bears. But we have an elastic sense of what might be representations made to our own measure—or if not to our measure, exactly, then to the measure of a swan, a rabbit, a duck, or a bear. The Water Bears began to seem a little familiar, and as I watched them nuzzle and

claw at their food, I became complacent about calling them bears. It started not to matter that they were nothing like bears, or even a plausible nightmare of bears. So I decided to go even further, out to the very boundary of the vast Kingdom of Anthropomorphism: first to things even smaller than Water Bears, and then to things almost too large, bright, and fast-moving to be captured by photography at all.

81 First the small things.

It seems it is only because there is an atlas for everything that there is an atlas of dust. (Lorraine Daston and Peter Galison, *Objectivity*.) It is called *The Particle Atlas*, and it was published in 1967, followed by a six-volume expansion that appeared between 1973 and 1980, and finally an online subscription-only version starting in 2005. (Walter McCrone, *The Particle Atlas*; mccroneatlas.com) The original one-volume book is as beautiful as *Five Kingdoms*. Page upon page of pollens, wood fragments, specks of glass, minerals, and "office dust," none of it recognizable without special training. Some is shown in polarized light, so that it glints in metallic roses and greens. Hairs are distinguished from artificial fibers, pigments from resins and cosmetics, cleaning materials from pharmaceutical materials, fly ash from forest fire dust. Because it's an atlas, the book has no plot, no story, only a potentially infinitely expandable array of examples.

The McCrone Research Institute in Chicago, which produced *The Particle Atlas*, has made a business out of microscopical analysis. After 9/11 they published an essay on the composition of the dust from the World Trade Center. Like many people who were in New York in September and October 2001, I remember the uncanny pale grayish-tan dust that covered the whole of the south end of Manhattan. It was mainly, as one scientist put it, "glass fibers, vermiculite, perlite, diatoms, plaster, glass fragments, paint particles, calcite grains, and paper fragments." ("Comparisons of the Dust/Smoke Particulate . . .," *Journal of the Air and Waste Management Association*, 2004, 515–28.)

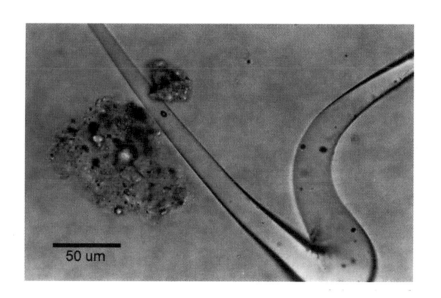

*"A stream of molten glass runs across two clots of dirt,
against a pale brownish-purple background"*

Dust from the World Trade Center. 2002.

82 The McCrone paper on the dust from 9/11 has a number of striking photographs. A glassy particle gleams in the microscope's light, giving off a pinkish glow against a dark grey-blue background. An odd shape, something like a lint ball, rests among other irregular forms. A stream of molten glass runs across two clots of dirt, against a pale brownish-purple background. ("Microscopical Studies of World Trade Center Disaster Dust Particles," *The Microscope*, 2002, 29.)

The accompanying text provides an analysis of the dust, tabulated in a long column. Most of it is paper, metal, insulation, carpeting. Far down on the list is "organic dust" of unknown origin: although the authors do not say so, that would include incinerated or pulverized bodies. Skin cells were found in many samples, but they are common in any indoor dust. (Paul Lioy, "Characterization of the Dust/Smoke Aerosol," *Environmental Health Perspectives*, 2002.)

Nothing more is said about the "organic dust." The pictures resonate with possibility. I scan them, sorting through the tiny pieces of litter, ash, and glass, expecting to find—what? A piece of skin? Looking through the McCrone photographs reminds me of news footage of workers climbing in the ruins just after 9/11, searching for survivors. When I leaf through the McCrone paper or the endless *Particle Atlas*, I know I will probably not recognize anything, and yet I know everything I see is already part of my world. Around its roots the world is rubble, and I—my human self, my body, its cells—I am part of that rubble. Or as the philosopher Henri Van Lier would say: the world is granular, and so is photography. (Van Lier, *Philosophy of Photography*.) Those hackneyed lines from the Book of Common Prayer about earth, ashes, and dust somehow never convinced me, but these photographs have.

83 A "body, a face, and what is more, frequently, the body and face of a beloved person." (p. 107) That is what I do not care about when I think of photography. When I look at photographs, then yes, I often do care about bodies and faces, but then I am not thinking of photography: I am

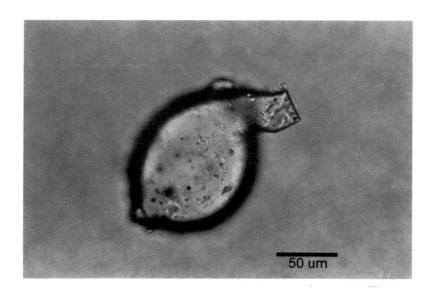

"*I look among the tiny pieces of litter, ash, glass, expecting to find—
what? A piece of skin?*"

DUST FROM THE WORLD TRADE CENTER. 2002.

thinking of a few individual photographs, or at the most I am thinking of a part of photography, a devious part that prevents me from thinking about most of it.

Pictures of people and places, bodies and faces, are too familiar, and I am acquainted, too, with my own interest in taking pictures of people I love. I do it all the time; my archive of family photographs has been superseded by gigabytes of family videos that no one wants to watch, including me.

But when photography is the subject, I prefer faceless pictures like the ones in this book. When I think of love, loss, or death, I am not reliably drawn to photographs. In pictures like Barthes's I see only mirrors of my own thoughts, or mirrors of the thoughts of people whom I'm comforted to think must have been like me, who therefore affirm my sense of what love or loss may be. (Or else I see people who appear "exotic," who therefore affirm my sense of love or loss by showing me what is supposedly different from me.) All that is Pierre Bourdieu's idea, which Barthes peremptorily placed in a footnote. Barthes is bent on his quest, and each line in the book pulls forward toward the Winter Garden—the photograph that seems so hallucinatory it convinced some very sober scholars it must not exist, until the publication of Barthes's *Journal du deuil* proved it really did exist. *Camera Lucida* is like a living room illuminated by the glow of a woven fire screen: the screen diffuses the light from the hearth so the flames are never visible. (The metaphor is Goethe's elusive answer to his friend Eckermann, who asked him what principle governed his work.) *Camera Lucida* is always turned toward the promised warmth of memory fixed as a photograph. It is, finally, a religious book: which is a way of saying that this book is not. This book has no hidden center, at least none I have been able to spot. It doesn't know what photography is, it only knows what photography is not. And so it wanders. Away from things like faces and memories, away from contemporary art, away from what people so often hope photography is.

Five
The Rapatronic Camera

In section 14 of *Camera Lucida*, Barthes develops a theory of photographic "shock." (The word is always, in this section, in quotation marks: "choc.") It is, he says, "quite different from the punctum" in that it is less about "traumatizing" than revealing what had been hidden. "Shock" comes in five flavors, which he calls "surprises," also in quotation marks.

First "surprise": the "rare": "man with two heads, woman with three breasts, child with a tail, etc.: all smiling."

Second "surprise": the "numen of historical painting," where we are shown the moment that "the normal eye cannot arrest": Gros's *Plague-House at Jaffa* in the Louvre, in which "Bonaparte has just touched the plague victims" and his hand withdraws. Such moments are "habitual to Painting," but a "surprise" in Photography.

Fourth "surprise" (skipping for a moment the third): the "contortions of technique: superimpressions, anamorphoses." These days we would add post-production effects of all sorts, which can postpone the moment of surprise by fooling the viewer, and only becoming surprising in retrospect, after the viewer has been told how the photograph or the film was made.

Fifth "surprise": "the *trouvaille* or lucky find": "an emir in native costume on skis."

Barthes doesn't like these "surprises" of "shock" because they become so familiar, making it necessary, "by a familiar reversal," to find the "surprise" in all photography, in photography itself. Instead of searching out "surprises," amateur photographers say that whatever odds and ends they photograph are "notable." Anything becomes a "surprise," so nothing can be a "surprise." (Every winning photograph in a photography contest has to have at least one of these unsurprising surprises, and that is one reason why photography contests are so systematically ignored by people in the art world. It is also why the experiments in *The New York Times* go completely unremarked outside photojournalism.)

By this devaluation and democratization, the theory of "shock" escapes the theory of the punctum to which it is so closely allied. It is not the first time in *Camera Lucida* where a Doppelgänger to the punctum is put rather quickly aside. But I want to look more closely at the third "surprise," the one I skipped.

The third "surprise," Barthes says, is prowess: "For fifty years, Harold D. Edgerton has photographed the explosion of a drop of milk, to the millionth of a second." (Barthes copied this from a popular magazine, which reported the facts inaccurately: Edgerton's milk-drop photos cover only one decade.)

The only other comment Barthes has about prowess is in a parenthesis appended to this sentence: "(little need to admit that this kind of photography neither touches nor even interests me: I am too much of a phenomenologist to like anything but appearances to my own measure)." In that one remark Barthes compresses a massive rejection—so much of photography, speaking only of numbers, has to do with appearances out of measure with the human—with a significant contortion of the concept of phenomenology. The avocation (avowal? conviction?) of "a phenomenologist" could be said to entail the rejection of appearances that are not made to human measure, but only if that avocation were based narrowly on Merleau-Ponty's rejection of scientific epistemology and his interest in embodied knowledge of the world. This is quite different from claiming allegiance to a "phénomenologie vague, désinvolte, cynique même" as he says earlier in the book. (p. 40) Phenomenological understanding does not ordinarily begin by delimiting responses to representations of body-sized objects, and even if it did, it would be wholly in line with Merleau-Ponty's point about experience to say that a photograph of milk droplets can elicit a strongly embodied reaction. After all, from a phenomenological perspective, how could such a photograph fail to be seen *as if* it were human-scaled both in time and in size? Indeed, what can be apprehended—in Kant's sense of that term, in which it is opposed to comprehension—without being taken as an image made to our own measure?

I am not fond of this sentence of Barthes's, or rather the parenthesis that extends and ends it, because the lack of argument on a point so crucial to the book's axial theme of embodied experience can only function, so it seems to me, as a sign that a region of photography is being insouciantly and hastily closed off. Edgerton and everything he is made to stand for is administratively disposed of, in Section 14, which is itself a brief essay-within-the-

book, within the third of five somewhat pedantically listed "shocks," in a parenthesis of a point made in passing: and with that rejection Barthes is off to apparently more important things.

As sympathetic as I am about lapses in argument when the subject is personal, I have to remain unhappy that images not made to the measure of a certain phenomenology are being excluded. If Barthes's subject were the Winter Garden photograph, my objection would be irrelevant: but the subject, as Barthes says, is Photography itself.

 All this makes me want to return to Edgerton, and spend some time with his images not made to the measure of human experience. Of all Edgerton's photographs that lack human figures, the most compelling, I think, are his Rapatronic images of atomic explosions.

At first the object in this photograph looks like a nectarine, left to rot at the back of the refrigerator until it has half-sunk into the shelf. It has some of the gloss and fuzz of a fruit, and a fruit's liquid softness. There is a scar on the left where the stem once was.

But then something goes wrong with the metaphor. Those spots on the surface, more like a constellation of stars gleaming through thin clouds than the first signs of mould. Those clouds of pale light playing across the surface, more like gauze curtains in a night breeze than the mottled colors of a fruit. Or more like washes of watercolor paint on damp paper. Or more like the fused surfaces inside an opal. That torn patch at the left, more like naked brain tissue than fruit pulp. Or not like a brain exposed by carefully sawing the skull, but more like a fleshy tumor, slowly liquefying its surrounding tissues. Or like a weeping sore. Or like salt water seething in a tide pool. The longer I look, the wilder the metaphors become.

The nectarine mass rests on a tripod of ejected fluids, as if it had burst under its own weight. Then suddenly, and with a start, I recognize the small black bushy forms silhouetted on the horizon. They are Joshua trees, which are cactus-like plants, with plated bark and thorny, club-like heads. They are icons of the desert in

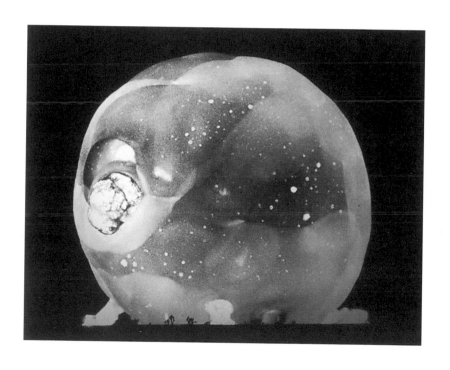

"Then suddenly, and with a start,
I recognize the small black bushy forms silhouetted on the horizon"

HAROLD EDGERTON, ATOMIC TEST EXPLOSION. UNDATED.

New Mexico, Arizona, Nevada, southern California, Sonora, and Chihuahua. And so immediately I sense the immensity of the explosion, and I try to match it to my experience. Some of the Joshua trees are set right on the horizon, but others seem sunken, so this is not a flat desert. It looks like the explosion has detonated beyond a slight rise, and we are looking up a hill at it.

Joshua trees are short, usually less than twenty feet high. Say these are about ten feet high: then the explosion is three or four hundred feet tall, and if it is a sphere it is already sixteen million cubic feet of—of what? The thing is a bubble, and it is in the process of swelling and bursting. The spots that had reminded me of stars are a kind of acne, percolating to the surface in blotches five or ten feet across. The bubble has violently burst at the bottom, and three eruptions of flame are crashing into the desert floor. The veils of pale light I compared to clouds are really the first indistinct signs of larger explosions beneath the surface, rising like blurry forms from the depths of a lake. The boiling mass at the left is one of them that has already broken the surface. Nothing at all in this image, except the Joshua trees, seems made to any human measure.

87 It is disturbing—perhaps "shocking"—to look at this image, even apart from the fact that it is an atomic explosion: that is, aside from all the images, clichés, fears, and hopes about atom bombs. The object in this picture refuses to be described in terms of things I know. Even a mushroom cloud looks like a mushroom. (That is an exact metaphor: some mushroom clouds even have annuli, the rings partway up a mushroom's stalk that are the remains of a part called the inner veil.) But this object will not be made into something familiar, and so it sets my mind racing. Like a constellation? Clouds? A nectarine? A bubble? Acne? A tumor? A tide pool? A watercolor painting? An opal? Nothing works.

Like the discoverer of Little Proteus, I fall into a kind of visual desperation, finding and discarding metaphors one after another, increasingly willing but increasingly unable to look directly at the thing.

I μS EXPOSURE AT ABOUT I μS

"*apparently the intense radiation has caused the Plexiglass to become a light source*"

HAROLD EDGERTON, BOMB CAB AT FIRST 1/1,000,000TH SECOND. UNDATED.

The nectarine is one of an undetermined number of surviving photographs Edgerton made of the first fractions of a second following the detonation of atomic devices in the desert Southwest. All but three were unpublished until 2003, when the Edgerton estate released a number for an exhibition in New York City. (*After and Before: Documenting the A-Bomb*, 2003.) Many more remain classified. The known photographs are mostly undated and their locations are unspecified. Some depict explosions detonated from balloons, a previously undocumented arrangement (the government denies explosions took place in balloons); others are ordinary thousandth-of-a-second exposures that were taken with unmodified 35 mm cameras.

The camera Edgerton used to take most of the high speed photographs of atomic tests was called the Rapatronic. ("Harold Edgerton's Rapatronic Photographs of Atomic Tests," *History of Photography*, 2004, 74–81.) Although it had no moving parts, it was one of the most complex cameras ever built, using a device known as a Faraday gate as part of what Edgerton called a "magneto-optic" shutter. The cameras were attached to eight-inch Newtonian telescopes, which were mounted on towers about seven miles from the blast.

At the blast site was another tower, and on it was a "bomb cab," constructed like a little house with Plexiglass casements about one foot wide. Of the photograph I am reproducing here, Edgerton says, "apparently the intense radiation has caused the Plexiglass to become a light source. In two places, however, radiation has come through the enclosure and ionized the surrounding air, causing darker spots to appear in the picture." This is one-millionth of a second after denotation. In another one-half of one-thousandth of a second, the bomb cab will be enveloped. In the following photograph the explosion looks soft and fuzzy, like a ball of mould. The next few ten-thousandths of a second will produce the nectarine.

"Now the explosion looks soft and fuzzy, like a ball of mould."

HAROLD EDGERTON, BOMB CAB AROUND 1/2,000TH SECOND. UNDATED.

The Rapatronic was distinct from all other cameras because its millionth-of-a-second shutter speed made it possible to look in detail at the explosion before the eye could take it in, from 0.0 seconds to around 0.006 second.

In that imperceptible interval, the nectarine grew very rapidly and flashed in unimaginable brilliance. The flash was the first thing people saw, although no one could look at it without wincing. In about two seconds the unbearable flash was gone, and a high fireball began swelling upward. In a few more seconds the fireball faded in clouds and the stalk of the mushroom began to grow.

The fireball was next to impossible to photograph because it grew and changed brightness so quickly. A few people tried to express what it looked like. The best description I know is from a witness named William Laurence:

> It was a sunrise such as the world had never seen, a great green super-sun climbing in a fraction of a second to a height of more than eight thousand feet, rising ever higher until it touched the clouds, lighting up earth and sky all around with a dazzling luminosity.
>
> Up it went, a great ball of fire about a mile in diameter, changing colors as it kept shooting upward, from deep purple to orange, expanding, growing bigger, rising as it expanded, an elemental force freed from its bonds after being chained for billions of years. For a fleeting instant the color was unearthly green, such as one sees only in the corona of the sun during a total eclipse.

All that was in silence, before the sound arrived, and before the column of smoke capped. The mushroom-shaped cloud became the icon of the bomb not only because it was easier to see and photograph, but also easier to comprehend.

Bomb cab → mould → nectarine → intense flash → fireball → sound → mushroom: the phenomenology of the atomic bomb. The first three were revealed by Edgerton. The fourth was seen by many people; the fifth, the fireball, was the precious possession of just a few witnesses, and the last became a cliché of modernism.

Only one witness, as far as I know, noted that the fireball was irregular, that it had the swelling, healing scars of the nectarine. (That is described in a typewritten account by Otto Robert Frisch, preserved in Trinity College, Cambridge, Fr. B1351. He observed the fireball's odd irregularity: it wasn't just a rising, bursting sun, but a diseased sun with scars of its irregular birth.)

"Shocking" is not the right word for all this: Edgerton's photographs are nearly frightening, and they are hard to look at and hard to think about. They make me visually desperate: staring at them, I am compelled to think about how little they resemble things I recognize as part of any possible experience. It is as if I am seeing the world through the selenite window, and it will not come together in my mind or in the image. Something about these photographs resists being seen: they repel my eye, my vision trickles off them like water running down a windowpane.

90 It is easy to name the thing that is so obdurate, that repels my gaze, that seems so hard to simply see: it is texture without meaning.

For scientists, those textures were exactly the point. The primary purpose of the high-speed photographs was to measure the yield of the explosion. Because each Rapatronic camera could only take one image, Edgerton had a bank of cameras and seven-inch telescopes set up to take a sequence of photographs, making it possible for physicists to measure the rate of increase of the fireball. The results are classified, but they can be re-calculated, if one were so inclined, by using formulas in declassified texts. (*The Effects of Nuclear Weapons*, 1962, §2.103–2.118.) The strange cavities and veiled forms in the photographs also made it possible to evaluate the timing of the "explosive lenses" that surrounded the atom bomb and imploded to initiate the atomic reaction, and for that reason the Department of Energy asked Edgerton to falsify the dates and places on several of his photographs to prevent people from drawing conclusions about the shapes of the lenses. The technology of bomb-making has gone far beyond Fat Boy, but now, after all these years,

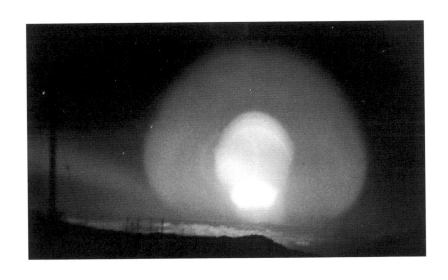

"up it went, a great ball of fire about a mile in diameter,
changing colors as it kept shooting upward,
from deep purple to orange"

HAROLD EDGERTON, ATOMIC TEST EXPLOSION. UNDATED.

those "explosive lenses" are once again sensitive, because so many countries are on the point of being able to make such "low tech" atomic devices.

And even aside from the missing calculations and wrong dates, much of this material remains mysterious. No one knows how many Rapatronic images there are. Edgerton was a perfectionist: his assistant Gus Kayafas tells me he took ten thousand pictures of milk droplets and printed only twenty. The atom bomb pictures were commissioned by the government, and it is possible many thousands survive in classified archives. (Joseph Masco, *The Nuclear Borderlands*, 2006.)

So to be perfectly accurate: the textures of the nectarine were never significant. The *shape* of the nectarine—its large regions, its diameter—was intensely significant, and remains that way, but only for people who know how to calculate, and who have an interest in those mechanisms. The acne, the stains and veils and starry spots, have never been read.

 This photograph is a few millionths of a second before the first one I reproduced. The "nectarine" is hollow. Faintly glowing serrated knives pierce through the bottom. The knives are following the guy wires that hold up the tower, vaporizing them, turning them into plasma. The explosion hangs still in the air: it has not yet reached the ground. The curling hollows inside the explosion are tidal echoes of the shapes of the bomb's compression chambers, its "explosive lenses."

The empty nectarine will fill with ionized air and radiation. It will become soft, swelling outward, producing—for a single millionth of a second—the putrescent nectarine, its surface shimmering with veils and stars. I look into those hollows, and think of cold sea caves, of ancient bones. What are those hollows? Are they anything in my life?

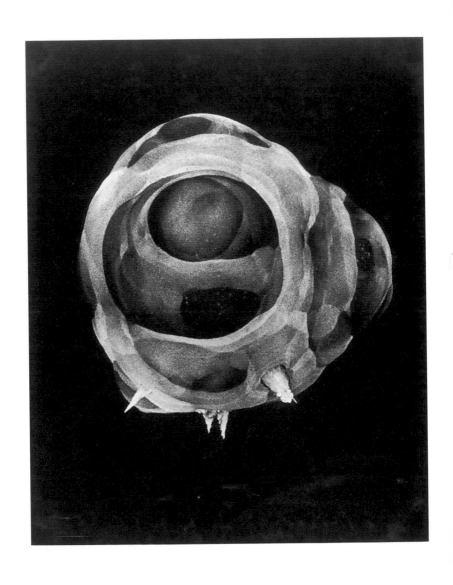

"I find myself staring, again, at the uncanny images.
The metaphors flood in, and again they fail"

HAROLD EDGERTON, ATOMIC TEST EXPLOSION. UNDATED.

92 There is more science and history in these images, which you can read if that kind of knowledge provides any comfort. I have studied that literature, but I find myself staring, again. The metaphors flood in, and again they fail, and then they flood back, like water sucking in and out of a tidal pool. This is one of photography's coercive, unpleasant rhythms.

When I put one of the Rapatronic pictures side by side with a photo of the mushroom cloud, the mushroom cloud changes: it begins to look familiar, even friendly. I recognize it from my childhood, where it was supposed to terrify us in textbooks, or chasten us in TV documentaries. I remember it in movies, from *Dr. Strangelove* to films that really have learned to stop worrying and love the bomb, like *True Lies* and *The Sum of All Fears*. The mushroom cloud, which should be an icon of everything international diplomacy and coercion have worked to avoid, is really a house pet, an image that is as much a part of my life as Disneyland, the Zapruder film, and *Happy Days*.

Edgerton's Rapatronic images are of an entirely different order. They are not crusted with middle-class memories or domesticated by familiarity. The photograph of the object that precedes the fireball, looming behind the Joshua trees, festers in my mind's eye. The few publicly available Rapatronic images from the first six thousandths of a second after detonation are among the most compelling photographs I know. They are exactly as only photographs can be: nearly unbearable, insistently present, perfectly resistant to the pressure of meaning. And because they are not made to human measure, they are intensely interesting.

93 Now I am unsure whether I want to know too much about what photography is "in itself." Barthes said he wanted to know "at all costs," but that is the kind of thing a person says when they know their wager won't involve discovering what those costs might be. What counts as photography, what counts in photography, what pertains to

photography, what happens around photography, what is given by photography: these are different questions. Modernist writers like Fried and Krauss are concerned with what counts as photography, what counts in photography. There are social theories about what pertains to photography, what happens around photography, how it is talked about and disseminated and used and interpreted. (As I mentioned at the very beginning of the book.)

But what is given by photography: that is a different kind of question.

I think the answer is that photography gives us all kinds of things that we don't want it to give us. Things we prefer not to dwell on, things that are magnetically attractive and at the same time repulsive to our eyes. Sad things, of course, like *she has since died*, or *he is older than I thought*. But also things that we cannot quite make sense of, that we would rather not be asked to make sense of. Boring things, repetitive things, things that are beside the point, annoying things, buzzing distractions at the edges of our vision, thousands of pointless rocks to count, splotches and stains, cracks, unpleasant shadows, errant dust, blooms of mould, and nectarines. Photography is at war with our attention.

 So Barthes removes "surprise," third of the "shocks" that aren't really shocks, and he does so by fastidiously and peremptorily herding phenomenology into a footnote. He doesn't really mean "shocking" or shocking: I think he really means something like manipulated, artificial, stage-managed. (In an earlier essay, "Photos-Chocs," the real reverberating shock of war photography was more at stake—but that is not what Barthes is after in *Camera Lucida*, where war photographs are barely mentioned.)

"Manipulation" could have been the word that guided Barthes's critique, rather than "shock." As a critique of staged manipulation and meretricious skill, Barthes was more right than he could have imagined. These days there are not just thousands of such images, as there were for Barthes, but literally billions. Nothing is more

interesting in this regard than a photo site like Flickr, at least for the first half hour or so. The site is full of "surprises": the HDR (high dynamic range) group, the DOF (depth of field) image stacking group, the fake tilt-and-shift group, the computational photography group. Each one showcases a technology that is fascinating for a few minutes. Each group puts its favored technology to the most kitschy imaginable uses. HDR photography is used to turn sunsets into Technicolor extravaganzas that outdo Thomas Kinkade, or chromatic symphonies with better color balance than Frederic Church. Fake tilt-and-shift is used to make enormous things like St. Peter's Cathedral into cute toys, and people into matchstick dolls. The image stacking groups do the opposite, using software like Helicon Focus to make small things like coins and insects look like looming monumental sculpture.

Flickr and other sites boast their own contests, exhibitions, and superstar photographers, all of which are unknown in the art world. The exhibition groups, such as the Cubism Award, relentlessly equate quality with "surprising" skill. The internet critic Virginia Heffernan has noticed that individual superstar Flickr photographers sometimes claim to be free of the influence of art, but it would only take a few minutes to show they are utterly dependent on Hollywood CGI, romantic landscape painting, or watered-down surrealism refracted through the Syfy Channel. (For Flickr-style surrealism, you can visit the Man Ray group, which showcases appalling antiqued fetishized Photoshopped Daliesque landscapes and figures, and also, very rarely, something Man Ray might have liked.) Nothing is more amazing than Flickr for the first half hour, and then nothing is more tedious. (Virginia Heffernan, *The New York Times*, April 27, 2008.) A little of this leaches into the art world, in photographers like Noriko Furunishi, but most is exiled to popular photography. Flickr is the monstrous, unimaginable progeny of the tiny samples of "shock" that Barthes knew. In November 2007, Flickr passed the two billion photo mark.

(If you are active on Flickr, if you read popular photography magazines, if you enjoy *National Geographic*, if you use Photoshop to create effects, then this is a critique of your work. It may not seem pertinent, buried as it is in the middle of a book on many other things, but this is what the critique of your work looks like.)

But back to Barthes.

He was right to reject "shocks," but the way he rejects the third "shock," which he calls "surprise," is surprising, because he doesn't say he doesn't like it, or that he's tired of it, or that it is unconvincing. He says, in effect, *I cannot like this*, because I am a phenomenologist. It's as if he needs a rule to stop himself from exploring any further, and whenever anyone lays down a rule for himself, there's a question of motivation. What is it about appearances that are not fit to our own measure that made Barthes so peremptory? What could be more interesting than the thing not made to human measure?

Six
Lingqi

95 "Not made to human measure": that means apparently not to human measure, because I am too loyal a phenomenologist to say that any image can be apprehended in some way outside of human measure, but I am also too fascinated a post-phenomenologist not to care about images that appear not to be made to anything I can count as human measure. The two contrary impulses are built into phenomenology, as its conflicted starting point: reject whatever isn't to human measure, but continue to insist on the rejection, returning to it, mulling it over, wondering whether it is stable, whether it will hold. I can think of two ways that photographs can show me things that seem not to be made to my measure. The one I have been exploring so far has to do with the photographs that are presented to me, and my own inability to say what they mean, to demonstrate, in the perennially falsely comforting movement of interpretation, that they make sense. I sense things are not made to my own measure when I fail, repeatedly, to compel apparently meaningless things to make sense, to make them make sense. I have been comforting myself by saying that such photographs tell me about what photography is, and that they help me to understand how I see all photographs, whether they are a rare amoeba or little Ernest.

There is another way that photographic images can be outside "my own measure," and that is when they show me people whose bodies are torn or deformed in ways I cannot bring myself to see as being like my own body, or like anything that might happen to it. Photographs often alienate and repulse me in this manner. Images of people maimed in wars, starving bloated children, men mangled in car accidents, birth defects and deformities. The common ground of these photographs is pain, and it compels me to return to photographs of people—although in a fundamental sense, these are no longer representations of people, but pictures of the body in pain. Represented bodily pain has long been a strength of photography, and it is the power that I think Barthes most feared, the one he was most anxious to cover over in the soft blanket of memory and nostalgia.

I have deferred pain until the end of this book, because it is the hardest subject. So now I propose to go straight to the most intensely painful photographic images that I know—which means the most painful images of any kind.

It is necessary to insist on bodies rather than faces in pain. Photography also gives us faces of people who are dying, or are dead, and those faces can also be hard to understand. In photographs, the faces of people in pain can be distorted in unreadable grimaces or ecstatic visions, and I may feel entirely cut off from the possibility of understanding them. Strongly contorted faces have seemed to many people as an artifact of photography, because they never appeared as such in painting; but to others the photographic distortion somehow represents the mental distortion. (David Sylvester, *Interviews with Francis Bacon*, on the subject of Velázquez's popen.) Either way, I am unsure how such faces can be read, and I usually don't try to read them. Is that person in anguish? Is her face contorted by anger, psychosis, or contrition? Or am I looking at a thin slice of time—one I could never experience without a camera—and trying to read it as I would read a real person's face?

Photography often shows me faces of people who have suffered in ways that I can only faintly begin to imagine, or have done things I can never picture myself doing. It also tricks me by showing me blank faces that I believe must have felt pain. Everyone has seen the police photo of the serial killer who stares blankly into the lens, or the rapist who gazes complacently or carelessly somewhere past the camera. In contemporary fine art photography in the 1990s and 2000s, blank stares were all the rage. Ruff, Streuli, Struth, Dijkstra, Luc Delahaye, and Jaume Plensa made photographs of people who stare straight ahead, apparently without affect or interest. The practice derives from a mistrust of theatrical expressions, which Fried traces to the generation of Manet, and which the critic Michael Newman understands using Levinas and Deleuze. Photographs of affectless stares also respond to the notion that an expressionless face is potentially more ambiguous, and therefore more profound, than one that registers a namable emotion.

Anguished faces have been around since Le Brun, Bernini, and Goya. Blank stares have been a stock in trade of portraiture since portrait photography, and later since Manet. Against all that I want to insist on the body in pain, not the face. When I see a photograph of a body opened, cut, or dying, I feel something of an entirely different order, something that I only sense unsteadily in

photographs of faces. There is an unpleasant, electric hurt in an image of the damaged body that is one of photography's harshest properties.

97 Barthes's essay "Shock Photos" (*The Eiffel Tower and Other Mythologies*), yet another text in which he flirts with and then rejects the idea of shock, makes the claim that some photographs intend to "disorganize" the viewer, but mainly fail because the photographer has "almost always overconstructed the horror he is proposing," leaving no imaginative room for the viewer. The machinery intended to produce the shock effect ends up insulating the viewer, and we see such pictures "from inside our own freedom."

It has been proposed that news photographers break down this insulating effect to circumvent "media saturation" and bring horrifying images home. (Jeffrey Kastner, *Art Monthly*, October 1998.) But Barthes kept disengaging from the whole notion of shock: he was less interested in rejuvenating such images than watching them collapse under the rhetorical burden of their impossible self-renewal, and in using that collapse to write them out of the "nature of photography."

Truly shocking photographs, Barthes says, "astonish because at first glance they seem alien, almost calm, inferior to their legend." (This is quoted by Kastner, who is interested in using such insights to restore the "unpredictability" he sees as intrinsic to shock.) Some of the images in the following pages are of that sort, especially ones where the details are hard to make out. The grainy black and white photography produces something close to "calm," or at least some relief. Yet I have watched students grow slowly unaccustomed to such images over the course of an hour or two of steady looking. When they first appear onscreen, images like the ones in these pages provoke a flinch, but their poor quality is a relief. In comparison to the many full-color horrors of the internet, these look harmless. (www.rotten.com) But the longer they are pondered the deeper they gnaw, and some of my students have told me they were put off their

food or had bad dreams, days after the class, days after they thought the images had already been forgotten.

So there are three lines of defense against real shock: first the hope, or the claim, that some images are staged, and therefore only capable of an overdetermined "shock"; second the hope, or the claim, that grainy or monochrome images are incapable of real force; third the hope, or the claim, that when such images are seen at length, instead of just glimpsed, the shock will drain out of them until they become patterns of dye in paper.

Since the 1980s there has been a literature on the mingling of pain, the body, and modernism, but even this literature has its built-in defenses. Gilles Deleuze stops at Bacon's "meat" even though he is after the problem of represented violence and what he calls "sensation." Jay Bernstein, who has a good reading of Deleuze—he feels Deleuze's real subject was Cézanne, but he couldn't write about Cézanne because Merleau-Ponty had taken that subject—stops, in his own book, at Cindy Sherman. But beyond Sherman's horror-show photographs of guts and fluids there is Andres Serrano, Joel-Peter Witkin, Sally Mann's corpse photographs, and many others. Yet each one aestheticizes: Serrano's morgue photographs are also lovely abstractions; Witkin's concoctions are antiqued and precious; Mann's corpses are printed faintly, with aesthetically arranged scratches and print flaws to help soften the subject. All that is in the name of certain ideas of fine art. If there is an identity between pain, the body, and modernism, and if that identity is sharpest in photography, then I want to see it. (Deleuze, *Francis Bacon: The Logic of Sensation*; Bernstein, *Against Voluptuous Bodies*; Steve Melville, in *College Art Journal 66*, 2007; Elaine Scarry, *The Body in Pain*; John Taylor, *Body Horror*; *Pictures of the Body: Pain and Metamorphosis*.)

On this subject, I think it's necessary to push to the end of the scale. First to push past metaphorical discussions of represented pain, where the subject doesn't need to be illustrated and images

are not confronted; then to go on past pain as it might, or might not, be glimpsed in faces; past a distaste for "shock," or a defensive thought about the powerlessness of little black and white images, or the hope that even searing images heal quickly in the mind; and past the ambition to make art out of painful pictures of the body by upping the aesthetic ante. After all those increasingly desperate dodges, photography waits patiently, always willing to give us naked pain if we would only look.

 In my office, I keep several hundred slides of burns, diseases, birth defects and other deformities, which I use in a course I teach on representations of the body in art and medicine. (Some of the slides went into the book *Pictures of the Body*.) I have several photographs of a birth defect called "clover head syndrome," in which the skull is lobed, and the skin stretches tight over the face. One photograph in particular, sometimes reproduced in medical textbooks, is deeply horrifying. The newborn infant screams, its eyes bulging from the pressure of its malformed skull, the capillaries of its eyes full to bursting. That image was intended to go into the book *The Object Stares Back*, but it was censored at the last moment by the publisher himself, a person who usually stays out of decisions about content and editing: he said that if customers bought the book, and then took it home and discovered that photograph, they might try to return the book for a refund. The book had to be re-set at some expense, and now there is a page of description of clover head syndrome in place of the image.

I could have reproduced the clover head photograph here, along with other photographs that create a similar autonomic repulsion. Even the names of the medical conditions are disturbing: "tower head syndrome," "anencephaly," "cyclopism." Or, in search of a shock stronger than "shock," I could have gathered an entire chapter of close-up photographs of orifices. I could have shown photographs of people who sew their mouths and eyes shut (there are many on the internet). I could have chosen recent, full-color

images of war casualties. It would have been easy to make the argument I am after using only photographs of skin lesions, scabs, pustules, flakes, crusts, milia, "eczemas, urticarias, seborrheas, exudative lichenoid and discoid dermatoses." (*Pictures of the Body*, chapter 1.) The force of the images would have been comparable to the ones I reproduce here. I only mean to say that photography is full of these things.

100 The slides I show in my class demonstrate how photography altered the history of medicine. The history of Western anatomical illustration since the middle ages has been told as a give-and-take between schematic representations and images that attempt to record the body's real complexity; in that history the invention of photography played a decisive role. It compelled doctors to consider the body's detailed shapes and textures in a way that even the most myopically precise engravings never had.

The history of Western medicine is replete with authors who demanded the utmost precision from their illustrators—Thomas Sömmerring, William Chelsenden, William Hunter, Nicolas Jenty —but nothing prepared the medical profession for the shock of photography. Anencephalic infants, born dead, their brains partly or wholly missing, were first depicted in early eighteenth-century treatises. They were rendered cleanly, in outlines or neat grids of engraved hatchmarks. Photography insisted that anencephalic still-born infants have masses of gore around their temples, that they look impossibly old and wrinkled, that their eyes are puffed and swollen shut or rheumy and unfocused and bursting open.

Human cyclopes, one-eyed infants, had also been illustrated in Enlightenment medical treatises. They were depicted as healthy infants with a single central eye and a flabby little trunk of flesh protruding above it. (The "trunk" is an anomaly that accompanies cyclopism in humans and other animals.) Photography revealed cyclopes can have rippled eyelids that look like they were cut with decorative "wave" fabric shears. They don't seem to have single

eyes, but rather imperfectly fused eyes ruined with cataracts and broken capillaries. The "trunks" are like wrinkled penises hanging down over the sort-of double eye, whose half-fused pupils can make it look like a pair of testicles.

Photography pushed the unspeakable horrors of skin lesions, pustules, and burns into vivid relief. Neurofibromatosis was a standard subject in nineteenth- and twentieth-century pathology texts. Before photography, neurofibromatosis was an obscure condition, illustrated as nubbly skin. (It is associated with the Elephant Man, who actually suffered a different and equally distorting disease called Proteus Syndrome.) Photographs showed the real horror: skin that has become something other than skin, erupting in hard fleshy growths the size of grapes, or apples, or gravel, crowding in people's armpits, clustering around their necks, pushing out between the hair of their heads. In the medical profession, it is commonly acknowledged that textbooks will have one or more gruesome pictures when the subject permits: it helps them sell to doctors. (There's another book waiting to be written on that topic.) Along with clover head syndrome, neurofibromatosis has become a common choice.

The chilling details in these photographs seldom proved useful in diagnosis, and they have become curiosities in the history of medicine and in the psychology of the medical profession. Photography showed doctors a pitch of pain and detail that proved unnecessary. Before the camera, medical illustrations of teratologies were accurate but not faithful, to adopt Joel Snyder's distinction: engravings did not show what the things would look like if we saw them. ("Documentary without Ontology," Tate Modern lecture, June 2003.) After photography, the pictures were routinely accurate and sometimes faithful, but often useless.

Again I just want to say: this property of photography is general. It is not restricted to these lurid examples, although it is strongest in them. Photography also revealed common gross anatomy was very different than it had been imagined. (Jules Bernard Luys, *Iconographie photographique des centres nerveux*, 1873.) Healthy skin, fascia, organs, and muscles revealed asymmetries, creases, pockmarks, and other imperfections that hadn't been visualized—hadn't been seen—before the camera. The body had become infinitely more complex.

101 Medical photographs of deformations and wounds have always had an uneasy relation to fine art: as the students in the class discover, it is not easy to incorporate strong photographic material into artworks. Yet the art world is capacious, and there are counter-examples such as the Taiwanese artist Chen Chieh-jen, who has made digital versions of photographs like the ones in the following pages, adding surrealist medical monstrosities. (Making, for example, the image of a man being executed into a Siamese twin, also being executed: a rum mixture, adding sour kitsch to pain.) Artists have created images of genetic defects, teratologies, dissections and vivisections, from the surrealists to Joel-Peter Witkin. (Helge Meyer, "*Empfindnis* and Self-Inflicted Pain in Performance Art," in *Representations of Pain*; Petra Kuppers, *The Scar of Visibility*.) Yet those images remain marginal. Photographs of the opened body are such strong signifiers of pain and death that it can be challenging to take them into existing art practices. They overwhelm the strongest intentions to see them as art. People read strong medical imagery as Barthes reads photographs in general: through the image, to the thing itself. Once again it's Krauss's "it's" response: "it's a boy holding a dog," "it's a syphilitic sore."

Art photographers of the turn of the twenty-first century who used medical imagery, including Serrano, Mann, Damien Hirst, and Rosamund Purcell, made sure their work was emotionally distanced from the viewer: flesh was abstracted or cleaned up, framed, set at a safe distance aesthetically and ethically. Places like the Museum of Death in Los Angeles (which trades in a mixture of sweet kitsch, like a photo of Groucho Marx lying in state, and images of pain like the *Faces of Death* series), the Mutter Museum, the Musée Véterinaire Alfort, and rotten.com, are refuges for viewers addicted to pictures that can still genuinely shock, as opposed to "shock." Those viewers are trapped in the kitsch economy of perpetual inflation: each shock has to be stronger than the one before, because otherwise shock will become "shock." (Karsten Harries, *The Meaning of Modern Art*, which has a brilliant chapter on kitsch.) This is one place where Barthes is absolutely right, and it is why I am not reproducing any art in these last pages.

At this limit of pain, in regard to these images, even the scholars who make the *lingqi* their life's work read through the image to the event. It is as if I am pulled into the picture itself by the pain.

102 Georges Bataille's *Tears of Eros*, finished (or abandoned) in May 1961, is an extended photo-essay on eroticism, divided into two parts: "Prehistory," and "The End." The second part, subtitled "From Antiquity to the Present," samples art history down to surrealism. The book concludes with a brief Afterword, itself divided in three, and the last of those three sections is called "Chinese Torture." There Bataille reproduces four photographs taken in China between 1901 and April 10, 1905, together with an image of Aztec human sacrifice from the *Codex Vaticanus* 3738. The text in the "Chinese Torture" section is terse, and the book ends with a further half-dozen pages of illustrations of Western executions, intended to press the point that "the contraries" of "sacrifice," "religion," and the "abyss of eroticism" are linked. The four photographs Bataille reproduces before the Aztec codex are pictures of Chinese *lingqi*, a form of execution, generally called the "death of a thousand cuts." They are among the most difficult photographic images to see, to attend to. (That is the argument I made in *The Object Stares Back*, 110.) In Bataille's book the *lingqi* images are nearly pulverized under the tremendous double weight of their political context and their aesthetic, sacrificial, and erotic significance, so they do not need to be attended to, only glimpsed—and there is evidence Bataille himself experienced them that way.

103 Less pressurized images—other pictures and films of war—already have the capacity to distort scholarly accounts that are only interested in photography's status as art or its place in society —its aesthetics or its politics. The tortured justifications that sometimes accompany exhibitions of war photography make interesting reading in this regard. For example, the art historian Julian Stallabrass describes a discussion about whether or not to include a violent photograph by Simon Norfolk in an exhibition called *The Sublime Image of Destruction*. When it was enlarged "to museum photography scale"—in other words, the scale that would declare it as fine art—it "troubled" the artist and the curators. The scale implied the photograph was art, which in turn meant it had aesthetic properties, and that seemed wrong. But art world thinking on this subject is confused. Surely the photograph, even if it were exhibited mainly as an example of Norfolk's work, had properties of art before it was enlarged. After some discussion, they decided not to exhibit the photograph. Stallabrass presents this as a problem of "keeping both particularity and generality in mind"—the photograph had to remind people that atrocities happen all the time, and that they happen "to individuals." (Stallabrass, "Rearranging Corpses, Curatorially," *Photoworks*.) But of course any photograph can remind people of particularities. The problem was that if the disturbing photograph were enlarged, that would imply it was art, and art itself might appear as an irresponsible posture, riding on atrocity; and it might even have seemed that Norfolk's photo needed to be enlarged to qualify as art. Peter Campbell, writing about this, says there was a "tangle of meanings." (Campbell, *New Left Review*, 2009, 67, 68.)

These issues are less muddled if politics is what matters, because then art photography can work as a platform, helping the art move into the world. If politics is at stake, then it would be unobjectionable if a photograph appeared as art by virtue of being exhibited at an exhibition called *The Sublime Image of Destruction*, or the 2009 Brighton Photo Biennial called *Memory of Fire, The War of Images and Images of War*. Nor would it matter if the photograph deserved to be art, or even, usually, if it seemed unethical to display it as art. If the point is to change people's minds, it would even fail to matter

if the photograph made violence and suffering seem aesthetic. (A very high resolution photo by Norfolk, showing a bloody baby, can be seen on his site, simonnorfolk.com. You can see every chip of dried blood caked around the infant's mouth.) All that matters for political purposes is that the images are seen, so that they can help change the world. But that simple case usually isn't the case. Normally images are shown both as art and as politics, and the problems that conventionally creates are made much more difficult when the images are violent ones.

The collision of aesthetics and politics hardly bothers *Camera Lucida*, but it tortures some of the book's commentators. "Nothing To Say: The War on Terror and the Mad Photography of Roland Barthes" is the title of Karen Beckman's meditation on what war photography in newspapers can accomplish. Beckman's subject is artworks by M. Ho and Sarah Charlesworth, who exhibit photographs from newspapers without their surrounding text. (*Grey Room*, 2008.) Without captions, the political force of the images becomes unmoored: as Susan Sontag would say, the photographs remind us of atrocities and injustices, but they don't tell us what to think about them. Some of the world's most serious images—the ones that provide evidence, bear testimony, indict and vindicate— are helpless without their supporting explanations. Yet when those explanations are given, the work can have a hard time appearing as art. As Campbell says, commentary gives war photographs a context, and "they become evidence." The distinction is clear and clearly to be avoided.

This discussion of aesthetics and politics is endless, because there is not yet any way to stand back and judge the difference: there is no third term, no third position, no sensible combination. Historians and philosophers have spent their careers on this issue. Something about intensely painful images forces the issue: it makes both positions sharper, more naked. In these closing pages I want to take a cue from some of the best accounts, and write my way through *Camera Lucida*'s obtuseness on politics by looking at a particularly vicious and painful politics as an unremarkable and routine aesthetics.

The *lingqi* photographs that Bataille owned, and the many others that have come to light in the last decade, are exemplary for the sheer force of will required just to look at them, and *therefore* they are exemplary as photographs, because photography has given us pain more intensely than any art before it.

I first encountered pictures of the *lingqi* in a German periodical published in the 1930s, and when I re-published the photographs they caught the attention of a French and Chinese group that was researching the subject. (*The Object Stares Back.*) That led me to a conference in Canada in 2000, and another in Ireland in 2005. The later conference will be a book, *Representations of Pain*; and there is also a definitive study of *lingqi* with an accompanying disk. (Jérôme Bourgon, *Supplices chinois*; *Representations of Pain*, which I edited with Maria Pia Di Bella.) As these events unfolded, I developed a curiosity about the way the researchers were looking at the images. Even though some of the scholars were specialists in pictures of Chinese torture, they could only stand to have the images onscreen for a few minutes; during the 2005 conference the images were barely shown. Bataille was apparently the same way with the photos he had: he kept them in a jacket pocket, and I imagine that is because he would take them out for a moment to consult them, perhaps quickly compare them to some other image he was looking at, and then put them back. He only published his four *lingqi* photographs at the very end of his life, and at that point he was so ill that it is not clear what he intended, or even whether he meant to publish them at all.

With images this strong, it seems normal, even healthy, to look as little as necessary. When I study these images I feel like I am absorbing poison from their surface. Or, in one of Bataille's own metaphors, they are like the sun: they actively hurt my eyes, they are hard just to see without wincing. That is exactly my reason for looking slowly and at length. These photographs surround photography: they are at one limit of what photography is, at its boundary, and they are also, I think, at the very center of what photography is.

105 As politics, and as images of pain, the closest photographs to these are the images Georges Didi-Huberman has studied, the only remaining photographs of people being led to the gas chambers. But they are taken from a distance, so they are still too much about representing the unrepresentable, witnessing, obliteration, and the ability to say and show, and not enough about what photographs can do when they are about pain that is registered directly in the photograph. (Didi-Huberman, *Images in Spite of All*.)

As Didi-Huberman says, it is apparently impertinent but actually necessary to ask parallel questions about art and aesthetics, precisely because they seem so obviously irrelevant, so clearly excluded, from the study of photographs of pain, torture, atrocities, and death. There is no way to see photographs of pain without thinking of the power that we hope inheres in fine art photography (if only fine art photography could be this strong, without being this toxic) and there is no way to see them without wanting to learn about how they were produced, justified, and disseminated.

The *lingqi* photographs compress politics, bodily pain, and aesthetic qualities so intensely—like the steel compression chambers of the old atom bombs—that they almost cannot be seen. Nothing can give me that except photography, and that is my reason for wanting to spend time with the "death of a thousand cuts." If we care about photographs, if we think of photography in relation to art, let's not exclude some images because they are too "shocking." Let's look hard and long at the most painful images we can find. Let's try to think about what happens when photography gives us ravishing detail of ravaged bodies, when the politics cannot be disentangled from the photographic quality, when the evil of what is shown refuses to let go of the aesthetic pleasure of it.

The *lingqi* images give me ethics and aesthetics, fused into an intolerable mixture.

And now "shock" comes back in a slightly different form, the one Barthes gave it in the essay "Photos-Chocs," which opens with a criticism of an exhibition of "shock-impact photographs" at the Orsay. He says the photographs of war atrocities mainly failed to shock him, because the photographers had "over-elaborated the horror" they offered him, using artifice, skill, "contrasting and complementary elements," and other tricks of the trade to stage-manage the "horror." (*Creative Camera: Thirty Years of Writing*, 32; and there is also Richard Howard's translation in *The Eiffel Tower and Other Mythologies*, 71–73.)

The problem, Barthes says, is that we have no freedom looking at these photographs. The photographer has "groaned for us, thought for us, judged for us." It's the same argument as in section 14 of *Camera Lucida*, except that the earlier text applies the thought more narrowly, just to photographs of atrocities.

Again my doubts come creeping back. He slides from "shock" to "horror" so smoothly it seems he has not noticed it himself. Very few photographs in the Orsay exhibition succeed in "shocking us," he says, and then, in the same sentence, the "shock" becomes a matter of "horror": "the photographer must do more than signify the horrible, if we are to feel horror." But why is horror the name of the effect produced by shock? Isn't "horror" a very poetic and theatrical word? It is Julia Kristeva's word in French (*Pouvoirs de l'horreur: essai sur l'abjection*), but in English, to me, it means campy movies and haunted houses in amusement parks. Is it the word for a news photograph of the victims of a Guatemalan firing squad? It seems there is something else here, hiding behind the wall of shock, nestled under the blanket of horror.

Of all the "shock" photographs Barthes decided not to illustrate, W. Eugene and Aileen Smith's *Tomoko is Bathed by her Mother* is the most telling. "Shocking," of course. Premeditated, posed. But full of political power, and now proscribed. Tomoko's parents have

asked Aileen Smith not to exhibit or publish the photograph any more, because otherwise "Tomoko's soul can never rest in peace." (Yuko Yamaji, in Henning Steen Wettendorff's essay in *Photography: Crisis of History*, 152 n. 3.)

Barthes claims he is only recoiling from "shock." But he is also wincing at the power of some photographs.

108 First, some elements of the background of the *lingqi* photographs. Since the beginning of the twentieth century, the practice they record has made its way into the common culture. Twice in Don DeLillo's *Underworld*, characters say "I'd rather die the death of a thousand cuts" in response to trivial annoyances. The *lingqi* is part of the ill-informed argot of Orientalism: the same procedure is also known as the "lingering death," "death by slicing," and "death by division into a thousand parts." It appears along with the *cangue* (the block of wood, worn like a collar), the so-called "Chinese water torture" (which was in all probability not Chinese at all, and possibly is not even a torture) and rumors of even more horrific punishments. At the beginning of the twentieth century such practices were widely disseminated in novels and on postcards, exaggerated and even counterfeited, but always in the service of a certain bourgeois Western European taste.

Bataille's *Tears of Eros* has had its own influence, and the photographs have achieved a twilight currency in the art world. His reading of the *lingqi* photographs has mingled with the Orientalist fascination, producing a singularly unjustified series of artistic practices and allusions.

The photographs, in short, seem entirely compromised by projection and misuse. Aesthetics has crept over them like a damp fungus.

 I first looked into these images because I wanted to understand why they were so important to Bataille and other surrealists. Everyone who studies surrealism becomes entangled in ideas of transgression, shock, and genuine otherness of experience and representation—all the things exemplified, for Bataille, by the *lingqi* photographs. These pictures have had an intricate social, institutional, and political life: they functioned as the seldom seen, but actually existing, proofs of the concepts that support surrealist practice. Current descendants of surrealism continue to need there to be something genuinely, unsurpassably transgressive, even if that thing turns out to be so strong that it undermines the very artistic practices it is called to support. At any rate that was my first interest in the *lingqi* images. ("The Very Theory of Transgression," *Australian and New Zealand Journal of Art*, 2004, 5–19.)

Here I have a different purpose in mind. I want to find out what happens when the *lingqi* images are attended to as we might look at a less painful subject: carefully, slowly, repeatedly. As if they were routine photographs like the other ones in this book.

Is it possible, for example, to spend time looking at them, as we would with ordinary photographs? Can I do more than peer quickly and then flinch, as I do when I pass a car crash? What would happen if I were to look carefully and slowly, as I habitually do with fine art, and as I have done with other images in this book? What happens to photography here, at one of its limits, where pain becomes so intense it interferes with my ability to concentrate, or just simply to see?

(Before I begin, an explanation. The principal scholar of these images, Jérôme Bourgon, has criticized my reading for perpetuating French Orientalist stereotypes. For the original French consumers of the images, up to and including Bataille, it mattered that the people being tortured felt exquisite pain and remained conscious until the very end of the process. The evidence from Chinese

historical sources is overwhelmingly against that interpretation: the Chinese legal intention was to ensure the impossibility of the victim being reborn, by destroying the body and thereby preventing a proper burial. Pain never figures in the Chinese documents. To this I want to say, emphatically: the reading I am going to give here, in an abbreviated form, has nothing to do with those facts, or with the *fin-de-siècle* or surrealist reception. I am interested in what happens if a viewer asks, as carefully as possible: What is happening in these photographs? That kind of looking, I find, is absent in the reception as a whole, all the way from Bataille's reaction—it seems he flinched at his own photographs, and mainly kept them hidden away—up to the contemporary scholarly interest, which is also predicated on not looking more than is necessary. Just as I have tried to look long at rocks, I am going to try to look patiently at bodies being cut.)

 For my abbreviated demonstration—there are many more images, and much more to be said—I choose the same case of torture and execution that Bataille knew, although he probably did not know that the photographs he had were cropped prints made from stereo pairs, and he probably did not suspect his photographs were samples from a longer sequence.

The man's name is given as Fuzhuli, and the place is Beijing. The accused man is bound to a tripod of stakes in a public square. In this sequence and in others, the crowd is complicit with the photographer: they step back, so the victim can be seen, and they pose in characteristic gestures as they do their work. Behind them is a large crowd, and a tumultuous market street. (The exact street is also known, but I am going to focus on the images.)

The four pairs I am reproducing here are preceded by another two, which show the man apparently more tightly bound. It is possible he was untied slightly so that his arms could be cut. (For the other images, turandot.ish-lyon.cnrs.fr, and Bourgon's study, *Supplices chinois*.)

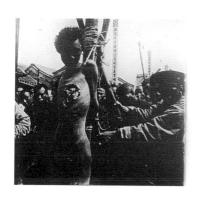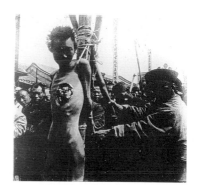

"the crowd is complicit with the photographer:
they step back, so the victim can be seen."

Anonymous Photographer. Death by *Lingqi*, Beijing, detail. April 10, 1905.

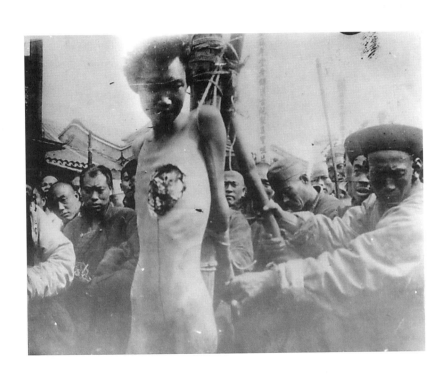

"the sequence begins with a very clean removal of skin and superficial fat, with almost no blood loss."

Anonymous Photographer. Death by *Lingqi*, Beijing, detail. April 10, 1905.

112 The two smaller poles in back are steadied throughout the procedure by several men. There are thin ropes around the victim's armpits and wrists. In photographs of other executions, ropes around the ankles are also visible. The man was suspended several inches above the ground, and pressed against the large vertical pole. In that position, the ropes under his armpits would be especially painful. He may have been tied with that in mind. In this first photograph, the man watches as the initial cut is made.

A large knife with a sharp blade is used to slice down through the breast. There is a photograph from another execution showing the executioner holding the nipple with one hand and cutting with the other, producing a characteristic incision with a sharp half-circle above.

Thus the sequence begins with a very clean removal of skin and superficial fat, with almost no blood loss. The same can be done skinning an animal, and the techniques used here must have been learned, by butchers and hunters, on animals. Beneath the skin, muscle, and fat of the chest, the ribs are covered with a bright whitish wrapping of fascia, smooth connective tissue. Under that are the ribs and the short muscles that knit them together, called the intercostal muscles. In this photograph the shiny fascia covering the intercostal muscles are still intact, just as they are when a rabbit or a deer is neatly skinned.

The man doing the cutting has slipped a little, and nicked the victim's side. Other than that his cut is very skillful, and only a small trickle of blood runs down from the wound.

113 In the second stereo pair, additional dissection has been done. The fascia have been dissected away, and either a rib has been cut or the intercostal space cleaned. The man's left arm has been cut.

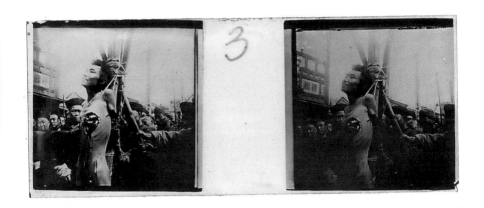

"In the second stereo pair, additional dissection has been done."

ANONYMOUS PHOTOGRAPHER. DEATH BY *LINGQI*, BEIJING. APRIL 10, 1905.

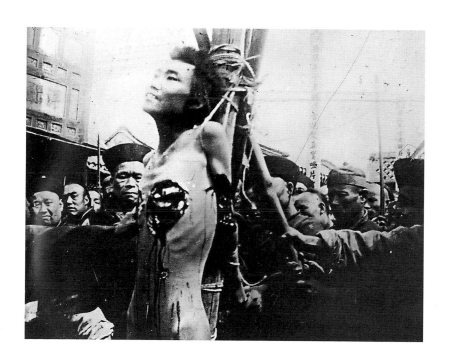

*"There is now a lens-shaped aperture,
neatly dissected inside the cut area of the victim's left breast."*

ANONYMOUS PHOTOGRAPHER. DEATH BY *LINGQI*, BEIJING. APRIL 10, 1905.

 There is now a lens-shaped aperture, neatly dissected inside the cut area of the victim's left breast. The same shape appears in photographs of other executions. The aperture or cleared area is located just where the fifth and sixth ribs tend upward toward the sternum (breast bone). If the superficial fat and intercostal muscles were cleared away, they would reveal a thin membrane, and beneath that would be the apex of the heart. It is possible that the point of this lens-shaped dissection is to show the victim his own beating heart.

115 The same picture shows a cut to the upper arm. A single cut opened the arm, nicking the victim's side in two places.

It is also possible that the humerus (upper arm bone) may have been severed, and ripped out at the joint. The arc of its cut end is visible midway along the wound, and so are the condyles, the round ends, of the forearm bones, the radius and ulna. In practice it would not be difficult to hack through the humerus with one or two strong blows of the cleaver. There is no satisfactory way to say this, but people who have experience in Chinese cooking know that heavy Chinese cleavers can cut large bones. Cutting through large bones is a standard process in Chinese cooking. By grasping the cut end, and pulling forward, the bottom portion of the humerus could be disengaged from the elbow joint. It is not clear in this photograph if that has been done, but in other photographs, and in other executions, the cuts and the result are evident.

The next stage, in other executions, was the amputation of the arms at the elbow joint. It is not clear if that is done in this sequence. When it is done, people have to help hold the man down, possibly to make sure his arms do not raise up and slip out of the ropes.

Ultimately the victim's body was dismembered, and there are also photographs of the body parts lying in the street. Pulling out the upper arm bone would have made it easier to dismember the body later.

"This is the photograph in which Bataille invested so much."

ANONYMOUS PHOTOGRAPHER. DEATH BY *LINGQI*, BEIJING. APRIL 10, 1905.

This third pair includes the photograph in which Bataille invested so much. For him, it possessed a tremendous fascination: the man's body, he said, was striped like a hornet, and his face showed ecstasy as well as pain. To Bourgon, the expression is very difficult to classify ("bien difficile à classer"). Bourgon also notes that his hair stands on end, although he does not try to explain why. It is impossible not to fix on the man's face, and wonder what that feeling is. Could we even understand it if we felt it ourselves?

But I do not want to speculate on the man's mental state: I just want to see how the cuts were made.

The ribs and their cartilage continuations, called the costal cartilages, are clearly visible in this photograph. They are probably ribs numbers 4, 5, and 6. The intercostal spaces are scraped clean: that would have made the motion of the lungs visible, as well as the heart. In theory, the victim could have looked down and seen his heart beating under a thin and nearly bloodless membrane. The membrane would have sucked in and out with each breath.

A broader, lower cut on the man's right side may be designed to reveal the liver. There is no way to know the intentions of the cuts, but they are done very skillfully and deliberately, and they do not vary significantly in photographs of other executions. So it is plausible, but not provable, that the lower cuts on the man's right side are intended to reveal other organs.

In the same photograph, the executioner is amputating the man's left leg by slicing through the knee joint. He has cut through the tendons of the superficial and deeper muscles of the front of the thigh (the quadriceps group of muscles) and revealed the condyles of the femur. The cut is half-finished.

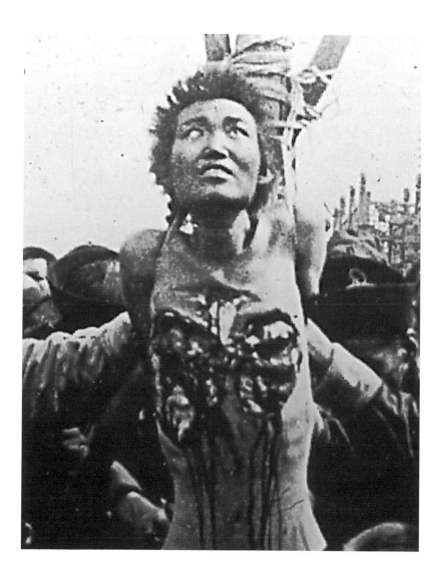

*"In theory, the victim could have looked down
and seen his heart beating under a thin and nearly bloodless membrane."*

ANONYMOUS PHOTOGRAPHER. DEATH BY *LINGQI*, BEIJING, DETAIL. APRIL 10, 1905.

"the executioner is amputating the man's left leg by slicing through the knee joint."

ANONYMOUS PHOTOGRAPHER. DEATH BY *LINGQI*, BEIJING, DETAIL. APRIL 10, 1905.

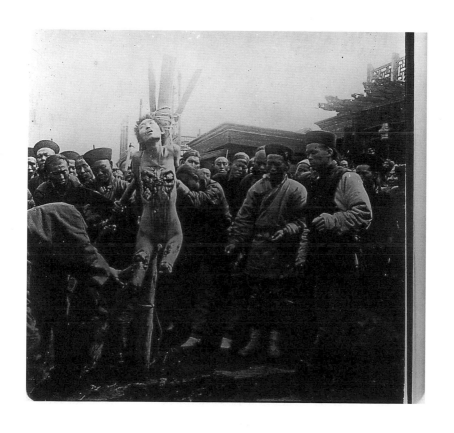

*"Cuts have been made to the front of the thigh,
like the cuts made to the arms before they were amputated."*

Anonymous Photographer. Death by *Lingqi*, Beijing. April 10, 1905.

All the photographs in this series, and many in the other series, are posed, and the moments chosen are ones that could be held for the camera. Here the cleaver is held at just the angle that would be needed to make a clean separation of the joint, above the knee bone. I imagine that the cleaver, in this photograph, is not moving, but the slice would be easy to finish.

 In the fourth pair of photographs, the last I will reproduce here, the electrifying expression of ecstasy or pain is gone. The man's expression is easy to read as exhaustion. "C'est une expression très compréhensible de fatigue et de dépression infinie," Bourgon says. (turandot.ish-lyon.cnrs.fr, photo 264.) But again, it is the cuts that interest me: as unpleasant as it is, the man's face is easier to look at, and think about, than his body.

Here the same cut is made to the man's right leg. One man holds the lower leg, while the executioner poses with his cleaver as before. Cuts have been made to the front of the thigh, like the cuts made to the arms before they were amputated. In other sequences of photographs, large cuts are made to the front of the thighs, with serrated sides, and the femur is cracked and pulled out.

Such amputation would not cause a fatal loss of blood, because quickly cut vessels spasm and clot. Given the careful attention to the loss of blood, it is entirely possible the victims could remain conscious through all these operations. Because the poses of the observers do not change significantly from one picture to the next, it appears the process was relatively rapid.

(And once again, for Jérôme Bourgon: the victim's consciousness does not mean that pain was the goal of the procedure; nor does it mean that the victim suffered the kind of quasi-religious ecstasy that Bataille and others thought they could read on his face.)

After this, the victim's head would be bent forward, and the executioner would cut through his neck from behind. And finally, the pieces might be thrown into baskets or onto the street for public viewing.

120 What I have done, and excerpted here, is an inventory of the basic contents of the photographs, paying attention only to the *method*, and not to all the other things that happen in the photographs, or to their production and dissemination, their social and legal contexts, the history of their reception in France, or even their place in contemporary scholarship. The tour has been brief, because I have not reproduced this entire sequence, or compared it with the other extant photographs. Even so, an analysis like the one I have just done could easily be expanded to the length of a book. (A fuller account is in *Representations of Pain*, 2012.)

What kind of analysis was this? If these images were something different—say, Renaissance paintings of the martyrdom of St. Lawrence, being roasted on an iron grate over a fire—then what I have just written would be called iconography or formal analysis. I would have talked about the saint's contortions, his *contrapposto*, his gesture of submission to God, and his last words (which I won't repeat here), and I would have mentioned the foreshortening of the grate, the light of the flames (a difficult achievement for Renaissance painters), and all the details of the Roman soldiers (spears, helmets, tunics, baldrics, breastplates and greaves). If an angel appeared in one of the paintings, I would have discussed the palm of martyrdom. In paintings, the study of obscure details is usually called iconography, and study of visual things such as lighting and composition is called formal analysis. I will call all of what I have just done *formal analysis* for short, because that expression captures my interest in forms and formalities. There are some agreed-upon traits of formal analysis that account for its universal application in entry-level courses on visual art:

1. Formal analysis is taken to be effectively neutral. It does not distort a picture's meanings, and so it is fairly unproblematic as a starting point. Whatever a student goes on to say about the artwork is not jeopardized by the initial inventory of symbols, actions, forms, or events.

2. Formal analysis is therefore appropriate for elementary pedagogy. It is the stock in trade of so-called "art appreciation," and a centerpiece of beginning history of art courses. It is a way of encouraging students to articulate what they see.

3. Formal analysis is bureaucratic because it is systematic and thorough. It labels and classifies everything in sight, like a secretary managing a system of files or a civil servant processing people in a government office.

4. Formal analysis is affectively noninvasive. It does not disturb the artwork's emotional, aesthetic, or intellectual power. That is so, apparently, because it is calm, slow, and methodical.

These four things are effectively true because the habits of academic and scholarly work make them true. Now I will add four more, which occurred to me following the experience of methodically looking at these images of torture. (If this listing sounds too academic, it is because I am aiming at an idea about rigid seeing, and a rigid exposition suits it.)

121

The four further principles of formal analysis:

5. Formal analysis is cold: it forecloses empathy, suppressing a full and open encounter with the subject of the image. When I concentrate on the cuts and their logic, I shut out my concern for the person who died on April 10, 1905, and I set aside my anger at the crowds who placidly stood aside for the photographers, and my incomprehension at the French tourists who bought the photographs and later mailed them home to their relatives. Likewise, when I think of the attributes of St. Lawrence, I do not think of what might be called the beauty or the power of the art. I am interested in the mechanism, the technique and presentation. I am cold, because I am preoccupied.

6. Formal analysis is dissective: the *lingqi* actually is dissection, while most introductory formal analysis is metaphorical dissection. My review of the procedure of *lingqi* is also metaphorical dissection, of an even higher level of abstraction. Visual dissection is strictly analogous to actual dissection.

7. Formal analysis provides the illusion of control: just as the victim's body in the photographs is controlled, so my desire to possess the image, to understand it, is regimented and kept in check by the incremental progress of the analysis. I control the image with

my rigid, strong interpretation: I sequester whatever in it is unruly or incomprehensible, I possess it by virtue of my regimen.

8. Formal analysis increases the pain of looking at these photographs, but it also creates pain in any photograph, any image. My desire to understand the image, to feel what it has to say, becomes a regimen, and like any regimen it is uncomfortable and finally even painful. Normally, when I am responding to fine art I am unaware of any opposite to pleasure. But formal analysis reveals that the pain of interpretation is inseparable from the pleasure the image is expected to yield.

122 Formal analysis feeds my desire, promising to increase whatever pleasure can be found following the displeasure of methodical viewing, and yet the formal analysis itself actually creates the only pleasure the image provides: it produces the pain of interpretation as the pleasure of the picture.

123 Formal analysis is my name for the kind of systematic, pinched, compulsive looking that I have fallen into several times in this book. Hopelessly counting stones in the O'Sullivan photograph. Rummaging in the dust of the World Trade Center. Looking into the cavities of the emerging atomic explosion. Counting cuts at the Chinese execution. This kind of looking is something Barthes never knew. Is that because my way of seeing is pathological, or just a quirk? Or because Barthes was sheltered from photographs by exotic faces and sweet-sour memories?

124

These *linqi* images are the most painful photographs I know. If a photograph produces any degree of pain, my looking becomes regimented. I flinch, and when I look again I am tense. This is true even when the pain is so slight that I don't recognize it as pain. Even in a supposedly pleasureful picture, like a Renaissance oil painting, the picture itself can begin to produce the pain of interpretation. It produces a tiny distress, and sets my seeing slightly on edge. A tiny displeasure, which I probably don't notice.

Things are much worse, in this respect, in photography than they are in painting or film. As Kafka said, in cinema it is not the look that chooses the images, but the images that choose the look. If I choose to look at these *linqi* photographs, I have to choose to look at every moment. The pain that builds up during an afternoon of viewing is of an entirely different order than with the cascade and grateful succession of images in film. (I got this thought from Enrique Vila-Matas's pleasureful and obsessive book of successive memories, *Montano's Malady*, 197.)

The *he-is-going-to-die* of the photograph, in which Barthes was so invested, does not generate the kind of looking I am calling formal analysis. Thinking *he is going to die* does the opposite: it helps me escape from seeing into reverie. It is the decision to pay attention that draws me into this uncomfortable Procrustean kind of seeing that borders on—and, I know, often falls into—the pathological. (*Pathos* + *logos*: it hurts logic, it strains sense. I am reading the word in the literal sense: pathology means disease of logic, or in this case really *pathoscopy*, ill seeing.) I see O'Sullivan's stones and Edgerton's atomic explosions the same way as I see the delirious face of the man being cut to pieces, but with Edgerton and O'Sullivan the vacuum of affect makes the experience airless and empty. It is no less pathological for that.

And yet: what is pathology here? Is it anything more than the absence of the little boy whose life would make a novel? Is anything in photography outside the pathological except *memories*, *hopes*, and *brief glimpses* of Photography, except little Ernest and the others, which are all that Barthes sees? Is there is a way to look at photographs without gazing transfixed, searching bewildered,

undertaking interminable inventories, compiling acts of butchery, gaping and staring, squinting and peering, wincing and flinching?

125 I become fascinated (undoubtedly compulsively) by what might be non-pathological about looking at photographs. "He is looking at nothing; he retains within himself his love and his fear; that is the Look . . ." Photography is full of unseeing and unseen looks, people who know they are being made into objects—who are caught, as Barthes says, in a little death, a crevice between acting person and seen thing. In academic criticism this subject is called the theory of the gaze. Lacan and Sartre are credited with founding the theory by speaking of seeing as the experience of seeing your look returned, of seeing yourself being seen. In this way of thinking about seeing, everything—objects included—have a kind of "seeing," a way of returning our look. (*The Object Stares Back*, chapter 1.) In the apparently simple act of seeing, we are caught in a web of gazes, woven from our own look and that same look as it is returned to us by others. The theory of the gaze can become intricate. It reaches its scholastic phase, for example, in a PhD thesis by Constance Blomgren, which classifies gazes according to the eight species of cat's cradle: 1. Cradle, 2. Soldier's Bed, 3. Candles, 4. Manger, 5. Diamonds, 6. Cat's Eye, 7. Fish in a Dish, 8. Clock. ("Gazing Forward, Gazing Back: A Hermeneutic Inquiry Regarding Photographs," University of Calgary, 2007.)

In this web of theories, the pathological is woven everywhere. Gazing, after all, is not ordinary seeing: it is unusually forceful or sustained. (Olin, "The Gaze," *Critical Terms for Art History*.) A web of gazes, a net or snare or cat's cradle of gazes . . . the theory of the gaze is strained, artificial. We normally look at photographs without thinking about how we look, and in that sense everything to do with gazing and theorizing the gaze is pathological, but only in the sense that we are not aware of how we see photographs, so that when our seeing emerges from the dark cave of spontaneity it looks differently than we might have thought.

126 I don't deny that what I have done in this book is perverse, and possibly also pathological (or *pathoscopic*). I have taken a small sliver of photography, and some out of the way examples, and tried to build a story about all of photography. I have framed this story, improbably, with three models of photography—selenite, ice, and salt—that evoke photography's inadequacy at clearly representing the world, which is the one thing it is normally understood to do with dependable accuracy. To construct this airless story, I have pushed aside the vast majority of all photographs, which are family photographs, and I have even tried to keep portraits out of this book, even though—as Benjamin said—"to do without people is for photography the most impossible of renunciations." ("Little History of Photography," 519.) I have sidelined the concerns of my fellow academics, because I haven't talked about history, race, gender, or politics. Most self-destructively, I have demoted fine art photography, even though nearly anyone who picks up a book called *What Photography Is* will expect discussions of the art world. And on top of all that I have aimed this book at another book instead of directly at photography, which risks missing the point entirely. Writing a book about a book is an academic thing to do, but photography—happily!—is not mainly an academic pursuit, so how can this book possibly be about photography in general?

Perhaps in the end it isn't. I am still not sure, and content not to be. Yet there is a way of arguing that what I have been calling perversities and pathologies are not so much clinical categories, pointing mainly to me, but modes of experiencing photographs, which we do not recognize because we have arranged our habits of seeing so that we seem normal to ourselves.

127 Here is my position: I think that if the kinds of seeing I have described in this book seem irrelevant, if it seems wholly possible just to go on looking at Jeff Wall and the others, if it seems that my concerns are disconnected from the many things that make

photography fascinating, that is because the photograph itself is scarcely being seen. What you are seeing may be just the bare minimum you need to see in order to get on with whatever themes interest you: art, history, gender, philosophy, digitization, post-modernism, social functions, love, memory. I think photography is more difficult than all of that. I am reminded of some lines from another W. S. Merwin poem, this time an older one:

> So it's mine
> This leg of a thin gray traveling animal
> Caught in the web again

That captures my thoughts when I started writing this book. There are so many ways of avoiding thinking in detail about what photographs give us that it can be a surprise to feel even a slight tug, now and again, from the web. Photography is warm and entrancing, a place to live and work and not notice the strangeness of the material that we supposedly know so well.

128 That is how I would argue I have said something about photography after all. What about the other purpose of this book, trying to inhabit Barthes's book in order to write *through* it to something else? I wanted to take his sense of writing, of *écriture*, seriously enough so that my own intentions about photography would be at risk of being washed away. At the beginning of this book I wondered what would happen if I got to the end and realized that my writing had in fact smothered my argument, producing a book that is more a knot of idiosyncratic meditations and "creative writing" than it is a contribution to the understanding of photography. I am not sure if that has happened either, but I am less happy to say so.

A fair amount depends on these words I have been over-using, "perversity" and "pathology." As Geoffrey Batchen has noted, Barthes does not make perverse selections from the history of photography, even when he is making personal choices, as for example with his

frontispiece. His pathologies (in the clinical sense now), such as his *deuil*, his desperate mourning, which nearly drives his philosophy to distraction, have no parallels in this text. Because Barthes let his mourning expand without limits, I wanted to sequester my own mourning in just one or two pages, knowing of course that is not possible. Barthes's mourning underwrites his annoying unaccountable certainty that memories of his mother can lead him to understand photography. If mourning underlies my own attraction to such inhuman things as dust and amoebas, it must be a very different sort of mourning.

Looking at things this way, it seems there is minimal contact between his book and mine. I like to think that all books are strangers in the end, even when—or especially when—one sets out to talk to another. I know that my analytic, sometimes literally microscopic way of looking at photographs has nothing in common with Barthes's synoptic gaze, and I have come to believe that the two occlude one another, with one sometimes beginning where the other one ends. If the two habits of seeing have a common point, it may be the punctum—the quilting point, as Lacan would have said, at which the two narratives are pinned together. On my side, doubting the punctum makes everything possible: on Barthes's side, the punctum must be retained even if its meaning changes completely in the course of the book.

But I find I am starting to talk again about Barthes's claims, and not his writing. I suppose that I should be content not being able to tell if the acid of writing has entirely perforated this book, eating away its claims about photography, or even if it is the same sort of acid that seeps through *Camera Lucida*, weakening its stability, undermining its logic. At least I have tried to see what it might look like, just for me, just with this one subject, if we take our allegiance to the poststructural critique of truth, writing, and philosophy as seriously as we say we do, and actually write something that forgets to behave itself, that fails to be dependable, that isn't good scholarship, but that tries to remember that even the most determinedly erudite and well-researched monograph is only writing.

129 I want to end on the point of pain. In *Camera Lucida*, "Photography's" facing of death is proposed as its hardest truth. Barthes says it over and over: the feeling of *that-has-been, it-has-taken-place, they-were-there, he-stood-there, he-is-going-to-die*, are sunk at the bottom of the well of what photography is. The thought and image of death are the heart of photography's darkness. ("Flat Death: Snapshots of History," *diacritics*, 1992, 128.) His conviction permits Barthes his serenity, so incongruous with his bereavement and his search, and allows him to persuade us—at least initially, and then intermittently—that his subject is actually Photography "in itself." The thought of represented death is what steadies the writer's voice, giving it what T. J. Clark calls, in another context, the "pessimism of strength."

There is a closely packed sequence of presence, presence of death in representation, and presence of the memory of the mother, which taken together sounds as close to Photography's "essential feature" as it is possible to be and still remain in language, in theory, in writing. (p. 3) This Photography can bring a viewer breathlessly close to the represented presence of death, "my mother's very being." (p. 99)

But I have been picturing photography as something less freighted with the passing of time, less perfectly suited to Barthes's own life. I have been imagining what it would be like if loss and Photography turned out not to be made for one another after all. I have tried re-reading the concerted search in memory that gives *Camera Lucida* the feeling of a detective story as a diversion, an elaborate way of failing to find a more difficult answer. If the search is not real, then the logic of the punctum, which is apparently intended to capture Photography "in itself," is *designed* to fail (and I take it this is Derrida's reading of the book), but its failure reveals more than an excess of desire (which is Derrida's reading). All the writing through toward death can be understood, I think, as a brilliant self-deception, a way of avoiding thinking about what photography "itself" continues to show us.

130 Many people have noticed occluded debts in *Camera Lucida*. It has been observed that Barthes's text circles around the representation of death the way Jacques Lacan's *Seminar IX* conjures and draws back from representations of the Real. Barthes cites Lacan's seminar and very briefly mentions Lacan's *tuché*, the impossible, traumatic touch of the Real pushing through the "automaton" of language and representation. (p. 4)

It has been noticed, too, that Barthes's supposed fascination with the punctum (I think it is better to say: his fascination with seeing what he might make out of the hope that he decided to pin on the word "punctum") is anticipated in Walter Benjamin's "A Little History of Photography," where the shock of traumatic photographs leads to the famous idea that "it is another nature that speaks to the camera than to the eye: 'other' in the sense that a space informed by human consciousness gives way to a space informed by the unconscious." (*Selected Writings*, vol. 2, part 2, 510.)

For Margaret Iversen, who has investigated these parallels with Lacan and Benjamin, what Benjamin should have said—in a sense, what he meant—was that "the Real appears in the visual field as the Gaze." (Iversen, "What is a Photograph?" *Art History*, 1994, 454.) What Benjamin called "the optical unconscious," she thinks, is due not to photography's mechanical nature, but to its display of the unrepresentable Real. Similarly, although Lacan seldom mentioned photography, his sense of the Gaze depended on what he took to be its capacity to "write" on his gaze: "photo-graphy," as he spelled it.

131 I do not doubt Barthes's debt to Lacan, nor the idea that the irruption of the Real is a way of understanding what Benjamin called "the optical unconscious" in photography. (Krauss, *The Optical Unconscious*.) But I think Barthes might have felt a different affinity with that sentence of Benjamin's. To say that "it is another nature that speaks to the camera than to the eye: 'other' in the sense that a space

informed by human consciousness gives way to a space informed by the unconscious" is to say something steeped in metaphor and poetry. "Another nature": beautiful phrase, full of portent, close to romanticism. "Human consciousness": a famous conundrum, a sign for something that cannot mean anything less than every mode of awareness, all reflection, and all thought—everything, and therefore nothing. And how am I to imagine those "spaces" Benjamin names? Are they photographic—"in" the photograph, or "in" the camera—or do they exist in imagination, or in language? What does it mean to "inform" them? Benjamin's thought is a lovely one, and its beauty makes me suspicious. I am suspicious, too, of the slide from thoughts of gazes, death, and "ominous distance," which lead up to the passage Iversen quotes, to the passage on stop-motion photography of walking, pictures of maple shoots, ostrich ferns, and other "image worlds . . . meaningful yet covert," which are the scientific and technical contexts in which Benjamin mentions the famous "optical uncon-scious." In a literal reading, confined to just the one sentence, "optical unconscious" isn't about psychoanalysis. It's a parallel: just as the "instinctual unconscious" was revealed by psychoanalysis, so this "optical unconscious" of tiny and ephemeral forms was revealed by the camera. The entire passage—one long paragraph—is intensely, strangely constructed. I wonder if Barthes didn't sense a fellow euphemist, another writer working to misdirect his own thoughts about photography. ("Euphemism," from *eupheme*, a word that substituted for a sacred word that should not be pronounced.)

I suspect Benjamin's paragraph of being seductive and poetic, and therefore I suspect it hides something, and I suspect Barthes heard that in Benjamin's text, and felt it would be best to keep it out of his book.

132 And more: I suspect Barthes's book is at the beginning of a long and flourishing literature of trauma, pathos, confession, and affect in art. I suspect it of being the first to hint at the restrictive nature of the art theory that had come before it—semiotics,

poststructuralism—and by doing so, being the first to license so many later writers, whose work has become a new way of thinking about feelings in art, what the art itself feels, how images themselves think and feel and want things of us, and how the viewer feels encountering the art: a literature that takes *affect* as its model and emblem.

Once I was guilty of all that myself. (*The Object Stares Back: On the Nature of Seeing*.) Now I want something both more painful and duller. I want to wring the feeling out of the writing and out of the photograph, so that the image sits uncomfortable and uninteresting in my mind, like a towel dried in the sun and frozen into an unattractive shape.

133 Perhaps the expression "optical unconscious" needs not to make sense, so that it can disguise other facts of photographic experience that Benjamin does not wish to articulate. What might be worse than the possibility that photographs "prick" us, that they harbor an "optical unconscious," that they point so uncomfortably at the viewer's own death?

In a word: that they might be boring. Or apparently meaningless. Or cold, inhuman, painful in a somatic way, hard to look at. Photographs threaten to show us that the photographed world we thought we had wanted to see—especially when, as some critics wish, that world might be traumatic, psychoanalytically inflected, severely challenging to our senses of identity, gender, and social place, and entangled in poststructural theory—is often dull. Even shock wears down to "shock" and finally to a chilled and unpleasant calm. (When I have spent a day looking at the *lingqi* photographs, I have felt cold and slightly numb, but also composed and immune to further shocks.) This is my answer to much of the current academic scholarship of photography: it finds gender and identity embodied in photography, but in doing so it forgets that the photographed world behind the sitters, the edges of the picturesque scene, the floors and walls and ceilings that were never invited into

the photograph, crawl with the uninteresting and the unpoetic. The parts of photography I have been stressing in this book are unclothed by the glamorous robes of the sublime, the rote elusiveness of the punctum, the vicissitudes of precariously constructed selves, the attractions of the ill-defined "optical unconscious."

134 So I have been writing a catalogue of displeasures. There is a kind of irritation in not being able to understand what I am seeing, and I find I am attracted to that irritation, the way I am perplexed by an itch that I can't scratch. There is a pleasing irritation in not knowing what is being shown, and I enjoy that perplexity provided it doesn't lead anywhere. (I don't want the solution, the explanation.) There is a sharp pain in suddenly encountering an image of pain. There is a softer pain in sliding down from real shock into the anesthetic numbness of Barthes's "shock" or my own calm, and I recognize that softer pain as the common unthreatening displeasure that photography is so good at providing. There is a low-level unhappiness in knowing that the grainy surface of the world is what is given in photography, and that it is—with some exceptions, and in a historically determined opposition to painting—not very interesting. There could be displeasure, but for me at least there is not, in realizing how much hope is pinned on the supposed rationality of the metaphor of the camera. There is a severe and steadily growing absence of pleasure, and even a deepening feeling of the permanent failure of pleasure, in the awareness that the life we see in snapshots is so untypical of photography. Those uncommon moments of photographed memory and love are like a sparse scattering of flowers growing on a mainly barren ground.

Photography is a *camera dolorosa* (from *dolor*, discomfort or pain): a compound of displeasures, each of them hidden by the very things Barthes loves: a smirking face by Kertész, a skipping boy by Eistenstadt, steam on horses' backs by Stieglitz.

135

Despite everything that the writing tries to do and the photographs undermine, pain is a point of pride in *Camera Lucida*.

It is advertised on the dust jacket of my copy of the English translation, where the only endorsement, by Douglas Davis, notes Barthes's "last painful discovery." It is broadly hinted at in the dust jacket of the French edition, with its "exotic" and unexpected but entirely transparent Tibetan story about the death of a monk's son. It is true there is personal pain in the *Journal du deuil* and in the elaborated journey, in *Camera Lucida*, that leads to the Winter Garden photograph, but those are matters for Barthes, or "Barthes." The actual pain of photography is effectively hidden under cover of the supposedly greatest pain, that of the *he-is-going-to-die*, the sign of death in photography: a pain that, for me, is so sweet and sensuous, so easy and tempting, so invitingly melancholy, that it is in the end just another source of pleasure.

I have tried to write against that warm, moist, and invasive sadness. I have tried to write a sterile book, with a minimum of interruptions from pathos, art, memory, loss, or nostalgia, because that is what I think photography also is.

Credits

Numbers in the left row are section numbers in the book. All photographs not listed here are property of the author.

Chapter 1

1, 10 Selenite window. Photo courtesy American Museum of Natural History, neg. no. 260769.

Chapter 2

11 Black lake ice in Antarctica. c. 2005. Photo: John C. Priscu and the Priscu Research Group, Department of Land Resources and Environmental Sciences, Montana State University, Bozeman.

15 William Henry Fox Talbot, *Articles of China*, detail. 1844. Salt print from a calotype negative. Private collection, courtesy of Hans P. Kraus Jr, New York.

21 Russell Vreeland, Halite crystal (piece of rock salt). 2000.

22 Everett Lawson, *Untitled*. 2008. Courtesy of the artist.

23 André Kertész, *Little Ernest*, in the English edition of *Camera Lucida*, p. 83.

24 André Kertész, *The Puppy*, in the English edition of *Camera Lucida*, p. 114.

Chapter 3

33, 37, 38, 39 Timothy O'Sullivan, *Vermillion Creek Cañon Looking Downstream*. 1872. U.S. Geological Survey. Photo courtesy Mark Klett.

33, 37 Mark Klett, *Vermillion Creek Canyon, Colorado*, for the Rephotographic Survey Project, 1979. Photo courtesy Mark Klett.

40, 42 Photos courtesy University of New Mexico Press.

47, 48 Wolfgang Hamburg, Noctilucent clouds, Bernitt, Germany. 2001. Photo: Wolfgang Hamburg, Bernitt, Germany.

51, 52 Frank Chapman, Darwin's rhea, near Punta Arenas, Chile. c. 1924. Photo: American Museum of Natural History, neg. no. 264329.

Chapter 4

69 Bernard L. Madoff, photo by Michael Appleton. *The New York Times*, March 11, 2009. Photo courtesy Redux Pictures.

70 Anonymous photographer, Greyhound. Undated. Photo: public domain. Collection Library of Congress, photo 302018.

71 Protest in Peshawar, photograph by Mohammad Sajjad. *The New York Times*, March 15, 2009, p. 11. © AP/Wide World Photos.

73 David Scott, *Untitled [Long-Handled Tong Being Used on the Moon]*, photo chosen by Michael Light, original taken in 1971. Photo: public domain.

T Tear of a Swan. Photo © Gerald Helbig, lebendkulturen.de.

M Mastigamoeba sp. (aspera?). Photo: Hiromi Yoshino, University of the Ryukyus, c. 2002. Photo © Protist Information Server.

G Gromiid. Photo: Yuuji Tsukii, Saitama Prefecture, Japan, May–June 1999. © 1995–2010 Protist Information Server.

82, 83 World Trade Center dust. Images courtesy of *The Microscope/Microscope Publications*.

Chapter 5

86–91 Harold Edgerton, Atomic test explosions. Edgerton archive nos 14.233, 14.244, 11.547, 10.217, 11.769. Courtesy Palm Press.

Chapter 6

111–19 *Lingqi*. Photos courtesy of the Musée Albert Kahn.